Reassessing the Theatre of the Absurd

Reassessing the Theatre of the Absurd

Camus, Beckett, Ionesco, Genet, and Pinter

Michael Y. Bennett

palgrave
macmillan

First published in hardcover in 2011 by PALGRAVE MACMILLAN® in the United States—a division of St. Martin's Press LLC, 175 Fifth Avenue, New York, NY 10010.

Where this book is distributed in the UK, Europe and the rest of the world, this is by Palgrave Macmillan, a division of Macmillan Publishers Limited, registered in England, company number 785998, of Houndmills, Basingstoke, Hampshire RG21 6XS.

Palgrave Macmillan is the global academic imprint of the above companies and has companies and representatives throughout the world.

Palgrave® and Macmillan® are registered trademarks in the United States, the United Kingdom, Europe and other countries.

ISBN: 978–1–137–37876–7

The Library of Congress has cataloged the hardcover edition as follows:

Bennett, Michael Y., 1980–
 Reassessing the theatre of the absurd : Camus, Beckett, Ionesco, Genet, and Pinter / Michael Y. Bennett.
 p. cm.
 Includes bibliographical references.
 ISBN 978–0–230–11338–1 (alk. paper)
 1. European drama—20th century—History and criticism. 2. Theater of the absurd. 3. Absurd (Philosophy) in literature. I. Title.

PN1861.B44 2011
809.2′04—dc22 2010041714

A catalogue record of the book is available from the British Library.

Design by Newgen Knowledge Works (P) Ltd., Chennai, India.

First PALGRAVE MACMILLAN paperback edition: December 2013

10 9 8 7 6 5 4 3 2 1

To my parents

And in loving memory of
Julius Yudkovitz (1915–2010)
Leah Yudkovitz (1919–2007)
Mark Bennett (1944–2007)

Contents

Acknowledgments

I have a number of people I need to thank who helped me over these past five-plus years with this book project. First, I am indebted to a number of professors who gave me a lot of their advice, support, and time: my dissertation committee (Jenny S. Spencer, James Freeman, and David Lenson), Joseph Donohue, Nicholas Bromell, Robert Combs, Adam Zucker, J. Chris Westgate, and Mark Blackwell. I would also like to thank my friends, who have constantly been there for me (both as friends and as readers) and inspired me (both intellectually and emotionally) throughout this long process: Eyal Tamir, Joel Anderson, Colin Enriquez, Shai Cohen, and Madelyne Camera. And a special thanks to my parents and family: I literally could not have completed this without all of your love and support.

Preface

It has been about two and a half years since my book, *Reassessing the Theatre of the Absurd*, first came out. This book has seemingly struck both a chord and, possibly, a small nerve among academics. It seems as though no two scholars have—*for the same reasons*—the same response to my book. Because of this, I would like to very briefly discuss two issues that address both what this book *is* and what this book *is not*, or, rather, what this book *attempts to do* and what this book *does not attempt to do*.

First, *Reassessing the Theatre of the Absurd* was never meant to try to *replace* Martin Esslin's seminal book, *The Theatre of the Absurd* (1961). The last thing that I wanted to do in this book was to get rid of Esslin's labels/categorization and replace it with my own labels/categorization. Instead, as one reviewer of my book, I think, appropriately observed, "Bennett and Esslin do not replace each other but form a cohort. Together, their critical works form a 'double-reed flute.' With one end we listen to a melody composed in the 1960s, and from another end, we listen to the one orchestrated...[in] our [time]."[1] While in my book, I did point out a number of perceived "misreadings" in Esslin's book, my goal in enumerating these misreadings was, ultimately, to "free" these plays from being straightjacketed by their "absurd" label. In short, I believed that if it could be demonstrated that the polar opposite reading of Esslin's exists (and this polar opposite reading was what I attempted to provide in *Reassessing the Theatre of the Absurd*), then these two readings related to the absurd (Esslin's reading and my own reading) would *cancel each other out*: ultimately rendering plays that are not, by default, so imbued and saturated with connotations of the absurd. Therefore, it was my hope that this cancelling out would allow future scholars to create and

[1] Shiva Rijal, "Absurd, Parables and Double-Reed Flute," *Journal of Philosophy: A Cross-Disciplinary Inquiry* 7.16 (Fall 2011): 71-72.

explore their own paths, rather than have to start time and time again from the same, oft-covered critical lineage that emerged from Esslin's book.

And second, in general, Esslin's *The Theatre of the Absurd* takes a, primarily, *thematic* approach, while my *Reassessing the Theatre of the Absurd* takes a, primarily, *structural* approach. My structural approach—that is, viewing these plays as examples of "parabolic drama"—was meant to accomplish two things: 1) aid my attempt to offer the opposite thematic reading of Esslin (which, as I note above, is necessary, ultimately, to *cancel out* the thematic absurd reading), and 2) offer future scholars more tools (of a structural nature) that could be used to interpret the plays associated with the absurd. Thus, importantly, the term "parabolic drama" was only meant as a means to an end. I was not trying to replace the "absurd" with "parabolic drama"; I created the term and concept of "parabolic drama" in order to suggest that the *form* of the parable that I believe is used in these plays can enlighten and broaden our understanding of the plays commonly thought of as absurd.

While I understand that challenging a book like Martin Esslin's *The Theatre of the Absurd* (and a good amount of the last fifty years of scholarship on these plays) is an ambitious undertaking filled with countless pitfalls (some of which I avoided better than others), I did think it vital, with the gift of hindsight, to further and more fully delineate the intended scope of my project and what were the (above-mentioned) *goals* and *limits* of my analysis.

MICHAEL Y. BENNETT

Traditional
Theatre.

Introduction:
Reassessing the Theatre of the Absurd

In 1953, a play premiered that confounded audiences, arguably, unlike any play that has come before or after it. That play was Samuel Beckett's *Waiting for Godot*. One early critic probably summed up the frustrations of the 1950s theatre audience the best, taking a line from the play: "Nothing happens, nobody comes, nobody goes, it's awful."[1] Audiences who were used to Aristotelian, Shakespearean, melodramatic, and realistic drama, a play with a clear beginning, middle, and end—exposition, action, climax, and a dénouement—had a right to be bewildered by a play like *Godot*. However, though *Godot* received the most press, it was not the only play of its kind. A new avant-garde theatre was taking shape. Though none of its practitioners claimed they were part of a movement, playwrights such as Beckett, Harold Pinter, Jean Genet, Eugene Ionesco, Arthur Adamov, and Edward Albee befuddled audiences in a similar manner. As the 1950s proceeded, these plays started to gain a following, but, for the most part, the general public lagged behind.

Then, in 1961, a landmark book—Martin Esslin's *The Theatre of the Absurd*—codified this avant-garde movement and demystified the structure and subject matter of these plays by arguing that the reader or audience member must judge these plays not by the standards of traditional theatre, but by the standards Esslin set forth for what he called the Theatre of the Absurd. If you are reading this book, you have almost undoubtedly either read or have heard about the central arguments of Esslin's now-famous book.

Fifty Years Later

Now it is exactly 50 years after the publication of Esslin's book and it is time for the Theatre of the Absurd to receive a thorough re-working. *Godot*

is no longer a mystery. It is even taught in high schools around the world. However, for the most part, *Godot* and the plays of the Theatre of the Absurd have been pigeonholed as absurdist texts by the general public and academia alike. Since 1960, with Esslin's introduction of the term in an article by the same name—the Theatre of the Absurd—the prominent idea of absurdity expressed in these plays has been largely accepted as a given when understanding these plays. I want to be clear here: when I reference the plays of the Theatre of the Absurd (or "these plays"), I am referencing the plays that Esslin characterizes as absurd. I argue that Esslin based his understanding of the plays he characterized as absurd on two significant misreadings: 1) Esslin mistranslates and miscontextualizes a quote by Eugene Ionesco, which Esslin uses to define the absurd,[2] and 2) Esslin misread Albert Camus as an existentialist.[3] As such, Esslin posits that the Theatre of the Absurd contemplates the "metaphysical anguish of the absurdity of the human condition."[4] I will suggest, instead, that these texts, rather, revolt against existentialism and are ethical parables that force the audience to make life meaningful. Ultimately, I argue that the limiting thematic label of Theatre of the Absurd can be replaced with an alternative, more structural term, "parabolic drama."

I argue in this book that these plays that constitute the Theatre of the Absurd can be read in a new light through a re-examination and re-application of Camus's philosophy. In 1995, 35 years after the death of Camus, the publication of Camus's unfinished *Le premier homme* brought tremendous renewed interest in Camus and led to a reassessment of some of the basic assumptions about his work.[5] I argue that if we read Camus as he is now understood—not as an existentialist, as he once was understood, but as someone revolting against existentialism—then our entire understanding of the Theatre of the Absurd can be reconceived. Such plays were first understood in terms of Camus and existential philosophies, accenting the meaninglessness of the world and life. Reading them with an up-to-date understanding of Camus allows us to better gauge the ethical implications of their work. This book has three purposes: 1) to use an up-to-date reading of Camus to free the playwrights from the absurdist label placed upon them; 2) to suggest an alternative reading, positing that the playwrights that Esslin characterized as absurdist write, rather, in a parabolic manner; and 3) to suggest new readings of canonical Absurd plays. This approach differs from the thematic approach that Esslin takes; I take a generic, structural approach that simply offers more tools for reading the plays that Esslin characterized as absurd.

I begin with Esslin's argument to provide a common ground. From there, I will turn to the current conceptions of the absurd: some of which restate

Spiritual disrupt

Esslin → Thematic approach

Generic structural approach

Thematic — Throughout the time

Esslin's arguments and some of which suggest other readings. Based upon some of these other readings, I examine Esslin's two misreadings. Finally, I argue that the thematic label, "Theatre of the Absurd," should be jettisoned and the term "parabolic drama," which suggests merely a structural reading, should be offered as one alternative.

"Absurd": A Note

Before I start, even though this entire Introduction and the book as a whole appear to be about the absurd, let me preface this by stating that neither is really about the absurd, per se. The absurd has a long and complicated lineage, with many different versions and definitions of the word and the concept.[6] I am engaging with Camus's sense of the word and the concept for two reasons. First, Camus is the chosen philosopher that Esslin writes about, and Camus's quote from *The Myth of Sisyphus* found in Esslin's book is central to the understanding of the Theatre of the Absurd. Second, Camus was a stated possible influence of Ionesco and, as will be observed in chapter 1, *Waiting for Godot* is a recast myth of Sisyphus. James E. Robinson, though he makes no attempt to "define a watershed" in Beckett's change, also suggests that Beckett "takes a Sisyphus-like turn from the absurd struggle in the mountain to his mastery of the rock."[7] Also, in a new book, *Beckett Before Beckett*, Brigitte Le Juez sheds light on Beckett's early influences and thoughts on literature through a notebook from a former student at Trinity College. Beckett was fascinated by René Descartes, who provides a direct link to the Enlightenment period, where individual reason was used to make sense of the world.[8] Beckett's understanding of the world in such a manner fits in nicely with Camus. Furthermore, Beckett saw literature as something not concerned with the unfolding of events, but with an essence that needs to be acknowledged and contemplated for its complexity. The world for Beckett was, in some ways, paradoxical, as it was for Camus: life, for Beckett, was *"parfaitement intelligible et parfaitement inexplicable* [perfectly intelligible and perfectly inexplicable]."[9]

In a sense, though, the "actual" definition of absurd does not even matter for understanding the Theatre of the Absurd. Whether it comes from a nihilistic perspective of "nothingness" or more from Camus's paradoxical perspective where our desires will not be met by the realities of the world, the Theatre of the Absurd really is not concerned with this fact. Esslin was correct in that the playwrights of the Theatre of the Absurd do not argue whether the world is absurd or not, and they certainly do not try to define this sense of absurdity: they merely present it as such.[10] Camus, in some sense, just states absurdity as a given. And in his philosophy, one would

Generic = Individual focused.
Interpersonal processes.

be much better off if one realizes that it is just a given. And in this way, the question becomes, specifically for Camus, what is one to do, given that the world is absurd? This is the question that preoccupies Camus and, as I argue, the playwrights of the Theatre of the Absurd. *So the world is Absurd, who cares?* I believe Camus and these playwrights are contemplating, however, the *consequences and our resulting actions* of our Absurd situation: even though it is left unsaid in these plays, the question is, how is one to make meaning out of such a world and a situation?

As I explore later, one of the reasons that I want to avoid the word and concept of the absurd (and, as you will see, it will be used very minimally in the following chapters) is because of all of its variations and of the baggage attached to the word that dilutes or misconstrues its meaning. There is another reason, as well. Calling this "theatre" the Theatre of the Absurd really places the emphasis of the play on the wrong part of it. For example, it is like saying (though it is done most of the time) that *Saving Private Ryan* and *Full Metal Jacket* are *war movies*. But that really minimizes, bastardizes, and diminishes what these movies are trying to do. These movies are not really about war, per se, but about how humans either cope, overcome, succumb, etc., to the horrors of a situation like war, or the "absurd" contradictions present that juxtapose the desires of the combatants with the realities of war. Again, I am arguing that the Theatre of the Absurd is not about absurdity, but about making life meaningful given our absurd situation.

Part I: Current Conceptions of the Absurd

Esslin's *The Theatre of the Absurd*

I want to turn back, in order to move forward, to Martin Esslin's *The Theatre of the Absurd* because the Theatre of the Absurd came out of a *particular historical moment and was codified into one "genre" through Esslin's book.* In the Preface to *The Theatre of the Absurd*, Esslin clearly outlines the project of his book. He has three objectives for the book: 1) to define the convention of this "theatre" so that it can be judged on its own merits and not dismissed as nonsense or intellectual snobbery because it does not fit in with the standards of "conventional" theatre, 2) to elucidate the meaning of these plays, and 3) to show how this theatre is an "expression—and one of the most representative ones—of the present situation of Western man."[11]

Esslin stresses that this is not a self-conscious movement. He is merely noting a trend from a group of individual playwrights who, he argues, felt "cut off and isolated in [their] private world[s]."[12] Esslin lays out his project by starting with the theatre as an expression of the philosophy of the absurd

(objective #3). From there, he explains the dramatic convention (objective #1). These two goals make up the Introduction. The rest of the book is the elucidation of the plays, based on the philosophy and convention of the absurd in the Introduction (objective #2). In this section, I explain Esslin's claims about the philosophy and the convention.

Esslin argues that the faith of progress, nationalism, and totalitarian fallacies masked the decline of religious faith in and around World War II.[13] All of these things, however, that gave us hope and purpose were "shattered by the war."[14] Esslin turns to Albert Camus, the backbone of the philosophy of the Theatre of the Absurd, to comment on the feelings of the times. Esslin states that," By 1942, Camus was calmly putting the question why, since life had lost all meaning, man should not seek escape in suicide."[15] Esslin refers to Camus's *The Myth of Sisyphus*, as Esslin puts it, to "diagnose the human situation in a world of shattered beliefs."[16] Shortening the excerpt myself to highlight what is most important, Esslin quotes a passage from *The Myth of Sisyphus*: "... in a universe that is suddenly deprived of illusions and of light, man feels a stranger... This divorce between man and his life, the actor and his setting, truly constitutes the feeling of Absurdity."[17]

From this passage the idea of absurdity is introduced and defined by Esslin. He argues that the word *absurd* originally came from a musical context which meant "out of harmony," and is used in the everyday sense of "ridiculous." This is not the sense in which the absurd is defined in the Theatre of the Absurd according to Esslin.[18] For the definition of *absurd*, Esslin turns to Ionesco. Esslin translates this quote from an essay Ionesco had written on Kafka in 1957 (this is the entire quote as the ellipse is a part of it): "Absurd is that which is devoid of purpose... Cut off from his religious, metaphysical, and transcendental roots, man is lost; all his actions become senseless, absurd, useless."[19] Stemming from this definition, and its constant and continued use in the field, scholars and common readers alike, most likely because of the influence of this book, have basically understood the absurd and the Theatre of the Absurd as emphasizing the purposelessness and senselessness of life.

The sense of the purposelessness of life comes directly from what Esslin further has to say: that the theme of the plays of the Theatre of the Absurd is "their sense of metaphysical anguish at the absurdity of the human condition."[20] Though Esslin says other playwrights discuss this same subject matter—the "sense of the senselessness of life"—such as Jean Giraudoux, Jean Anouilh, Armand Salacrou, Jean-Paul Sartre, and Camus, these other playwrights do so in highly lucid and logically constructed reasoning, where this "new content" is presented in "the old convention."[21] What absurd playwrights do, however, is to match the philosophy with the aesthetic: "... the

Theatre of the Absurd strives to express its sense of senselessness of the human condition and the inadequacy of the rational approach by the open abandonment of rational devices and discursive thought.[22] In other words, Esslin suggests that the philosophy *and* the aesthetic are "absurd"; the theatre itself and/or what happens on stage are just as irrational and senseless as life itself. Esslin argues that the Theatre of the Absurd does a much better job at expressing both the artistry and philosophy of Sartre and Camus, than Sartre and Camus achieve in their own theatre (where they only explore their philosophy).[23] In addition to the quote about "other" writers who have written about the senselessness of life, this is the second time that Esslin *broadly* conflates the philosophies of Camus and Sartre.

Thus, for Esslin, the conventions of the Theatre of the Absurd are defined by an aesthetic matching a philosophy. For Esslin, "The Theatre of the Absurd has renounced arguing *about* the absurdity of the human condition; it merely *presents* it in being—that is, in terms of concrete stage images of the absurdity of existence."[24] In other words, these playwrights do not debate or even contemplate the possibility of an Absurd world: they take it as fact and merely hold up a mirror to this reality. However, if the reality is Absurd, as Esslin argues, the aesthetic will be, as well. Therefore, these plays of the Absurd,

> ... [tend] toward a radical devaluation of language, toward a poetry that is to emerge from the concrete and objectified images of the stage itself. The elements of language still plays an important, yet subordinate, part in this conception, but what *happens* on the stage transcends, and often contradicts, the *words* spoken by the characters.[25]

Esslin uses Ionesco's *The Chairs* to demonstrate this concept, suggesting that the poetics of the play does not rest in the "banal words" spoken, but in the fact that they are said to "an ever-growing number of empty chairs."[26]

Hence, Esslin argues that the absurd playwrights portray a purposeless, absurd world. This absurd idea is conveyed in both the philosophy and the aesthetic of the plays. By not matching what happens on stage with what is being said, the concept of incongruity forms the convention of the Theatre of the Absurd.

Contemporary Scholarship on the Absurd

Though not explicitly putting this event as the starting point for the absurd, Esslin starts his book with the now famous staging of Samuel Beckett's *Waiting for Godot* in 1957 at San Quentin penitentiary. Ruby Cohn, writing

almost 30 years later, and with hindsight, pins 1950 as the approximate date of the birth of the Theatre of the Absurd because it was five years after WWII and plays by Adamov and Ionseco were playing in Paris and Beckett had completed *Godot*, though he was looking for a theatre.[27] Enoch Brater argues that one must start with Beckett when discussing the Theatre of the Absurd, not only because others do, but especially because that is where Esslin starts with the above staging.[28] Beckett has had a huge influence on other writers, as Brater and others have pointed out:

> The plotless play, the use of discontinuous dialogue, the set empty but filled with mysterious suggestion, the denouement that never comes, the effects of silence and the tension that builds in a pause, the sheer theatricality held by the actor's voice in extended monologue, or the dramatic opportunity that lies in standing stock-still, have become so characteristic of our theater that we hardly notice them all.[29]

One of the most written about plays, *Waiting for Godot*, and the rest of the Theatre of the Absurd, has had a lasting impact in the theatre as well as in the university classroom. The absurd is commonplace and thoroughly understood as such. A look at recent theatre reviews can attest to this. Excluding the production of *Godot* in New Orleans, of the nine reviews of the four most-written-about European "Absurdist" plays from the four most-written-about authors from 1950 to 1959 (Beckett's *Waiting for Godot*, Ionesco's *Rhinoceros*, Genet's *The Blacks: A Clown Show*, and Pinter's *The Birthday Party*) by *The New York Times* and *Theatre Journal* since 2000, seven of them explicitly use the word "absurd" to describe at least an aspect of the play, if not the entire play itself.[30] The other two, though they do not use the word, characterize the plays in the same way.[31] All five reviews in *Theatre Journal* used the word "absurd," which can suggest that maybe "absurdity" has an even stronger affiliation within the academia.

The beliefs of the academy do not necessarily shape the way that the theatre-going public views a particular play. However, such is not the case with the "absurd." Ben Brantley, the head theatre critic at *The New York Times*, and arguably the most influential critic in the United States, could have been quoting Esslin directly in a very recent review of Albee and Stoppard's newest plays:

> Mr. Albee and Mr. Stoppard are directly descended from Beckett. Like him they consider the meaningless of a life that knows its own extinction, of being in the face of nothingness. They share this worldview with that other great successor to Beckett, Harold Pinter.[32]

Though Brantley certainly sees the "face of nothingness" when trying to make sense of these plays, his next-to-last line in the review unknowingly undermines Esslin's view of the absurd (and, thus, his own): "[*Rock 'n' Roll*]'s final lines address what is a basic human condition of Mr. Stoppard's world with defiance and triumph: 'I don't care! I don't care! I don't care!' "[33] When we examine Camus's view of defiance as that which helps create meaning in life, we will come to see the irony in Brantley's statement.

I am not the first scholar to suggest that maybe the Theatre of the Absurd does not necessarily comment on the purposelessness of life.[34] Although the legacy of Esslin's *Theatre of the Absurd* has remained strong and has not had any outright challenges, there are some recent scholars who have, either directly or indirectly, begun to see the Absurd playwrights, at least, engaging with the question of meaning, as opposed to dismissing the possibility of having meaning in this world outright.[35] I suggest that meaning-making, not meaninglessness, is integral to the plays characterized as absurd. Because of the plays' parabolic nature—metaphor, paradox, and a move to disorder—the reader or audience member is forced to confront his or her own worldview in order to create order out of the chaos presented in the plays. In addition to common structural elements, stemming from Camus's assertion that the absurd is just a given and that human reason is needed to make meaning in this world, the parable provides a genre in which to make sense of an absurd *situation*. The argument in this book is predicated on the two significant misreadings by Esslin. The first misreading is a mistranslation and miscontextualization of Esslin's well-known definition of the absurd. The second is that Esslin posited that Camus formed the backbone of the philosophy of the Theatre of the Absurd. However, like his contemporaries, Esslin mistook Camus for an existentialist.

Part II: A Re-examination of the Absurd

Esslin's Definition of the Absurd

> Absurd is that which is devoid of purpose...Cut off from his religious, metaphysical, and transcendental roots, man is lost; all his actions become senseless, absurd, useless.[36]
>
> Eugene Ionesco, qtd. in *The Theatre of the Absurd*

Definitions are usually a good place to start when making an argument, as definitions provide the common ground for understanding. The plays that we are examining are the ones that Martin Esslin characterizes as works of the Theatre of the Absurd from *The Theatre of the Absurd* (1961). The names

that immediately jump to mind are Beckett, Pinter, Genet, Ionesco, and Albee (as these are the most-written-about playwrights that Esslin dealt with in his seminal work). The above quoted definition may, more than any other line about absurdism, define "this" theatre for us.

The above quote was taken by Martin Esslin from an essay in French by Eugene Ionesco on a short story by Franz Kafka. A closer look at the context of this quote illuminates the parallels among Ionesco, Kafka, and Camus. The coincidences are rather amazing. In Esslin's view, Ionesco is one of the principal absurdists. It makes for a nice definition that it is Ionesco himself, indirectly, defining his own work. That this quote was about Kafka's work seems to fit in with the absurd, as well.

However, Ionesco was not the only writer who commented on the parallels between the absurd and Kafka. Actually, it was Camus, whose philosophy of the absurd formed the philosophical backbone of Esslin's book, who also wrote about Kafka. Camus, in his appendix to *The Myth of Sisyphus*, discusses Kafka and his relationship to the absurd. For Camus, Kafka certainly expresses the absurd and makes constant use of it; however, like the playwrights of the Theatre of the Absurd, "this world is not so closed as it seems. Into this universe devoid of progress, Kafka is going to introduce hope in a strange form."[37] This is the same point that Ionesco makes about Kafka. To draw the influences together even more, Ionesco said in an interview, that Kafka and, perhaps Camus, were his influences.[38] (Ionesco also explicitly said that Jean-Paul Sartre was not one of his influences; Ionesco did not like Sartre's philosophy.[39]) This definition, then, would *seem* to be the perfect one for analyzing the absurd. Furthermore, Ionesco and Kafka, along with Beckett in his own unusual way, were linguistic exiles. The three of them were all "cut off" from their society in this manner.

It is imperative to give the definition more context, as Esslin did not (without explaining where the quote came from, Esslin simply includes the quote). In Ionesco's short essay available only in French, Ionesco writes about Kafka's *Armes de la Ville*. Kafka's story is about the legend of the Tower of Babel. Ionesco says that Kafka explores the fact that the people's initial goal of building the tower got lost in the process and their pettiness. After a while, the people did not even remember why they wanted to build the tower in the first place. As Ionesco says, the goal is forgotten (*Le But est oublié*).[40] Because their goal was forgotten, humanity got lost in the labyrinth (*elle est égarée dans un labyrinte*).[41]

Esslin translates the all-important word, "but," from Ionesco's line, "*Est absurde ce qui n'a pas de but…*"[42] as, "Absurd is that which is devoid of purpose…"[43] The word "*but*," however, which Esslin translated as "purpose," really has more of a sense of "goal" or "target" or "end," especially

since Ionesco is discussing Kafka in terms of his engagement with history and the idea of completing a project. Reading the absurd, instead, as that which is *devoid of a goal*, sounds just like Camus and does not relate the absurd with the lack of purpose that has continually defined the meaning of the plays of the Theatre of the Absurd. Further, when Esslin quotes Ionesco, Esslin's use of the ellipse makes it appear that," Cut off from his religious, metaphysical, and transcendental roots, man is lost; all his actions become senseless, absurd, useless,"[44] is a further elaboration of the definition of *absurd*. However, Esslin does not put this line in the context in which the clause appears. There are two sentences in between these clauses that state that the final goal cannot be found beyond history, but needs to guide human history, rather, and the goal gives it meaning.[45] This view shows the profoundly religious (*profondément religieux*) character of Kafka in Ionesco's eyes.[46] Read in this context, the quote, following the colon before it, has more of the sense of, *when man is* cut off from his religious, metaphysical, and transcendental roots, *then* man is lost; all his actions become senseless, absurd, useless. This idea suggests that Kafka (and, thus, Ionesco) can be read in an entirely different light than that Esslin proposed. Kafka says that there is meaning in life, in a sense, if one *is* connected to his or her religious, metaphysical, and transcendental roots. And this is closely aligned to one's own man-made goals—such as building the Tower of Babel, for instance. This, again, brings Kafka much more into a dialogue with Camus. This point can be seen in Ionesco's reading of Kafka, in which he says that Kafka is writing about a world of material comfort (*confort matériel*).[47] This world of material comfort—without goals—is the desacralized world that Kafka is denouncing (*C'est le monde désacralise que dénonce Kafka.*).[48] In his renunciation, as Ionesco sees it, Kafka says that one has to revolt against this world (*se révolta*).[49]

Ionesco, then, understands Kafka's use of absurdity in the same manner as Camus, further demonstrating Camus's influence on Ionesco. For Camus and Ionesco, the absurd was a *situation*, but not a life sentence of destined meaninglessness or a comment on the world. True, life *might* not have any inherent meaning, but this stems not from the world, but from the contradiction between our desires and what the world offers us. However, even given the absurdity of this situation, it is up to us, through our defiance, revolt, and contemplation, to make our lives meaningful.

Esslin and Camus's *The Myth of Sisyphus*

First published in 1942, the American printing of *The Myth of Sisyphus* (1955) contains a special Preface to the essays. In the Preface, Camus looks

back at the book written in 1940, during what Camus calls the "French and European disaster." Camus calls this book, "the most personal of those I have published," in large part because *The Myth of Sisyphus* prompted an "exigency" of thought for Camus.[50] It seemed to be all the more personal, according to David Carroll, who recently wrote a reassessment of *The Myth of Sisyphus*, since Camus was suffering from tuberculosis during the period in which the text was written and Camus himself expressed, at times, doubts that he would survive.[51]

Shortly after the time of publication, a long intellectual quarrel sprang up with Sartre that distanced the two from each other, but brought each of their respective philosophies into greater relief. As Charles Forsdick suggests, the two shared little in common: Sartre had a prestigious Parisian education and was born into a bourgeois family, while Camus was brought up in colonial Algeria and was born into a working-class family in Mondovi.[52] Philosophically, their divergence started to become apparent when each reviewed the other's book. In 1938, Camus wrote of Sartre's *La Nausée* that it was a philosophical abstraction in which Sartre was unable to attach purpose to the freedom achieved by his characters. In 1943, Sartre wrote of Camus's *L'Estranger* that it was a philosophical novel in the Voltairean tradition.[53] Their philosophies and upbringing also affected their divergent politics that mainly defined their debate. With the political climate of the Cold War and the unlikely prospects of social revolution in France, Sartre drifted toward the French Communist Party, while Camus, who struggled to transcend politics, was increasingly unwilling to commit to any orthodoxy or common cause.[54]

The legacy of Esslin's book aided in the continued old assumptions of Camus's view of absurdity. What Esslin says in his Introduction that, in 1942, Camus poses the question, why not commit suicide?—is certainly true. However, the entire point of Camus's book-length essay, *The Myth of Sisyphus*, is that Camus explicitly argues why one *should not* commit suicide. If we accept our situation as absurd, Camus argues, and do not try to believe that there is meaning and purpose where there is none, then we can revolt against the absurd and create meaning and purpose for ourselves.

Esslin was entirely correct in quoting the passage the he did from The *Myth of Sisyphus* in defining the absurd. It is really the "divorce" between "the actor and his setting" that constitutes the absurd for Camus. Man is not absurd, and neither is the world: the absurd is their union.[55] The absurd derives from the fact that the world cannot offer man what he wants: "I know what man wants, I know what the world offers him."[56] The problem is that the two do not complement one another. In an early 1960 assessment of Camus's conception of the absurd, H. Gaston Hall puts it simply: "More

precisely, [the Absurd] depends upon the contradiction between man's will and the world."[57] Hall elaborates on this contradiction by suggesting the problem lies in "limitless desire destined to limited satisfaction."[58] This is the essential contradiction of life, or as Hall puts it, "By *absurd*, Camus means primarily the whole scandalous paradox of the human condition."[59] As will become more evident in the section on "parabolic drama," contradiction and paradox are the keys in which to re-imagine this theatre.

In *The Myth of Sisyphus*, Camus does indeed contemplate why we should not commit suicide. Though a human's situation may be absurd and full of contradictions, suicide is the wrong answer for Camus, because suicide is giving up. One should not ignore the absurd, but should confront it head on. If we are dead, we cannot do this. It is in our power to be free, understand the world, and feel passion, as Philip Hallie suggests.[60] If man gives up his liberty, lucidity, and passion, perhaps through suicide, then he, "surrenders his existence and becomes a mere thing. Camus calls the movement from thinghood to full existence *revolt*."[61] It is in our conscious rational revolt, for Camus, that life has value.[62]

Camus argues that we should live fully aware of the absurd in order to make sure that life *does* have meaning. Whereas the question used to be, does life have meaning, Camus suggests that life would be live better "if it has no meaning."[63] If no false or illusionistic meaning is imposed upon life, then a human can find his or her own purpose. In his Forward to Camus's *The Rebel*, Sir Herbert Read discusses the positive value of personal existence despite "the illusionistic trick played by religion or by philosophy":

> If we decide to live, it must be because we have decided that our personal existence has some positive value; if we decide to rebel, it must be because we have decided that a human society has some positive value. But in each case the values are not "given"—that the illusionistic trick played by religion or by philosophy. They have to be deduced from the conditions of living, and are to be accepted along with the suffering entailed by the limits of the possible.[64]

As Camus states, "He can then decide to accept such a universe and draw from it his strength, his refusal to hope, and the unyielding evidence of a life without consolation."[65] In doing so, man now possesses freedom and the power of defiance.

To explain his philosophy, Camus turns to the myth of Sisyphus, from which he gets the title of his entire essay. As punishment for angering the gods, Sisyphus is condemned to continually roll a rock up a hill, which will always return to the bottom the next morning. This is an absurd punishment

in that his desire to roll the rock up to the top is always contradicted by the reality of the situation, as it always returns to the bottom. Carroll, in his essay in *The Cambridge Companion to Camus*,[66] suggests that Camus's persistence in the face of absurdity, helped find purpose and meaning in his life. In contemplating his torment—in "keeping the absurd alive"—Camus understands that "[h]is fate belongs to him" and that he is the "master of his days."[67] As Camus concludes, "The struggle itself towards the heights is enough to fill a man's heart. One must imagine Sisyphus happy."[68] Thus, Camus does not just suggest that Sisyphus is happy, but he subtly implicates the reader, by making him or her active in making meaning even for Sisyphus, not just for the reader.

Judging from today's scholarship on Camus, especially major essays and books specifically about Camus and the absurd, Esslin misinterprets Camus's philosophy of the absurd as a bleak philosophy that espoused the meaningless of life. Esslin's view on Camus was well justified, as many of his contemporary scholars likewise pigeonholed Camus as an existentialist. However, recent scholarship has taken a second look at Camus and come to the conclusion that he actually revolted against nihilistic existentialism.

Marc Blanchard, in a 1997 article on Camus, states that "the Absurd we see today is the absurd from Beckett's and Ionesco's plays, and that certainly was not the kind of absurd Camus had in mind."[69] It is much easier to say the above in hindsight, as Camus's philosophy has been re-evaluated in recent years. One of the reasons why contemporary scholars have argued that Camus is not an existentialist was for the very reason that Camus concluded that Sisyphus was happy with his situation. In a famous exchange of essays discussed by Ramona Fotiade, Benjamin Fondane raised serious doubts about the aims of a revolt whose absurd hero is ultimately happy with his lot."[70] Jeffrey Gordon, in "The Triumph of Sisyphus," argues that the difference between Sisyphus representing the emptiness of our labors and a conception of a meaningful life is simply a little alteration, which would give an everyday point to his labors.[71]

Jacques Ehrmann recognized early in 1960 that Camus "has become a moralist," at least with his publication of *The Rebel*.[72] According to Lawrence D. Kritzman, in his article "Camus' Curious Humanism or the Intellectual in Exile," Camus is an "intuitive moralist" because, in confronting the irrationality of Marxist revolt, Camus confronts the absurdity of murder and terror.[73] In *The Rebel*, Camus espoused the inherent goodness of humans and life. Kritzman explains this point: Camus's politics of love and his ethos of reflective action and understanding create a moral imperative where human choices have a moral dimension.[74] With this understanding of goodness, as Ehrmann says, Camus's sense of "an absolute virtue, an absolute justice and

an absolute truth were decried as angelism by the existentialist."[75] Camus believed in an inherent human nature that contrasted with the basic existentialist tenant that existence precedes essence.[76]

Where existentialism works against reason (and, thus, the Enlightenment), Camus couched his philosophy within reason. For all of these reasons, it is very problematic to conflate Camus with Sartre and existentialism and their ideas of "nothingness" and the problems of reason. Discussing the Sartre-Camus controversy, Peter Royle states it thus: Sartre is an "existential phenomenologist in the grand European philosophical tradition" and Camus is a "disabused heir of the Enlightenment."[77] Debarati Sanyal, in "Broken Engagements," argues that," Camus is the idealist esthete whose luminous landscapes and classical forms so sharply contrast with the viscosity of Sartrean phenomenology,"[78] while Blanchard states that," Camus was not an existentialist."[79] The reason that it is so important to differentiate Camus from the existentialists, is that, like Descartes, whom Beckett read avidly when he was young, the world can be understood through reason by, and only by, individuals.[80] Therefore, meaning is drawn out from our own observations. And when we encounter contradictions, when we encounter absurdity, we must make a rational revolt and contemplate our situation. Camus's understanding of absurdity as essentially paradox, or more specifically, the contradiction between our desires and what the world has to offer, forces us to understand the paradox. Only when we contemplate the paradox can we create meaning for our lives. This is fundamentally what parables and the plays of the Theatre of the Absurd do.

Post–WWII Europe and Heterotopia

Given that this book reassesses the Theatre of the Absurd through both an up-to-date reading of Camus and a reading of its parabolic nature, it is also fruitful to reassess the historical moment of the plays. Given Esslin's contemplation of post–WWII Europe, maybe the world without a future best describes the historical situation of postwar Europe. Part of the reason Esslin might have come to his conclusions is how he read the history of the 1930s to 1950s. Esslin read the period leading up to the war through the decline of religious faith and the rise of progress, nationalism, and totalitarian fallacies. I, however, see the rise of progress, nationalism, and totalitarian support as the hope for utopia, especially the German fascist ideal, as the hope for progress. What followed the war was, I argue, the displacement of the hope for utopia for the hope for heterotopia. Camus was right: the future could not be visualized. Once

the war ripped apart Europe and dismantled the ideals of nationalism and fascism, the world looked random to Europeans and the future was uncertain—after all, how is a random world *supposed* to look? The world, especially in the 1930s, was gearing up for unilinear progress. The claims of an Aryan nation proved this fact. However, after the war, for the first time, postwar Europeans and the playwrights of the Theatre of the Absurd understood the paradox of progress. Theodor W. Adorno and Max Horkheimer, in *Dialectic of Enlightenment*, write about the myth of Enlightenment:

> The fallen nature of modern man cannot be separated from social progress. On the one hand the growth of economic productivity furnishes the conditions for a world of greater justice; on the other hand it allows the technical apparatus and the social groups which administer it a disproportionate superiority to the rest of the population.[81]

In essence, as Adorno and Horkheimer put it, "progress becomes regression."[82] This paradox of progress became awfully apparent with the rise of fascism and the technological progress that produced the atom bomb. The world may seem absurd in this paradox, but Adorno and Horkheimer, being Marxists, do not necessarily say that it has to be this way. The "absurdity" only comes from economic inequalities, a Marxist would say. Arguably, the two most identifiable plays of the Theatre of the Absurd are about this paradox of progress. *Waiting for Godot* literally does not progress. It is the strain of time moving forward and the goal of Godot arriving that is contrasted with stagnation of movement. In *Rhinoceros*, the world *evolves* into rhinoceroses, but that is a clear regression of humanity.

The world that Esslin presents with Camus is not the world of Europe and America of the 1950s. The supposed pessimism that Esslin saw, maybe incorrectly, in Camus no longer existed in Europe by 1948 or so. Right after the end of the war, there was, briefly, a renewed hope in peace and rebuilding that soon gave way to disillusionment at the prospects of the incredible task ahead of rebuilding Europe.[83] Food rations were slashed in early 1947, and an opinion poll in France placed "food," bread," and "meat" as the people's number one preoccupation.[84] Two problems caused this. The disappearance of the German economy stalled imports and exports, and the lack of American dollars in Europe did not allow European nations to buy American goods that were so badly needed.[85]

However, in 1947 everything changed with the advent of the Marshall Plan. United States Secretary of State George C. Marshall devised a plan that, instead of offering aid in cash, gave a free provision of goods to European

nations and provided these countries with aid in the form of annual requests by each nation:

> These goods, when sold in each country, would generate so-called "counterpart funds" in the local currency which could be used according to bilateral agreements reached between Washington and each national government. Some countries used these funds to purchase more imports; others, like Italy, transferred them into their national reserves in anticipation of future foreign exchange needs.[86]

In addition to the aid, the Marshall Plan created the Bank of International Settlements, which created lines of credit proportional to each country's trading requirements that "contributed not merely to the steady expansion of intra-European trade but to an unprecedented degree of mutually advantageous collaboration—financed, it should be noted, by a substantial injection of U.S. dollars to furnish the initial credit pool."[87] Besides amounting to incredible economic growth initially and throughout the 1950s, maybe most importantly, the Marshall Plan "helped Europeans feel better about themselves."[88] An article in *The Times* on January 3, 1949, stated emphatically that "when the cooperative efforts of the last year are contrasted with the intense economic nationalism of the inter-war years, it is surely permissible to suggest that the Marshall Plan is initiating a new and hopeful era in European history."[89]

Given that post–WWII Europe was not as bleak as Esslin made it out to be, it is important to see how the plays of the Theatre of the Absurd instill not a sense of hopelessness, but rather one of hope. Jill Dolan's *Utopia in Performance* defines, what she calls utopian performatives. Dolan describes utopian performatives as "small but profound moments" that lift an audience up "slightly above the present."[90] As a performative, like in J. L. Austin's sense, Dolan suggests that performance "becomes a 'doing' " in that "something in its enunciation *acts*."[91] What performance does, Dolan argues, is enact something onto the audience, who are a "group of people who have elected to spend an evening or afternoon not only with a set of performers enacting a certain narrative arc or aesthetic trajectory, but with a group of other people, sometimes familiar, sometimes strange."[92] Audiences, or participatory publics as Dolan calls them, experience a sense of Turner's *communitas*, where the participants "feel themselves become part of the whole in an organic, nearly spiritual way."[93] I want to play off of Dolan's idea of utopian performatives. However, as I will explain, the sense of heterotopia is much more appropriate for understanding the Theatre of the Absurd. Given the historical moment of the plays and the

"theatre's" parabolic tendencies of contradiction, heterotopia accounts for the unevenness found in this theatre, while still maintaining its drive for hope.

Post–WWII Europeans, and especially their American counterparts, were full of hope. The utopia that looked unilinear and gave way to the horrors of fascism transformed into a heterotopia that accounted for the unevenness and dissimilarity found within Europe. The Marshall Plan relied upon all of Europe to come together to build for a future that eventually led to the European Union. Success was dependent on difference. The new drive in Europe was a heterotopic one.

Michel Foucault, in *The Order of Things*, speaks of the constancy of order in changing human civilizations, but his examination of a passage of a Borgesian catalogue demonstrates that randomness can exist in this order, but that order can also exist in randomness. The juxtaposition of random items can only be found in the "non-place of language."[94] Between "empirical orders" and "scientific theories," there is a "domain" which is "more confused, more obscure, and probably less easy to analyze."[95] Cultures find themselves in a position where they themselves can be ordered. This idea that order, in fact, exists becomes clouded when it is understood that order exists but only through human thought. Order is subjective and changeable. Thus, the very idea that Foucault introduces with the Borgesian catalogue that disorder is part of order establishes a model for the parable. In the parable's quest for ethical knowledge, language creates a domain of uncertainty where order, created subjectively by the interpreter, can only be "ordered" through the juxtaposition of disorder.

William W. Demastes, in a book that tries to move past absurdism, discusses the notion of *orderly disorder*. Chaos is not the entropic result of degeneration, but "a place of opportunity, a site of interactive disorder generating new orders and of order transforming to regenerative disorder."[96] The movement between order and disorder creates a false sense of stability, which is really temporary and nonlinear.[97]

With the world that Argentinian-writer Jorges Luis Borges introduced with the random catalogue and the world as it exists in opposition to the utopia, the heterotopia is a subversive and playful world of language:

Heterotopias are disturbing, probably because they secretly undermine language, because they make it impossible to name this *and* that, because they shatter or tangle common names, because they destroy "syntax" in advance, and not only the syntax with which we construct sentences but also that less apparent syntax which causes words and things (next to and also opposite one another) to "hold together."[98]

Taken together with Jacques Derrida's notion of play in language and the possibility for multiple truths stemming from the same words,[99] the world of The Theatre of the Absurd, the parable, and parabolic drama is the world of heterotopias that "dissolve our myths."[100] Once this disorder is introduced into the world of the Theatre of the Absurd, the question of ethics, when combined with metaphor, produces a postmodern parable that questions, "How does one exist in a contradictory world?"

The quest of ethics is, in some ways, the quest for utopia. If everyone acted ethically, the reasoning goes, then the world would function perfectly. Is this not what Jesus desired? However, utopia, especially Sir Thomas More's *Utopia*, does not work with the idea of the parable and parabolic drama. Tobin Siebers, in *Heterotopia*, argues that postmoderns fundamentally yearn for utopia. However, the desire is heterotopic. The postmodern world wants to "bring things together," and the narrative most effective for this is the "assembly."[101] Fundamental to heterotopia, Siebers says, is the idea that "different forms of talk are allowed to exist simultaneously."[102] This profusion of voices, and subsequent messages, are all found in the disorder of parabolic drama. The clatter of differing viewpoints in parabolic drama establishes an "assembly" of thought that the audience must wade through in order to create sense and rectify their dismantled worldview.[103] It is very important to clarify that I am using the term *heterotopia*, as opposed to *utopia* (since they both have, ultimately, the same goals), because heterotopia describes the breakdown of language, as theorized by Foucault. Absurd drama, which is the subject of this dissertation, as Esslin states, poses:

> …a radical devaluation of language, toward a poetry that is to emerge from the concrete and objectified images of the stage itself. The element of language still plays an important part in this conception, but what *happens* on stage transcends, and often contradicts, the *words* spoken by the characters.[104]

Thus, the language of the Absurd plays aligns them with Foucault's heterotopia, not utopia. Even more, Herbert Blau suggests, using Gilles Deleuze and Félix Guattari's term, that the plays of the Absurd are constructed as assemblages.[105]

The "assembly" of heterotopia created a much-less-easily imagined future. Whereas utopia, nationalism, and fascism created an image of sameness, heterotopia invoked an image of difference. And difference and randomness are much more difficult to imagine than sameness. The plays of the Theatre of the Absurd were made up of a clatter of differing viewpoints. These differing

viewpoints, usually unresolved, created the paradoxical world of the play. What heightened the paradox was the fact that not only were the differing viewpoints unresolved, but largely, so was the play. The hard-to-imagine endings of heterotopia and the unresolved problems posed by paradox were heightened by the playwrights of the Theatre of the Absurd's engagement with mimesis, or its deconstruction.

Without digressing into the re-emerging field of mimesis, a couple of general points can be made that will enlighten this present study. We need only to turn to Aristotle's *Poetics* for one quote:

> A whole is that which has a beginning, a middle, and an end. A beginning is that which does not itself follow anything by causal necessity, but after which something naturally is or comes to be. An end, on the contrary, is that which itself naturally follows some other thing, either by necessity, or as a rule, but has nothing following it. A middle is that which follows something as some other thing follows it. A well constructed plot, therefore, must neither begin nor end at haphazard, but conform to these principles.[106]

Joseph Donohue personally suggested to me that once a beginning, middle, and end are imposed on a play, there is a certain arc, a certain didactic direction that the playwright wants to take his or her audience. The playwright desires the audience to begin without knowledge of the play and then directs them in a certain direction, with certain natural conclusions to follow. What the Theatre of the Absurd does is play off of the audience's expectation that the playwright will lead them in a direction toward a conclusion, providing the audience with finality and a point. However, as I argue, what the playwrights of the Theatre of the Absurd do is get rid of the end of the play, most apparently in *Waiting for Godot*. Without an end, there are also lingering questions that remain: literally and figuratively, paradoxes of progress. What is left, in the case of the Theatre of the Absurd, is the paradox with no conclusion. The audience is waiting for the (didactic) message; however, the playwright leaves the paradox open for the audience to make sense of.

The clatter of different viewpoints can seem contradictory and paradoxical. And the unanswered paradox may explain why world seems absurd to Esslin. However, that does not mean it is so, or that life is meaningless. One has to look to Camus and Viktor E. Frankl, even when times are hard, to find that meaning and purpose can be made out of life. The conclusion I draw from post–WWII Europe, Frankl, and Theodor Adorno and Max Horkheimer is that paradox is the "philosophy" of the Theatre of the

Absurd. Actually, I am not the first to say this. In fact, there has already been a book written on this subject. In his seemingly forgotten book *The Theater of Protest and Paradox*, George Wellwarth argues this fact. Unfortunately, he addresses this in only one sentence:

> It is the purpose of this book to explain the meaning of these plays, set them in their proper place in the history of dramatic literature, and point out their basic similarities. These similarities consist of a common theme (protest) and a common technique (paradox).[107]

The intellectual legacy that I have outlined provides the lines of protest from Camus and Frankl, and paradox from Adorno and Horkheimer. What I am trying to say, in order to maybe forward Wellwarth's point, is that the playwrights of the Theatre of the Absurd believed that life can have meaning if paradox is worked out. They created heterotopic worlds that lacked a conclusion and had a lingering paradox. And since I argue that these playwrights suggest ways to act, although most of the work in discovering the way to act must be done by the audience, the natural place to turn to evaluate these plays is to look at them from the point of view of parabolic drama, since the above suggests that these plays share formal characteristics with parables.

What are we supposed to do with the Theatre of the Absurd now that we have a more up-to-date understanding of Camus? Esslin was right: the playwrights of the Absurd do not argue *about* whether life is absurd, and they do, in fact, just present it *as* absurd. What they do argue about is now that the world is absurd, what do we do about it? This goes one step further than just laughing at our absurd situation.[108] In *The Rebel*, Camus specifically states, "The important thing, therefore, is not, as yet, to go to the root of things, but the world being what it is, to know how to live in it."[109] The question for Camus and the absurd playwrights, I argue is, how do we make meaning from this absurdity? How do we make meaning for our own lives?

Part III: Re-reading the Absurd

"Parabolic Drama"

Initially, what really tripped up the public and reviewers was the incongruity between the speech and what happens on stage. Once Esslin observed that all of these playwrights were doing similar things with language and gesture, then people had a language and concept with which to judge and understand these plays. People were, then, able to walk away with something from these

plays. Years later, Esslin, in an essay on Beckett's ethics, states the following, keeping the idea of the absurd in the background of the conversation:

> No course of action is ever recommended, no course of action ever discouraged. These texts are wholly descriptive, never prescriptive; and whenever anything resembling an opinion as to a recommended course of action is voiced, it is always immediately withdrawn... This absence of good or bad, right or wrong, must result in an absence of goals, of purpose in life.[110]

For Esslin, the meaning of the plays came from the aesthetic incongruity that marked the philosophical incongruity of life.

However, the ambiguous endings and the reliance on metaphor, now coupled with a more up-to-date reading of Camus, suggest that the audience has to make sense of the contradictions present to make life meaningful, to figure out how to live in this world, as Camus suggested in *The Rebel*. The need for audience interpretation, in some ways, echoes the philosophy of Camus. Life exists with contradictions, and without a false God-like system or other false systems for imposing meaning upon the world, we have to contemplate our situation to make our lives have meaning. Any play, in a sense, which forces meaning upon us, is, in some ways, imposing upon us a false authority for understanding our lives. Camus, in some ways, was a moralist. There was something inherently good in this world in Camus's eyes.

I want to start with something actually found in Esslin's *The Theatre of the Absurd* to expand upon Esslin's observations and suggest a new way to look at these plays. The epigraph for Esslin's book comes from Ionesco's *The Bald Soprano*:

> MME MARTIN: Quelle est la morale?
> LE POMPIER: C'est à vous de la trouver.
>
> Ionesco, *La Cantatrice Chauve*

For Esslin, I believe he quoted the above to refer specifically to what is the moral/meaning (*morale*)... *of these plays*. However, given Ionesco's propensity toward the philosophy of Camus, I believe that the question "Quelle est la morale?" is a grand philosophical question, especially given the context of the quote in *The Bald Soprano*. This quote occurs after the Fire Chief enters the Smith's house and tells an "experimental fable," as it is called in the text, about a cow that asked a dog, "Why have you not swallowed your trunk?" and the dog answers, "It is because I thought that I was an elephant."[111] Mr. Martin then asks, "What is the moral?"[112] The Fire Chief responds,

"That's for you to find out."[113] This "experimental fable," marked by logical incongruity, which is followed by a number of other similar stories by the characters, is about who we are, what defines us, and how we should act. In a sense, this little "experimental fable"—metaphorical, incongruous, ambiguous—represents the entire Theatre of the Absurd. It is, in some ways, about an act of defiance and the contemplation of a situation. It is about a dog that either refused to be a dog and/or made meaning out of his life by thinking of himself as an elephant. In this story, we are the ones who have to make sense of it. However, by making sense of it, we learn to make sense of our own contradictory situations. In acts of "defiance" and "revolt," we must "contemplate" and confront contradiction to make meaning out of our lives and learn how to act. Confronting us with such contradictions—asking *us*, ultimately, what is the moral?—the plays of the Theatre of the Absurd, in this sense, are ethical parables.

I would suggest then, that the ethical parable is a much better way to understand the plays of the Theatre of the Absurd. Here, I would like to define, what I call, "parabolic drama." This is meant to be a structural extension of Esslin's very keen observation that the words and actions of the plays of the Theatre of the Absurd are many times contradictory. 1) Parabolic drama is created through metaphor. One just has to look to the titles of some of the most notable plays to see how metaphor guides the entire play: *Waiting for Godot, Rhinoceros, The Room, Endgame,* and *Krapp's Last Tape.* 2) Parabolic drama is also performative in that it has an *agenda of transformation,* to play off Bert O. States's idea.[114] For example, we are left waiting and questioning with Vladimir and Estragon. We question whether or not we would be able to take on the onslaught of rhinoceritis. We feel the claustrophobia of *The Room* and want to figure out how to get out of a situation like that ourselves. 3) Gestural and lingual metonymic paradoxes are used frequently. Think most particularly of the removal of the boot in *Waiting for Godot* or Vladimir's many pronouncements that metonymically define the play.[115] 4) There is a move toward disorder[116] that results in a hanging dilemma that needs to be interpreted by an audience. One has just to think of rhinoceritis. 5) Working off of Paul Ricoeur's description that a parable orients, disorients, and reorients the audience,[117] I argue that the plot first orients the audience and then disorients it. The job of reorientation, as I argue and differ from Ricoeur, is left up to the audience.[118] This reorientation is "self-confrontative" as William G. Kirkwood describes the parable.[119] This is most apparent in *The Maids* or similarly in *The Blacks,* as the audience feels comfortable with the characters, but once the performance is revealed, and the events of the play unfold, the audience is left to grapple with the social construction of race and how the audience member,

himself or herself, plays a part in it. 6) The world of parabolic drama is heterotopic. We see the clash of viewpoints, most especially in the townsfolk and between Berenger and his co-workers in *Rhincoeros*. 7) Parabolic drama is not contradictory, but contemplates contradictions. Again, think of the role of the faulty syllogism in *Rhinoceros*, which is a metaphor for the outbreak of rhinoceritis. Though an entire essay could be written just about the "absurd canon" as it relates to my definition of parabolic drama, given that each chapter will explore each play's parabolic nature in more detail, I hope the few examples above will suffice, given space limitations.

I have argued that if we use a more up-to-date lens of Camus to read the Theatre of the Absurd, this theatre will not just present the world as absurd, but, will instead suggest that by contemplating the contradictions in the plays and in our lives, we, as humans, will be better equipped to know how to live and how to make our lives meaningful.

Four Core Plays

In my first through fourth chapters, I re-read four core plays of the canon of the Theatre of the Absurd in light on my observations from this Introduction. I chose the four most written about European "absurdist" playwrights and their four most written about plays that first appeared (either in print or on the stage) between 1950 and 1959. I chose these dates so that I could deal with the entire decade of the 1950s and 1950 is the year that prominent Beckett scholar, Ruby Cohn, gives as the approximate date of birth of the Theatre of the Absurd. In 1950, five years after WWII, plays by Adamov and Ionseco were playing in Paris and Beckett had completed *Godot*, though he was looking for a theatre.[120] I chose to work with major canonical plays because I am suggesting that reading plays with an up-to-date understanding of Camus and by turning to others writing at the time will yield vastly new readings. Therefore, I needed plays and playwrights with a large body of research to write with and against. These plays, partly because of their canonization through scholarship, helped shape our very understanding of the "absurd." I also chose to write on all different playwrights to show that my conclusions are not unique to just one playwright (or a couple of playwrights), but that questioning the idea of absurdity applies to the major canonical European "absurdists" and their, respectively, most canonical plays between 1950 and 1959.

In *Waiting for Godot*, by Samuel Beckett, "The Parable of Estragon's Struggle with the Boot" (as I call it) at the beginning of the play foregrounds the play and raises the ethical dilemma *why hope if you have no idea what you are hoping for will bring you any relief?* because the removal of the boot

brings no relief. In contrast to the standard reading of the play, I believe this play has nothing to do with hope, but, rather, it has to do with becoming your own personal savior and biding time, especially with friends. Estragon and Vladimir bide our time: they become our personal saviors and make the world bearable for us and them.

In *The Birthday Party* by Harold Pinter, interrogation leads to rape in the sense that lack of control leads a person to acting out in the ultimate act of control. Interrogation and all of the basic duties associated with it become metaphors for the dark side of the power-performance mode. The interrogation scene becomes a mini-parable within the larger parable, as numerous characters are subject to interrogation. This interrogation, due to the mode of objectification in this play, causes a Pinteresque Oedipal household: Stanley replaces Petey as the object of Meg's affection.

The Blacks: A Clown Show, by Jean Genet, is commonly read as a ritual. The play is also read as a comment on colonialism. What we have to take away from this play, rather, is the paradox and figure of the white clown, who both incites laughter and fear and language and silence. Through the contemplation of these figures, the play becomes not a ritual, but a parable on clowning around in a race-conscious world. Genet uses a series of rituals to create a parable.

In *Rhinoceros*, by Eugene Ionesco, the figure of the logician is a constant presence that destroys language and meaning. Imagining the world like a syllogism is faulty, just like the landing of the staircase that crumbles. Landings, of course, are a *part* of what connects floor A to floor B. The isolation of a part of the whole exposes the weakness of the syllogism. The dramatic syllogism becomes a garbled Kantian categorical imperative. Ionesco contemplates the fine line between Kantian universizability and conformity by naming the play *Rhinoceros*. As such, Berenger becomes a Sisyphean Hero.

My conclusion furthers the work of Celeste Derksen. Derksen contemplates the idea of a "feminist absurd" in the Canadian playwright, Margaret Hollingsworth. Part of the purpose of her article is that "to consider Hollingsworth as absurdist is at once a challenge to the male exclusivity that is a defining feature of absurdism and an argument for revitalizing absurdism as a contemporary critical term."[121] Derksen does this through an examination of the subject position. Both Derksen and I agree that "the subject of absurdism can be constructed and read from a more overtly political, socially engaged standpoint."[122] A combination of my arguments with Derksen's understanding of subject position will demonstrate how much of "feminist theatre" can be aligned with the Theatre of the Absurd, or parabolic drama.

I want to argue that, in general terms, the *male* Theatre of the absurd is concerned with philosophically ethical positions of universal bodies and one type of *female* Theatre of the Absurd is concerned with specific, *local* female bodies and interests. In general, the male Theatre of the Absurd deals with making meaning out of one's absurd position and the female Theatre of the Absurd deals with the absurdity of one's subject position and offers a call to action. Looking at one female playwright who has previously been characterized as "absurd" (Beth Henley), I define what it is to be a female absurdist playwright. More specifically, I compare it to, perhaps, the first (male) absurdist text, Genet's *The Maids*, with the most-written-about female "absurdist" text, *Crimes of the Heart*.

CHAPTER 1

The Parable of Estragon's Struggle with the Boot in Samuel Beckett's *Waiting for Godot*

Samuel Beckett's *Waiting for Godot* is most famously known as the play where nothing happens. Two tramps, Estragon and Vladimir, spend the length of the play anticipating the arrival of a man named Godot, who never shows up. While waiting, their conversations weave from Jesus to suicide, among many other things. Two characters, a master and a slave, grace the stage with their presence, only to withdraw and reappear again. There is also a boy who is supposed to be delivering messages from Godot to Estragon and Vladimir. Part of the immediate confusion (and, in some cases, vehement dislike) generated by the play was its lack of a conventional plot. As Jean Anouilh says in a very early review of the play's 1953 Paris production, the play is best summarized by the following line from the play: "Nothing happens, nobody comes, nobody goes, it's awful."[1] Some critics saw this as a brilliant move; others saw the non-linear language in this play without an arc as an attempt at intellectual snobbery. But this nothingness and emptiness created fertile ground for meaning. The audience and critics maybe anticipated the arrival of Godot more than do Estragon and Vladimir because early criticism looked (and continues to look) for answers to who Godot might symbolize. Alain Robbe-Grillet offers some of the initial reactions: "Godot is God...Or else Godot is death...Godot is silence...Godot is that inaccessible *self* Beckett pursues through his entire oeuvre."[2] Alan Levy offers some others:

> Who or what is the unseen Godot? To some he is death; to others, life; to a few, nothing. To one British critic, Kenneth Tynan, he is a "spiritual

signpost." To the director of the Miami production, Godot is the meaning of life. To the man sitting next to me in London, he was beauty. Harvey Breit of *The New York Times Book Review* said, "This is Hell, upper case—and lower case, too." Then he added: "This is life." In the same newspaper, drama critic Brooks Atkinson said: "It seems fairly certain that Godot stands for God." *Time's* reviewer wasn't sure if Godot stands for God or man's unconquerable hope. He wasn't even sure if the play is "a philosophic depth bomb or a theatrical dud." When the director of the first American production asked Beckett what the mysterious Godot symbolized, the playwright replied: "If I knew what Godot was, I would have said so."[3]

As the above readings can attest, there is no agreed-upon reading. However, hazarding to do so at the risk of simplifying, if one has to state the most common reading, one could probably settle on Godot as standing for God. In reactions to the early productions of the play Jacques Audiberti, Henry Hewes, Norman Mailer, and Brooks Atkinson, in one way or the other, suggest that Godot represents God.[4]

The reading that Godot represents God is an important one from a socio-historical perspective. These early responses to the early productions of *Waiting for Godot* are from the mid–1950s. Martin Esslin contextualizes the Theatre of the Absurd and the 1950s and early 1960s in the following way:

> The decline of religious faith was masked until the end of the Second World War by the substitute religions of faith in progress, nationalism, and various totalitarian fallacies. All this was shattered by the war. By 1942, Albert Camus was calmly putting the question why, since life had lost all meaning, man should not seek escape in suicide.[5]

The decade following the war brought about renewed hope in peace, but the "absurdity" of the war only confirmed that "life had lost all meaning." Faith in religion was lost and changed forever. Thus, the reading of Godot as God saw the reemergence of faith into a play, where the discussion of suicide that echoes Camus, promises the possibility of a second coming. Brooks Atkinson acknowledges that, "Faith in God has almost vanished," but in suggesting that Godot represents God, Atkinson believes that Beckett, "is unable to relinquish it entirely."[6] In the face of the absurd world following WWII, the critics that imagine Godot as God also imagine the simultaneous hope and absurdity of the situation. In their wait, Estragon and Vladimir *hope* for God to come, though they wait in vain.

The question of God, or (since Christ is mentioned) a savior, in the play, I believe, should still occupy the minds of students and scholars. If God or a savior is not just hinted at and never comes, but is actually *present* in this play, and *Waiting for Godot* is the quintessential example of the Theatre of the Absurd, then life has not lost all meaning and the Theatre of the Absurd does not necessarily represent the absurdity of the human condition. On the contrary, *Waiting for Godot* provides, as I argue, not only meaning, but a simple roadmap to making meaning in life. If *Waiting for Godot* is understood in this light, then human action and the human condition are not absurd but sensical, and these plays, instead of offering up confusion, suggest how humans are supposed to act. In other words, the Theatre of the Absurd is not absurd.

The Issue of Time

Understanding Beckett's *Waiting for Godot* as a roadmap for making life meaningful is in stark contrast to how *Godot* is most commonly read, especially under the influence of Esslin's "absurd" reading of the play in *The Theatre of the Absurd*. Esslin characterizes all of Beckett's work as having the keynote theme of "deep existential anguish."[7] For Esslin, this idea comes through in *Godot* as he posits that the play is not about Godot, but about "the act of waiting."[8] Esslin argues that Beckett highlights the activity of "passively waiting" and that this non-action serves as a contrast to the times we are active; it is a period when we "forget the passage of time, we *pass* the time."[9] Esslin explains the existential nature of time in the following manner: "The flow of time confronts us with the basic problem of being—the problem of the nature of the self, which being subject to constant change in time, is in constant flux and therefore ever outside our grasp."[10] Given that time always changes us, Esslin argues, our identity is never stable.[11] Esslin goes on to suggest that this instability is heightened for Vladimir and Estragon because their subjective desire—the arrival of Godot—is never attained.[12] Moreover, just as our selves are out of reach when confronted with the passage of time, so, too, Godot seems to be, "naturally ever beyond their reach."[13] Thus, Esslin concludes, "The ceaseless activity of time is self-defeating, purposeless, and therefore null and void."[14] For Esslin, Godot becomes an image of "bad faith," as the hope of salvation held by Didi and Gogo merely serves as an evasion of suffering and anguish rather than attaining an understanding that at the root of being human is nothingness.[15]

Although I, too, see this play as preoccupied with waiting, I do not see it as the *passive* activity that Esslin does. If we understand how active Vladimir and Estragon are and that talking to each other gives their lives meaning

(and ours, too), then we can read this play in a very different light. As Charles Isherwood concludes of a recent 2006 production of the play:

> Despite the bleak gray backdrop and the cartoonishly skinny tree (the set is by Louis le Brocquy), the universe the production evokes mostly feels as cozy as a friendly pub. Escape from the mad, meaningless routine of life hardly seems a dire imperative. Going on dully as before hardly seems a daily death sentence. The void that surrounds Didi and Gogo—and us—is banished by the light of their amused and amusing self-sufficiency. Their elaborate routines seem concocted not to prove to themselves that they exist, but to evoke affirming evidence from the audience, in the form of laughter and applause.[16]

Surely, the audience forgets the passage of time as they actively enjoy listening to these two tramps engaging in bantering dialogue. In fact, the audience becomes lost in the *moment* of theatregoing. Beckett, I argue, shows us how to fill up time, how to fill up *our* time: with theatre and idle talk.

One more recent production seems to address this issue. In J. Chris Westgate's review of a 2003 production of *Waiting for Godot* at the American Conservatory Theater in San Francisco, he observes that Carey Perloff's production resembled a cubist painting:

> The scenery of J. B. Wilson—a drywall backdrop with a huge rectangle cut out of it; a zigzagging ramp cutting between the low mound and woeful tree; and an additional proscenium, gold and ornate, that literally framed the action of the stage—suggested the baffling geometry of a cubist painting.[17]

However, Westgate also notes the production's departure from this interpretation:

> The overall action of the play defied simple explanation since it was framed—literally—as an imitation of a painting that imitates nothing. Yet Perloff continually interrogated the limits of the cubist metaphor by having the actors break the frame of the painting, as well as the fourth wall of theatrical realism. Peter Frechette as Didi and Gregory Wallace as Gogo did much of their acting at the edge of the stage, stressing the artificiality of any frame. The actors delivered many lines and made frequent gestures directly to the audience, compelling us to recognize that we are imitating the events on stage (instead of visa versa): we too are attempting to find meaning during an afternoon of our lives.[18]

Just as Perloff's production was seen as "reaching out" to the audience to incorporate them into the production, into the performance, into the *time* of the play, even so Estragon and Vladimir are engaging with us as readers or viewers of *Godot*. As we can see from this production, their idle talk helps them find meaning in their suffering, but also helps us "find meaning during an afternoon of our lives." While their idle talk appears to pacify their suffering and to bring them some happiness, it also brings happiness to every single member of the audience by entertaining them with a thoughtful and humorous plot. In the ethical tradition of act utilitarianism—which states that whatever action produces the most overall happiness is the most ethical action—during the time of the production, happiness is maximized for the most people.

The time of the play has something, but little, to do with the "action of waiting" that Raymond Williams describes in *A Modern Tragedy*,[19] or with the "structure of expectation" argued by Maria Minich Brewer.[20] Instead, through their talk and how they bide *our* time,[21] the two tramps are *our* saviors as well as their own. When *they* seek, *we* hear.[22] When *they* contradict, *we* understand. We hear the savior's words not as a promise of a perfect world, but as teaching us to live in an imperfect world. Estragon compares himself to Christ not because he is the son of God, but because saviors give us the invaluable power to cope in the face of tenuous hope or when we sense no hope at all.

Waiting for Godot *and Meaning*

As a way of summing up recent productions of *Waiting for Godot*, I would like to turn to two that deserve further assessment: a 2007 production, simply entitled *Godot*, performed in New Orleans, and a 2009 production on Broadway. *The New York Times* review of the 2007 New Orleans production reads the play as a call to action. The production took place outdoors in an area that was hit especially hard by Hurricane Katrina. The reviewer, Holland Cotter, says that when the actor, Wendell Pierce, spoke the line, "In an instant all will vanish and we'll be alone once more in the midst of nothingness," that "[Pierce] really was in the middle of nothingness, or what it looked like a lot."[23] Cotter continues, "Under these circumstances, Beckett's words sounded less like an existential *cri de coeur* than a terse topographic description."[24] This *Godot* performance was part of a larger project by New York artist Paul Chan, who designed signs printed on small cardboard that all contained phrases from *Waiting for Godot*: "A country road. A tree. Evening." These signs appeared all over New Orleans starting a couple of months before the theatrical performance: "They added up to a visual

network, art as a connective tissue for a torn-apart town."[25] Chan's usual art of "video animations of paradises embattled and lost" and his activist politics set the stage for a unique reading of the play:

> A canny tactician, Mr. Chan insists that his art and his political work run on two separate, possibly conflicting, tracks. Political action is collaborative, goal-specific and designed for power, he maintains. Art, by contrast, is individually produced, ductile in meaning and built to last. It is the opposite of ideologically instrumental; it is made to melt power.[26]

In Cotter's eyes, this New Orleans project as a "time-based collaborative work of performance art," captured the "power of personal anonymity," and the "freedom" that results from it.[27] As a statement of "dispersed authority," *Godot* also worked against the trends of capitalism that favor "the production of single objects."[28] Going even further than Cotter, I believe this production also philosophically echoes the inherent sentiment of both the play and Camus: that meaning should not come from or be imposed upon people from a false authority, hierarchy, or system. Rather, meaning should be made by individuals or a group of equal individuals—to use Camus, Adlerian psychology, and Viktor Frankl's logotherapy—to find meaning in situations as bleak and full of suffering as that found in the Lower Ninth Ward of New Orleans in 2007. In this way, meaning comes from or is created by seeing the connections between the suffering found in the solitary house that was once part of post–Katrina New Orleans and that now simultaneously serves as an element in Chan's *Godot* staging:

> The house in Gentilly was closer to a traditional stage and grounded the play in everyday life. The very fact that the house had survived, standing, registered as a triumph, and the vaudeville side of Beckett's play, the laughing in the dark, came forward.[29]

In this sense, we can see that the house stands in defiance of the nothingness that surrounds it, but we also see that we have to move past the nothingness. In such a setting, defiance really raises a call to action:

> But, Mr. Chan also wants to try out—everything is a tryout—a new story, as have other artists, Beckett among them, who feel they are living in a time of moral emergency. The soul of "Godot" isn't in Vladimir's despairing cry at being marooned in nothingness, but in something he says later in the play: "Let us not waste our time in idle discourse! Let us

do something, while we have the chance! It's not every day that we are needed. Let us make the most of it before it is too late!³⁰

Maybe we are finally in a place to suggest that these plays incite us to find meaning in our life.

The 2009 Broadway production of *Waiting for Godot* that I reviewed recently in *Theatre Journal* did just that for many theatre goers. This 2009 Broadway production staged by Anthony Page was a comedic masterpiece that "made every attempt to remove the existential and absurd overtones normally associated with the play."³¹ By having Estragon played by Nathan Lane as a "lovable, loud buffoon [with] his movements demonstrative and sure," and having Vladimir played by Bill Irwin as "stuttering, full of uncertainty," this production emphasized Estragon's joy over Vladimir's forlornness.

Thus, lines like "nothing to be done" were in an understated mumble. But lines like Lucky's "and I resume" were repeated with energy. The seeming central quote of the play, as it was delivered in this production, was, "a diversion comes along, let it not go to waste." The thematic thrust behind these quotes was echoed in the staging. The famous tree and country road "ran through a bowl-shaped mountainous pass." In such a locale, Estragon and Vladimir could not get lost in the endless expanse, and thus the two, "inhabited almost a fortress of friendship."

The effect of Page's reading of the play caused the dynamics between Vladimir and Estragon to change. As I noted in my review, "Whereas Estragon is commonly read by scholars as semi-dependent on the wiser, philosophical Vladimir, Estragon's joy of life and folly provided comfort to Vladimir, whose voice shook as philosophy did not seem to provide him with unshakable answers." The thematic conclusion, then, is this: "The world is a scary place in this production, both to the characters and the audience, only if one is alone. But with friends, laughing was the way to, 'bide one's time,' both for the characters... and the audience."

Current Criticism

What are these directors seeing that differs so much from readings of the past that were influenced by Esslin? In one sense, I believe that the directors' conceptualization of nothingness has changed from a Sartrean view of nothingness as negation to a Heideggerean view of nothingness as a springboard for possibility. Elsewhere, I have written about the fact that *Waiting for Godot* displays a Heideggerean sense of nothingness, especially when read in contrast to Sartre's short story, "The Wall." (Hcidegger said he was

not an existentialist, though oftentimes he is commonly ((mis))read as one.) As can be seen from all four productions mentioned above, the absence of Godot does not signal a sense of negation or death, but a sense of renewal, especially for the audience. The 2003 production forces the audience to find meaning in the play and in their own lives. The 2006 production proves not only that the characters exist, but that they display signs of joy and laughter. The 2007 production incites us to action. Finally, the 2009 production forces us to take comfort in biding our time with friends. Overall, there is a sense that the nothingness represented in Godot provides fertile ground for possibility.

However, besides the different sense of nothingness presented by these directors, all of these productions are presented in a sweeping parabolic form. The 2003 production uses the metaphor of a cubist painting to explore the interior spaces of Didi and Gogo. The 2006 production paints a picture of a cozy pub where friends can come together and pass the time by sharing stories. The 2007 production metaphorically equates the disasters and possibilities of Hurricane Katrina with the *Waiting for Godot* story. And the 2009 production metaphorically creates a "fortress of friendship." What I argue, then, is that *Waiting for Godot* can be effectively read alongside the form of the parable. I believe that these directors, perhaps unconsciously, are noticing the generic form of the parable and moving away from the thematic readings of the absurd.

Current scholarly conversations have recently taken up the question of God and religion in relation to *Waiting for Godot* and Beckett's work in general. In 1998, Mary Bryden published *Samuel Beckett and the Idea of God.*[32] In 2000, *Samuel Beckett Today* published a special issue on "Beckett and Religion." Obviously the study of Beckett and religion is alive and well in current scholarship. Therefore, it is highly appropriate to addresses our understanding of *Waiting for Godot* by presenting it in relation to the parable structure. Three articles in the important special issue in *Samuel Beckett Today* all assert that, no matter what, there exists a constant quest for meaning in human existence.[33] Most important, as Jane Walling argues, is that this quest is performed on an individual basis, since there is no overarching meaning in this world. It is up to each individual, as Camus argues, to use reason to give his or her life purpose. As a genre that presents a contradiction or paradox and forces the reader to makes sense of that contradiction, the parable fits in with the above understandings of how Beckett's characters proceed in this world. Thus, Beckett creates a mini-parable in order to argue that life is made meaningful by "biding one's time" with friends, rather than *hoping* for an outside savior.

The ethical nature of the *parable*, as well, relates to the recent criticism of *Waiting for Godot* where post–colonial, queer, and disability theorists have stressed *morality*.[34] I would like to address the moral element in contemporary scholarship on *Waiting for Godot*. Following A. Uhlmann and the contemporary turn to the moral element of the play, I argue that the questions and the attempt at answers that occurs in *Godot* have much more to do with ethics (moral crises) than metaphysics.

Part of the reason that this play has been read in a metaphysical manner is because of Esslin's statement that the plays of the Theatre of the Absurd display the theme and sense of "metaphysical anguish at the absurdity of the human condition."[35] However, as stated in the Introduction, Camus identifies Sisyphus as happy because he made meaning out of his life in the face of his absurd situation, even when his desires were contradicted by the realities of the world. In reading *Godot* through the perspective of Camus, viewers can understand the Sisyphean task at hand for Vladimir and Estragon: despite living in an absurd situation, where the world does not give Didi and Gogo what they want, the two tramps find purpose in their lives through literally and metaphorically "saving" the other by "biding one's time" in idle talk, talk that occurs most importantly, with a friend. Beckett seems to argue the potential for salvation by orchestrating a Sisyphean triumph over suffering and triviality in Vladimir and Estragon's dilemma.

If *Waiting for Godot* is written as a revolt against existentialism (in the vein of Camus) and—using the parable model—the play suggests that meaning can be made out of nothingness by using defiance and friendship. One important place in *Waiting for Godot* where Beckett creates such a mini-parable occurs in the opening scene where Estragon struggles to remove his boot. By creating a parable, Beckett engages with the Camusian idea that we have to make meaning out of contradictions or absurd situations. Given this possibility for redemption, this play has little to do with demonstrating hope in the face of despair. As we watch Estragon and Vladimir discover their potential to become their own saviors and our own, as we observe them, learning that through talk and enjoyment of each other, they not only bide their own time but bide our time as well, we find that Didi and Gogo succeed in helping themselves and us find meaning in life. What this reading allows for is the contemplation of the paradox of hope. This play exposes viewers to the fine line between hope and *active* waiting, arguing that the actual present and ambiguous future are tied together in rather unfulfilling ways. The question arises, why hope if one has no idea of whether sometimes that hope can offer any type of relief? Ultimately, though, this reading frees the play from an absolute thematic absurd/existential interpretations and

suggests new structural elements, based on Beckett's use of parables, with which to read the play.

Contrary to traditional readings, this chapter argues that Samuel Beckett's *Waiting for Godot* displays significant anti-existential leanings. I believe that a number of noticeable structural elements which parallel parables were overlooked in regards to this play.[36] My approach is designed to free *Waiting for Godot* from absurdist and existentialist labels and to move the play away from Esslin's influential thematic reading toward a structural interpretation, which simply provides more tools for scholars to analyze the play. A survey of recent productions indicates that directors have moved in this same anti-existential direction in their interpretation. Ultimately, I wish to contend that *Waiting for Godot* purports growth and purpose out of nothingness through continued struggle and friendship and that it is not a despairing reaction to life's meaninglessness.[37]

The Play

There are two ways to read the opening stage directions of *Waiting for Godot*: "*A country road. A tree. Evening.*" The first way is to imagine a desolate picture. "Country" can more or less be used as the opposite of "city" and its "road," then, would not be situated in any bustling area: few, if any, buildings, few, if any, people. The tree, "A tree," is unspecified, unnamed by species and genus, but we do know that it is solitary. The tree becomes all the more bleak when the dialogue fills us in (and fills the director in) that there are no leaves and that "It must be dead."[38] "Evening" alerts us to the end of daytime, the end of light, the end of a cycle. Desolation and death pierce the stage.

However, there is a second way to read this opening scene. Though most likely the road that we see is in the middle of nowhere, the "country road" does lead somewhere. It leads to, most likely, a "country" town. And, in fact, again, imagining a small countryside, it probably connects one "country" town to another one. This "country road" makes connection possible. This country road provides people an easier *journey*, both literally and metaphorically speaking. And sure, the "tree" may have no leaves on it now, it may be fall or winter, but just like "evening," the waning of one cycle only brings in the birth of a new cycle. I prefer, and will argue, this second reading of the play and the opening scene.

The opening scene of *Waiting for Godot* begins with a struggle: "*Estragon, sitting on a low mound, is trying to take off his boot. He pulls at it with both hands, panting. He gives up, exhausted, rests, tries again.*"[39] Clearly Estragon concerns himself here with something base. He is low to the ground on "a

low mound" and his hands, naturally, must be pulling at the bottom of his boot. The ground, then, is the indirect object of attention. How can Estragon remove that item of apparel which keeps him so invariably tied to the earth, to dirty thoughts, to thoughts which tie him down to that which is opposite of spiritual transcendence? Estragon has been well connected to the land.[40] He spends his nights in a ditch, where he is repeatedly beaten. Vladimir seems to think that nobody could take this much suffering: "It's too much for one man."[41] Yet suddenly Vladimir changes tone and suggests, "What's the good of losing heart now."[42] Estragon's response sets the philosophical tone for the play: "Ah stop blathering and help me off with this bloody thing."[43] Instead of concentrating on his lot, which may or not be "too much for one man," Estragon concerns himself with the *moment-to-moment* struggle. He does not concentrate on his suffering, but tries to rise above all things that tie him to the ground and to, instead, search for spiritual freedom.

Viktor E. Frankl, in *Man's Search for Meaning: An Introduction to Logotherapy*, asserts that, "It is this spiritual freedom—which cannot be taken away—that makes life meaningful and purposeful."[44] This spiritual freedom for Estragon consists of exercising his will to endure suffering, while symbolically removing that which ties him to the base earth. Bryden says that Estragon resembles Jesus: as a physical being, as a man "who suffered in his body, and who went barefoot."[45] Once Estragon finally removes his boot, the audience expects some triumphant remark. Instead, Estragon responds with a "Nothing."[46] Vladimir explains the situation: "There's man all over for you, blaming on his boots the faults of his feet."[47] Thus ends *Waiting for Godot*'s opening "parable."

In my opinion, the action is contained in a solitary metaphor: Estragon is struggling to remove his boot. The idea is that once the boot is removed his physical suffering will cease. The audience is made well aware of the struggle because this is precisely how we find Estragon at the beginning of the play. The tension and suffering increase, and, thus, the longer Estragon has to bear the pain, the more desperate he seems to become. Vladimir interjects: "Hope deferred maketh the something sick."[48] As noted previously, moments later, when he finally succeeds in removing his boot, Vladimir blames Estragon for "blaming on his boots the faults of his feet." The audience walks into this first symbolic statement at the beginning of the play after being oriented to the struggle and victory's delay. What disorients the audience is not Estragon's victory—the removal of the boot—but the meaninglessness of his victory. The removal of the boot solves nothing.

Beckett's two statements are two didactic "maxims." The first "maxim"— "Hope deferred maketh the something sick"—is generally thought to

encompass the thematic thrust behind the entire play. Estragon and Vladimir continue their existence on hope alone. Hope gives meaning to life. However, if we understand the structure of a parable, we understand that a parable usually consists of two parts. First, there is the part that orients the audience. In "The Parable of Estragon's Struggle with the Boot," the audience aligns him or herself with the struggle. We yearn for the removal of stress, just like Estragon. We can see the struggle, yet we can only hope for its happy conclusion. Thus, when we hear the line," Hope deferred maketh the something sick," we fully understand it. The longer we wait with Estragon, the sicker we become with anticipation and frustration. This brings us to the end of the first arc of the parable: the orientation section.

Then comes the "turn," as Robert Funk likes to call it.[49] The second portion of the parable, usually much shorter than the first, is the portion of disorientation. As said before, the anticipation of the removal of the boot and the realization that the boot had nothing to do with quieting the uneasiness throws the first part of the parable into question and provides the metonymic paradox of Beckett's opening use of a parable-like structure.[50] The "turn" generally questions or directly contradicts the first part of the parable, raising more questions than offering potential answers to the dilemma. Thus, "The Parable of Estragon's Struggle with the Boot" raises the ethical dilemma *why hope if you have no idea that what you are hoping for will bring you any relief?* This is a question that act utilitarianism would try to resolve. Removing the boot should relieve one's suffering, producing the greatest amount of happiness. Hope would, then, make sense.

In *The Shape of Paradox: An Essay on Waiting for Godot*, Bert O. States describes the play as mythic and reads the play as a play of hope. States labels *Godot* not an old biblical myth but a new myth in old dress; the mythic dimension lies in the fact that there is a "constant 'oscillation' of background and foreground, elsewhere and here, a coming in and out of focus of what are often contradictory loadings of the same shape."[51] It is important to note that the "mythic" elements that States describes are labeled "contradictory," since his definition is congruent to my fundamental description of the paradoxical nature of parables. The "myth" and paradox (or parable) that States says encompasses the entire play is the parable of the two thieves: "the paradox (as Beckett sees it at least) of grace unaccountably given and unaccountably withheld."[52] This makes the thieves on the cross with Jesus, or the tramps, dependent on hope. However, as I argue, the hope generated by the prospects of removing the boot is wasted and only leads to disappointment.

The point of this parable is that Vladimir and Estragon should not merely rely on an abstract concept of hope, but should instead cultivate their continued friendship in order to make their lives meaningful. When we first

encounter Estragon and Vladimir, we see them on a country road with a tree that they describe as dead. Though homosocial readings could be generated, this is not a "couple" in the standard sense of the word: an "odd couple," perhaps but not a sexual one. There is no mention of a loved one: rather Didi and Gogo only have one another. But, at least, Vladimir is excited at this prospect: "Together again at last! We'll have to celebrate this. But how? (*He reflects*.) Get up till I embrace you."[53] Maybe because of his struggle with the boot or maybe because he spent the night in the ditch being beaten, Estragon is not in the mood. But then, again, it is Estragon who is suffering, or at least trying to remove a stress. Vladimir can sit idly by and philosophize the nature of "the struggle."

The struggle with the boot literally is a physical struggle that leads to frustration. Estragon is physically worn by this struggle. And, naturally, Estragon is hungry soon after.[54] In a sense, then, the physical body is very important. The scene with the turnips and carrot make it even more so. Vladimir asks if Estragon wants a carrot. Asking if that is all there is in response, Estragon is then given the choice of a turnip. Estragon, like most, we are lead to believe, would prefer the carrot. When Vladimir pulls out a turnip, Estragon, though angry, takes it and takes a bite out of it. Estragon makes the best out of a *bitter* situation because 1) that is all he has, and 2) it is sustenance. But when Vladimir finds a carrot and gives it to Estragon, Estragon "*looks at the carrot appreciatively*."[55] Estragon says, "I'll never forget this carrot."[56] In a sense, decent sustenance and simple pleasure change Estragon's mood.

When asked how he likes the carrot, Estragon responds, "It's a carrot."[57] This question is posed shortly before Pozzo and Lucky make their first appearance in the play and shortly before Vladimir and Estragon have a brief conversation about character. Both the carrot and the idea of character share the notion of essentialism:

VLADIMIR: Question of temperament.
ESTRAGON: Of character.
VLADIMIR: Nothing you can do about it.
ESTRAGON: No use struggling.
VLADIMIR: One is what one is.
ESTRAGON: No use wriggling.
VLADIMIR: The essential doesn't change.
ESTRAGON: Nothing to be done.[58]

Brigette Le Juez's recent *Beckett Before Beckett* examines Beckett's formative years at Trinity College, Dublin. Though not previously unknown,

Le Juez delves deeper into Beckett's early obsession with Descartes. One of my arguments here in this chapter is that in *Waiting for Godot* essence precedes experience and, thus, Beckett's thought is a version of Cartesian Rationalism, not existentialism. It is very important that Beckett chose the words "temperament" and "character" to begin this mini-conversation. The definition of "temperament" as it was first applied to humans (as opposed to compounds, natural things, etc.), stemmed from the medieval sense of humours: "In medieval physiology: The combination of the four cardinal humours of the body, by the relative proportion of which the physical and mental constitution were held to be determined."[59] In a sense, humans, then, were born with their own unique combination of the four cardinal humours and their corresponding physical and mental constitution did not change. "Temperament" is closely connected and defined in part as "disposition," which is the "natural tendency or bent of the mind."[60] Likewise, with the first definition of "character" as used in the everyday sense of the word, we see the idea of something innate, natural, and essential: "The aggregate of the distinctive features of any thing; essential peculiarity; nature, style; sort, kind, description."[61]

Vladimir and Estragon's reaction to this essentialist view of human nature only confirms what the two words imply: "Nothing you can do about it," "No use struggling," No use wriggling," and "Nothing to be done." In short, no matter what you "do," your essence will remain the same: your *actions* will not change your essence. As Vladimir states very succinctly, "The essential doesn't change." The line, "One is what one is," could simply be seen as an extension and/or reiteration of, "The essential doesn't change." However, given that this line is playing off of the Old Testament line from God, "I am what I am," this line deserves its own attention.

The very fact that the line is changed to no longer imply God rests this statement solely in the human realm. But this statement is, more or less, stated as a proof, much like Descartes's, "I think, therefore I am." Not only does the line, "One is what one is," provide an essentialist understanding of the world and of human nature, but it is stated as a logical maxim or even, to be creative, like the final part of a syllogism. The maxim or the conclusion of a syllogism can only be arrived at, not through experience, but through logic and reason.

In the larger sense of essence preceding existence in relation to *Waiting for Godot*, the characters are not defined by their actions. This has to do, in part, with each characters' temperament and disposition. But more importantly, their essences' are reinforced by their own use of reason. Pozzo, for example, is a master, not just because of how he treats Lucky, but because of how he rationalizes his relationship with Lucky: "He wants to impress me,

so that I'll keep him;" "He wants to mollify me, so that I'll give up the idea of parting with him;" etc.[62] Pozzo's rationalization of his, albeit dysfunctional/unhealthy, relationship with Lucky, no matter what, provides Pozzo and Lucky—in their interdependence—with a sense of purpose. In a world devoid of inherent meaning—without absolute notions of good and evil—this man-made sense of purpose is all that they can hope to have to make their lives meaningful. Pozzo understands, very clearly, his and Lucky's *absurd situation*, where the world does not always offer them what is desired: "Remark that I might just as well have been in his shoes and he in mine. If chance had not willed otherwise."[63] Pozzo acknowledges that life is unfair—that he got the lucky break (or, *Pozzo got Lucky*)—and that he has to simply make the best of it. Vladimir and Estragon continue to struggle and be defiant toward an absurd world (via Camus), not only because of their temperaments and dispositions, but because Vladimir, "*broods, musing on the struggle.*"[64] Though Estragon might state, "Nothing to be done," Vladimir, in this case, responds, "I'm beginning to come round to that opinion. All my life I've tried to put if from me, saying, Vladimir, be reasonable, you haven't tried everything. And I resumed the struggle."[65] In short, the characters from *Waiting for Godot* each rationalize suffering in a different manner, but as Pozzo states, in the most essentialist, and maybe hopeful line in the play, "You are human beings none the less."[66]

Returning to the above quote about Vladimir resuming the struggle, Vladimir "broods" and muses on this "struggle," suggesting that maybe he understands that this struggle is much more significant than an ordinary struggle with a boot. Viewers know that Estragon was "panting" and "exhausted." We recall one of the definitions of *struggle*: "A strong effort to continue to breathe, as in the death-agony or under conditions tending to produce suffocation."[67] Taken one step further, the biological term, *struggle for existence* rings true here: "used metaphorically to describe the relation between coexisting organic species when the causes tending to the survival of one tend to the extinction of another."[68] The imperfect foot and the imperfect boot ruin one another. Each misshapes the other.

Though not in a *struggle for existence* or a *struggle for life* as it is also known, Estragon and Vladimir similarly misshape one another. Vladimir is usually seen as the philosopher and poet, searching for consciousness while Estragon is the corporeal being. Yet the dialectical nature of the two is not so rigidly divided once Vladimir describes Estragon as a poet in the text[69] and exhibits his own physical nature by talking about erections.[70] In some ways, each personality rubs off on the other. These are not the two halves of Aristophanes's speech in Plato's *Symposium* trying to find its missing half. These are two casts, which to all quick glances seem to compliment

one another, but which on closer inspection, have edges that are rough and misshapen and do not fit well together like adjoining puzzle pieces. Peaks and valleys of their personalities push against each other, sometimes forcing the other to submit and yield, and sometimes causing a clash, which forces the two to back away from each other. Thus, when Vladimir goes to greet Estragon with a hug and Estragon refuses, we have our first sign that these two halves are not going to make a whole. In other words, the two do not seem to be able to "achieve fulfillment" by simply imagining the other.

This is not a "love or in love" relationship. When the opening scene starts out so bleak with neither of the central characters appearing to have a "love" to dream up, what is keeping them from committing suicide? Without an obvious love, the pair of tramps are left only to their suffering. But do they even consider this barren world as a cause of their pain? They do not have "masters" in the cast of Pozzo that oppress them and are not chained and subjugated, yet they appear to be without hope. While they never express hope that Godot will come, Vladimir does expresses his "hope" by refer- ring to Estragon, as "You're my only hope."[71] The two never "hope" to see Godot.

What makes the two consider suicide has nothing to do with their lack of hope, but with their identification with their possible future or lack of it. Rolled into the definition of waiting is the idea of a future. One waits *for* something. That something is something to come. Frankl explains that "It is a peculiarity of man that he can only live by looking to the future—*sub specie aeternitatis.* And this is his salvation in the most difficult moments of his existence, although he sometimes has to force his mind to the task."[72] What is most important here is not to confuse hope with talk of the future. There is nothing in this play to suggest that Vladimir and Estragon are either hopeful or without hope. What I am arguing is that the condition of waiting, on the other hand, postpones the future, or the realization of things to come. The two seemed damned to waiting, and, in their state in limbo, the future seems like it will never come. James L. Calderwood states that their "world time refuses to be shaped."[73] This is how the two suffer. Their future cannot be assured in the wait.

However, the two refuse to succumb to such suffering. Instead, they find meaning in their life even in its hurtful condition. Frankl says, "The way in which a man accepts his fate and all the suffering it entails, the way in which he takes up his cross, gives him ample opportunity—even under the most difficult circumstances—to add a deeper meaning to his life" (106). Despite their dire situations, the two tramps have yet to commit suicide despite the fact that they have seemingly lived this way day after day for maybe up to 50 years, ever since the day that Estragon threw himself into the Rhone River.

From that point on, the two subconsciously begin to accept what they subconsciously realize at the end of Act I:

VLADIMIR: We can still part, if you think it would be better.
ESTRAGON: It's not worth while now.
 Silence.
VLADIMIR: No, it's not worth while now.[74]

In this understated exchange, the two friends both realize how necessary they are to each other. As Frankl states,

When the impossibility of replacing a person is realized, it allows the responsibility, which a man has for his existence and its continuance to appear in all its magnitude. A man who becomes conscious of the responsibility he bears toward a human being who affectionately *waits for him, or to an unfinished work*, will never be able to throw away his life. He knows the "why" for his existence, and will be able to bear almost any "how" (*my emphasis*).[75]

Even though Estragon was at the end of his rope 50 years ago, without a love, and presumably, without a future, once he meets Vladimir, he has someone who waits for him every morning after he is beaten. Despite the fact that he suffers every night, he awakes to be greeted every day by Vladimir. And the two have an unfinished work: waiting for Godot. This is their "why" for their existence. Like Sisyphus, via Camus, they are still able to find purpose and meaning in a repetitive world full of suffering. As soon as this is realized—this impossibility of replacing each other—viewers can see life immediately spring up. As a seemingly direct result of this realization, in the beginning of Act II where the potential of life is revealed, we see the tree reborn.

In my aforementioned article on Sartre's "The Wall" and *Godot*, I focused on the character of Godot, arguing that his absence does not signify negation (Sartrean nothingness), but rather, signifies infinite possibility, where nothingness is part of Being (Heideggerean nothingness).[76] In a similar manner, I would like to address Estragon's suicide attempt 50 years before the time of the play. A quote from the previously-mentioned article is applicable here:

...in "The Wall," when faced with ultimate negation, death, the characters start to embody death, which negates their humanity. In *Godot*, on the other hand, confronting nothingness emboldens the characters with

the freedom to struggle and make meaning out of their situation (as in Camus's philosophy).[77]

In a similar vein, when Estragon jumped to his supposed-forthcoming death in the past, he was trying to negate his humanity. His failure shows that Beckett does not allow for that possibility: he refuses to let humanity negate itself. Instead, we see Vladimir rescuing Estragon and observe the two characters symbolically grow together and being drawn closer by this attempt. Their friendship emerges out of nothingness and despair. And so, as stated above, once they realize their own personal growth, the tree grows as well. The tree itself in *Godot*, however, is a grand metaphor for Hediggerean nothingness. The leaves on a (deciduous) tree cycle through growth and death with the coming seasons. Thus, nothingness, for the life of the tree, is a constant part of its being. This nothingness, however, also is essential for growth to occur later. In such a way, every night the two appear to part. Estragon, night after night, is beaten up and worn down, but day after day, Estragon's contact with Vladimir rejuvenates him and emboldens him with the will to go on and face the struggle. In reading *Godot* through the non-existential view of Camus and Heidegger, we can see that this play is about growth and possibility, struggle and meaning, and above all, about the human contact that gives life its purpose.

Vladimir, in the beginning of Act II, is quite conscious of the importance of his and Gogo's friendship. More or less repeating his line from Act I, "Come here till I embrace you" (37), Vladimir greets Estragon the next day. But again, Estragon reports that he was beaten and he is in no mood for hugs. Estragon is despondent and Vladimir recognizes this. It takes a violent, "Will you look at me!" from Vladimir to rouse Estragon.[78] Vladimir does not simply distract Estragon from Estragon's own misery with this statement. Vladimir presents *himself* as the alternative to misery by beckoning Estragon to look at him. The violence of the statement does not just get Estragon's attention because it is presumably loud, but the passion involved in the violence shows to Estragon that Vladimir is far from indifferent concerning Estragon's plight. Thus, passion breeds passion and Estragon and Vladimir embrace.

When Vladimir says that "Gogo, there are things that escape you that don't escape me, you must feel it yourself," Vladimir wants Estragon to experience how a friend's embrace both literally and figuratively provides a happy foundation to life.[79] Estragon claims that "I wasn't doing anything."[80] Vladimir's response to Estragon's assertion provides the answer to the seemingly impossible question, what to do *while* waiting: "Perhaps you weren't. But it's the way of doing it that counts, the way of doing it, if you want to

go on living."[81] First, this "perhaps" is one of the most important words in this play. The idea of doing "nothing" is a type of All-or-Nothing thinking. In a sense, a rigid binary is set up: one is either doing "nothing" or is doing "something." Therefore, every action is either assigned no value in this world (if one is doing "nothing") or assigned value (if one is doing "something"). The "perhaps" both acknowledges that, metaphorically, maybe our actions *are* devoid of any inherent value. But, also, the "perhaps" suggests that doing nothing except simply living could be meaningful itself. This "perhaps" echoes the "if" in Camus's *The Myth of Sisyphus*: it is better to live as if there was no inherent meaning in this world. *Perhaps* every action *is* insignificant in the grand scheme of things and the result is that, for all extensive purposes, we metaphorically *do nothing*. However, we have not only possibilities in terms of our action, Vladimir suggests, but we have a choice of what kind of attitude we can have and who we can *do* our "nothing" with: "You must be happy too, deep down, if you only knew it... To be back with me again."[82] Vladimir believes that attitude, and thus, one's happiness, can be chosen: "Say you are, even if it's not true... Say, I am happy."[83] The indeterminacy of the statement, "even if it's not true," allows Vladimir and Estragon to shape their own internal space. The elasticity of (or absence of) absolute truths enables and empowers the individual to find happiness, even if one's reality appears to contradict that fact. Beckett, maybe most poignantly of all in *Happy Days*, allows for Winnie to conclude time and time again, as she sinks further and further, that this is, in fact, a happy day.

In a sense, it takes both good memory and bad memory to be able to carry on with a positive attitude when life appears cruel and bleak. One must remember the good and forget the bad, in other words. In this play, Estragon, more often than not, has a bad memory and Vladimir, more often than not, has a good memory. Each character on their own would never make it: Estragon would forget every joy that has transpired; Vladimir would dwell on every misfortune. Going back to an early statement, the two misshape each other, but in a positive way. Estragon's forgetfulness not only forces Vladimir to remind Estragon of what transpired in their lives, but the saying of it, as discussed just above, reinforces that they truly exist and can be happy.

Vladimir and Estragon's ability to both remember and forget is exemplified when the two look at the tree in Act II:

VLADIMIR:...I was saying that things have changed here since yesterday.
ESTRAGON: Everything oozes.
VLADIMIR: Look at the tree.

ESTRAGON: It's never the same pus from one second to the next.
VLADIMIR: The tree, look at the tree.
Estragon looks at the tree.
ESTRAGON: Was it not there yesterday?
VLADIMIR: Yes of course it was there. Do you not remember? We nearly
 hanged ourselves from it. But you wouldn't. Do you not remember?
ESTRAGON: You dreamt it.
VLADIMIR: Is it possible you've forgotten already?
ESTRAGON: That's the way I am. Either I forget immediately or I never
 forget.[84]

Vladimir draws attention to the change and growth and it is noticed by
Estragon as he acknowledges that, "It's never the same pus from one sec-
ond to the next." But the same tree that reminds Vladimir of growth also
reminds Vladimir of pain, which Estragon was able to forget. Estragon
suppresses pain through selective memory. On the other hand, his selective
memory allows Estragon to remember only a couple of key things: most
particularly Vladimir. As is well obvious from the above passage, Estragon
forgets things that recently happened or that he would rather not dwell on.
Estragon constantly forgets that the two are waiting for Godot. In the sec-
ond act, Estragon cannot remember Pozzo and Lucky from the day before.
 Although Estragon cannot remember events from moments before, he
remembers the positive, the thing that defines his relationship with Vladimir
from 50 years before—the day Vladimir saved his life, both literally and
metaphorically:

ESTRAGON: Do you remember the day I threw myself into the
 Rhone?
VLADIMIR: We were grape harvesting.
ESTRAGON: You fished me out.
VLADIMIR: That's all dead and buried.
ESTRAGON: My clothes dried in the sun.
VLADIMIR: There's no good harking back on that. Come on.[85]

It is hard to imagine that the same person who could not remember who
he is supposed to wait for the last 50 years or cannot remember who he met
yesterday, can remember the fact that his clothes dried in the sun 50 years
ago on a particular day. Estragon's remembrance of Vladimir's heroism as a
sign of a loving relationship contrasts here with Vladimir's much more prac-
tical in-the-moment concern with the struggle of keeping the two of them
warm that moment in the play. Estragon's idealism is needed. Estragon's

ability to forget is needed. And Vladimir's ability to remember long-term and short-term purpose (respectively, that they are waiting for Godot and that Vladimir looks out for both of their physical needs, as Vladimir has food) is needed. We see all three of what is needed—Estragon's idealism and ability to forget and Vladimir's ability to stay focused a goal—in the following passage:

> ESTRAGON: You'll help me?
> VLADIMIR:I will of course.
> ESTRAGON: We don't manage too badly, eh Didi, between the two of us?
> VLADIMIR: Yes yes. Come on, we'll try the left first.
> ESTRAGON: We always find something, eh Didi, to give us the impression we exist?
> VLADIMIR: (*impatiently*) Yes yes, we're magicians. But let us persevere in what we have resolved, before we forget...[86]

Here, the simple but caring exchange is quite telling. First, Estragon says, "You'll help me?" Estragon does not formulate the sentence as a typical question: will you help me? Estragon states it as an imperative: You will (You'll) help me! This word construction suggests an inner certainty about their friendship. The question mark lessens the demands of friendship. The question provides Vladimir with the possibility to choose to help, which, "of course" he will. The way the question is constructed, then, allows Estragon to not make demands, while also having his needs fulfilled, in friendship. Vladimir also gets to feel good about choosing to help his friend, rather than being told to help his friend, regardless of whether or not he would be glad to help, which "of course" he was. Estragon, in turn, gets to hear Vladimir's happiness of making a choice to help him.

The reinforcement of their friendship rouses Estragon's long-term memory of things that are joyful: "We don't manage too badly, eh Didi, between the two of us?... We always find something, eh Didi, to give us the impression we exist?" Estragon speaks of "we" and "us" as a unit, a pair, but the affectionate "eh Didi" that splits up these two sentences suggests that it is specifically Didi and me (i.e., Gogo), not just anybody, that makes up the first-person plural "we." Estragon is able to see long-term here as Estragon observes what they "always" do. Vladimir's impatient response, "Yes yes, we're magicians. But let us persevere in what we have resolved, before we forget," seems cold at first. However, when we realize that literally and metaphorically the two tramps have been having these same conversations over and over again for 50 years, we see Vladimir's impatience less as a sign of *I do not want to hear it* and

more of a sign of *we do not need to waste our time saying it, especially since we have things to do together, because I agree and understand.*

The lines, "ESTRAGON: We always find something, eh Didi, to give us the impression we exist? / VLADIMIR: (*impatiently*) Yes yes, we're magicians. But let us persevere in what we have resolved, before we forget..." also suggest another reading as to why Vladimir is impatient. While the commentary on the intangible and ephemeral nature of our existence is present directly in Estragon's question and indirectly in how Vladimir calls them "magicians," Vladimir's impatience signals that question, again, is possibly wasting his time because, ultimately, the fact whether they exist and whether existence is meaningful means nothing when they have created their own purpose (they have to "persevere in what [they] have resolved").

When Estragon says, "We always find something...," this "something" is used as a binary-opposite to the ever-present word and idea of "nothing," as discussed earlier. "Something," which means *anything other than nothing*, demonstrates to them their existence. In a sense, then, anything that they "find" shows that they exist. Merely when they *find*—"To come upon by chance or in the course of events"[87]—they see that they exist. It does not even take any effort then to demonstrate to themselves that they exist. Think, then, what they will find when they actually *seek*—"To go in search or quest of; to try to find, look for."[88] (*OED*).

Later, Vladimir says, "When you seek you hear."[89] This rebirth of the tree is only affirmation that the senses come to life and life comes to life in the search for knowledge. The line quoted above is an adaptation of Mark 4:11–12:

> ...unto you it is given to know the mystery of the kingdom of God: but unto them that are without, all *these* things are done in parables: That seeing they may see, and not perceive; and hearing they may hear, and not understand; lest at any time they should be converted, and *their* sins should be forgiven them.

The play suggests that Beckett is coming up with his own interpretation of what a parable is. Grace and understanding come to those who try to understand and seek grace. Beckett beckons the reader or audience member to seek, along with Estragon and Vladimir. The form of the play is a parable as Beckett seems to suggest from the line.

However, Beckett complicates this biblical notion:

VLADIMIR: When you seek you hear.
ESTRAGON: You do.
VLADIMIR: That prevents you from finding.

ESTRAGON: It does.
VLADIMIR: That prevents you from thinking.
ESTRAGON: You think all the same.
VLADIMIR: No no, impossible.
ESTRAGON: That's the idea, let's contradict each other.[90]

This classical biblical notion of hearing is under attack as Vladimir and Estragon point out the pitfalls of the parable. Seemingly responding to the "one single point of comparison"[91] of C. H. Dodd that has been so prevalent in religious schools in the twentieth century, Beckett criticizes the homogenization of thought that emerged from the parables: "You think all the same." Instead, Estragon offers up the solution: "let's contradict each other." The parable that Beckett imagines (and States images, too, but does not quite realize) is a parable of contradiction where everyone thinks differently and has opposing viewpoints of the same material in contemporary terms: heterotopia reigns.[92] The parable, then, is essential to Beckett's vision of the play. But this vision also aligns Beckett with Camus and Frankl, both contemporaries of Beckett, who have to create meaning out of the contradictions/absurdity that are found in the world to make life make sense.

For States, as mentioned above, the parable of the two thieves is at the heart of play. It explains the drive for hope. Since Beckett does reference the parable of the two thieves perhaps the parable of the ten virgins (Matt. 25:1-13) provides a more appropriate analogy. This parable, like *Waiting for Godot*, is about waiting. There were ten virgins waiting for bridegrooms. Five were wise and remembered oil for their lamps. Five were foolish and forgot. They went to sleep while waiting and woke up when they heard the men coming. The five who forgot oil asked the ones who remembered for oil. They said go get your own. So the five went and missed the bridegrooms entering the house. The door was shut: "Watch therefore; for ye know neither the day nor the hour wherein the Son of man cometh" (Matt. 25:13). The question that the audience asks is how long does one wait for someone? How can one be prepared for the arrival of the person you expect to come? But the question becomes in the postmodern world, how can one be ready when one can never really know the person who is coming? Is it worth seeking when aging may render our facilities useless and we will miss the truth? We will not be able to recognize or communicate with the savior, who himself is unreliable and speaks through a child, and we must question the child's reliability.

In enduring the suffering of the wait, Vladimir and Estragon represent their own and the audience's saviors. The play yields three levels of reading that all have a deep ethical dimension. The surface level reading of the play is how long does one wait? A related reading is why not commit suicide when

one cannot imagine one's future? And, a more complicated reading is "when you seek you hear," but only when you "contradict each other." What is one to do if the savior is unreliable? Who do you turn to? The answer is that you turn to your own reliability. The two tramps realize that they cannot be replaced and their suffering is unique to them. They are situated in their own place in history and they have the unique task to be Good Samaritans to Pozzo in his time of need. Pozzo's nasty treatment of Lucky only further emphasizes the fact that Vladimir and Estragon would help out someone who may not even deserve to be helped out. "Accursed time"[93] will eventually kill all, but for Estragon and Vladimir, "One can bide one's time."[94] However, they bide *our* time. Here I disagree with Eric Bentley: "He is *presenting* people who have trouble filling up *their* time."[95] Beckett, I argue, shows us how to fill up time, how to fill up *our* time: with the theatre, with idle talk and diversions, and with friends.

Conclusion

The last two scenes, if you will, with 1) the Boy and then, 2) Didi and Gogo alone, deserve attention. There are two puzzles that still need to be figured out: 1) Other than simple frustration, why does Vladimir go after the Boy? And 2) how do we make sense of "Yes, let's go. / *They do not move*"?[96]

Concerning Vladimir's violent lunge at the Boy, I believe that what the Boy said about Godot a few lines earlier finally sunk in. When asked, "What does he do, Mr. Godot," the Boy responds, "He does nothing, Sir."[97] To return to an earlier line of inquiry, I would like to suggest that Godot's *doing nothing* contrasts with *doing something* (i.e., existing) as metaphorical binary-opposites. Vladimir, who was waiting for 50 years for what he thought was his goal of seeing Godot, realized he metaphorically was waiting for something that did or does not exist, or at least does not *affect* anything in the world (which is metaphorical non-existence).

Realizing deep down that there is no outside savior, Vladimir asks his final questions of the play: "Well? Shall we go?"[98] Estragon responds, "Yes, let's go."[99] And then the last line in this puzzling play is a puzzling stage direction: "*They do not move.*"[100] In order to make sense of this going versus not moving, it is fruitful to look at the definition of *go*:

go, v.

I. Of movement, irrespective of the point of departure or destination.

1. a. To walk; to move or travel on one's feet (opposed to *creep, fly, ride, swim*, etc.); to move on foot at an ordinary pace (opposed to *run*, etc.). *to go alone*: to walk without support. *Obs.*

b. *to go on, upon, the earth, the ground* (also simply): to live and move.[101]

While most of us will naturally think of the two tramps physically walking somewhere, I think we must turn to the ideas present in the two uses of *go*: "to go alone" and "to go on." "Let's go" is in the first person plural. Rather than referring himself in first person—if it was constructed *you and I*, implying that *you go* and *I go* at the same time and/or together (and, thus, we get the sense of "to go alone," "to walk without support")—the collective sense of "we" that Vladimir uses and the shortened "us" that Estragon uses, implies the exact opposite of "to go alone": implying to walk with support.

Further, as so much of this play is metaphorical, the idea of *going* may be metaphorical, as well. Hence, the idea of "to go on," "to live or move," is a possible way to understand the seeming contradiction of the last two lines. Especially relevant to this is the fact that "Let's go" contrasts with the first spoken line of the play, "Nothing to be done."[102] It is almost as if the two tramps have learned throughout the course of the two days how much they need each other and that their lives are meaningful because of this relationship. The two constantly "go on" because they always "resume the struggle," but most importantly, Didi and Gogo *go on together*.

CHAPTER 2

The Pinteresque Oedipal Household: The Interrogation Scene(s) in *The Birthday Party*

First produced in Cambridge, England, in 1958, Harold Pinter's *The Birthday Party* takes place in *"The living-room of a house in a seaside town."*[1] In perhaps Pinter's favorite setting—the room—Meg babies her lodger, the late 30-something Stanley. Stanley is a former concert pianist who seemingly prefers the safety of Meg and Petey's house to accepting a job. The particular day of the play is Stanley's birthday and Meg, being convinced by two brand new lodgers—McCann and Goldberg—plans a birthday party for him. It appears that McCann and Goldberg were looking for Stanley. Apparently, they were, at the very least, acquaintances before they meet again in Meg and Petey's home. Before the party, McCann and Goldberg aggressively interrogate Stanley in tangential lines of thought, to the point where he almost cracks. He does crack, however, at the birthday party and "rapes" a neighbor, Lulu. The next morning, McCann and Goldberg take him away, much to the hesitation of, especially, Petey.

The plot is rather simple and can easily be summarized. As many have noted, however, the complexity of the play is in the subtext. Writing an early reaction to Pinter's young career, Richard Schechner summarizes the subtext of *The Birthday Party*: "None of these victims knows what the others intend for them; nor are they able to find out until it is too late."[2] Schechner observes that even when apparently clear, Pinter's subtext carries "a heavy baggage of implication, confusion, and nuance."[3]

The play's London opening closed after one week. Most critics bashed the play. D. Granger of the *Financial Times* said that "Harold Pinter's first

play comes in the school of random dottiness deriving from Beckett and Ionesco."[4] M. W. W. of *The Guardian* noted its use of "non-sequiturs, half-gibberish and lunatic ravings."[5] Alan Brian of *The Spectator* said the following: "*The Birthday Party* is like a vintage Hitchcock Thriller which has been, in the immortal tear stained words of Orson Welles, 'edited by a cross-eyed studio janitor with a lawn mower.'"[6]

Harold Hobson of *The Sunday Times* appears to be the only critic who praised the play: "The plot, which consists, with all kinds of verbal arabesques and echoing explorations of memory and fancy, of the springboard of a trap, is first rate."[7] Based on the comments from critics above, it appears that much of the poor reception had to do with the play's characteristic alignment with the Theatre of the Absurd and its "radical devaluation of language."[8] By way of subtext, the language often contradicts what happens on stage.[9] Martin Esslin suggests that *The Birthday Party*, "speaks plainly of the individual's pathetic search for security ... of the tragedy that arises from lack of understanding between people on different levels of awareness."[10]

Schechner, however, did not feel as though the "absurd" title fit Pinter's plays.[11] Schechner agrees that Pinter uses many of the techniques of Beckett and Ionesco, but argues that "Pinter's riddles, mysteries, and terrors are not 'metaphysical' or 'absurd.'"[12] Schechner believes that Pinter's theatre revolves around "conceptual incompleteness," in line with what he says about the use of subtext in Pinter's plays:

> No Ibsenite "secret revealed" ties the loose ends together. The plays—as aesthetic entities—are completed, but the conceptual matrices out of which the action arises are left gaping.[13]

This chapter picks up where Schechner left off and argues further that Pinter's *The Birthday Party* is not "absurd" and, in fact, is an example of parabolic drama that serves as a guidepost for the audience to making meaning in life. The reason why I believe that Schechner states that the victims in *The Birthday Party* are unaware of what others intend for them is that I argue that this play can be read as a parable about an unhealthy family relationship that resembles Oedipus's family due to their own inability to *interrogate* themselves and their own situation.

Ann C. Hall argues that *The Birthday Party*, "underscores the relationship among spectacle, individuality, and supremacy through the oscillation of subjectivity and objectivity."[14] I would like to play off of Hall's argument that there exists an "oscillation of subjectivity and objectivity" in the play. As I read *The Birthday Party*, to use Hall's language, the dominance of objectivity over subjectivity during scenes of spectacle and supremacy

(the interrogation scenes, in particular) destroy individuality. The dark side of the interrogation is control. Here, the mode of the interrogation is the unsteady and non-linear movement between the subjective and the objective. Interrogation, in this play, helps further the development of the unhealthy Pinteresque Oedipal complex present in this play: Stanley (the surrogate son) replaces Petey (the "father") for the mother's (Meg's) attention. The interrogation scene, also, serves as a mini-parable by which to examine the other "interrogations" in the play: the opening scene (what I call "The Interrogation of Petey"), the birthday party, and the "rape" scene.

The classically known "interrogation scene" is a mini-parable of the entire parabolic play, as Goldberg, especially, takes on the role of conman/actor whose objective speech objectifies Stanley.[15] This is due, presumably, to the fact that Goldberg and McCann do not communicate in a subjective reality. The dominance of objectivity in speech in this play yields unhealthy relationships. The effect is that we encounter a Pinteresque version of the Oedipal household. As Steven H. Gale says, Meg acts more like a "combination mother/mistress than landlady."[16] Meg, indeed, is a combination mother/mistress, in the sense that Meg's need to feel like a subject (as opposed to an object who merely prepares food for her husband, etc.) develops into an unhealthy need for her surrogate son (Stanley) to replace her husband (Petey).

Francis Gillen argues that these characters are like "fragmented beings," who, Gillen says, are, "caught between a world of fact, which does not satisfy them and a world of meaning which eludes them."[17] This inability to synthesize the "world of fact" and the "world of meaning" is due to the fact that these characters brush aside their "absurd" situation and prefer to live in a world of contradiction where their desires are not met by the realities of the world, rather than contemplate their situation and make meaning for themselves. The ultimate reason, though, that Stanley is in the position is that he does not know himself. Living in a Pinteresque Oedipal household, he is exposed to the terrors of interrogation that destroy the "questioning voice" needed to understand oneself and one's situation.

In 1988, on a BBC television interview, Pinter reflected on his older plays:

I think plays like *The Birthday Party* and *The Dumb Waiter* and *The Hothouse* are metaphors really. But I think, when you look at them, they are much, much closer to an extremely critical look at authoritarian postures. Not only state power, but family power, religious power, power used to undermine, if not destroy, the individual or the questioning voice, or the voice which simply went away from the mainstream and

refused to become part of an easily recognizable set of standards and values, social values.[18]

This chapter examines how language creates family power[19] that destroys the "questioning voice," thereby creating a Pinteresque Oedipal household and leaving Stanley not just blind (like Oedipus), but literally and metaphorically mute.

Here I disagree with Bernard Dukore's early assessment of Pinter's plays, which states that, "Pinter's people do no fail to communicate: they avoid communicating."[20] I argue, instead, that it is the Pinteresque Oedipal household that creates a dynamic of unhealthy interrogation while simultaneously destroying healthy interrogation (the "questioning voice"). Because Meg and Petey only live in an objective reality, Meg's develops an unhealthy attachment to Stanley, which destroys Meg and Stanley's "questioning voices." Meg and Stanley's relationship ostracizes Petey, which effectively "silences" Petey's objections to Goldberg and McCann's behavior. The ultimate tragedy of the play is that the characters, and most particularly Stanley, are defined, not by themselves through self-contemplation, but by the "interrogators."

In Camus's *The Myth of Sisyphus*, Camus explains that Sisyphus becomes a "master of his days" because he makes sense of his absurd situation: he "contemplates his torment," his punishment of continually rolling the rock.[21] In *The Birthday Party*, there is no attempt at contemplation. The solitary "questioning voice," in Petey, is "silenced" (almost ignored) because of the unhealthy Pinteresque Oedipal household that probably developed over the years. But even though Petey can question the motives of Goldberg and McCann, Petey cannot turn the questioning voice in a more important direction: on himself. It seems as though Petey is the only character who has the wherewithal at the present to "contemplate his torments." The tragedy is that the Pinteresque Oedipal household effectively destroys the "questioning voice," thereby eliminating any chance of self-contemplation. If one cannot define oneself, this play argues, then one's identity is vulnerably in the hands of outside "interrogators."

In this chapter, I extend the metaphor of the "interrogation scene" in Pinter's *The Birthday Party*. Looking at three other interrogation scenes— the opening dialogue between Meg and Petey, the birthday party itself, and the "rape" scene—I suggest that there is an unhealthy balance between subjective and objective speech, which results in poor communication. The result of this poor communication is that Meg, Petey, and Stanley are all treated like objects. This objectifying destroys what Pinter calls "the questioning voice." Without a "questioning voice" to investigate themselves and

their situation, these three characters develop an unhealthy dynamic. The dynamic creates what I call a "Pinteresque Oedipal household," where Meg (the surrogate mother) turns toward Stanely (the surrogate son) to replace Petey (the surrogate father) as the object of her affection. In the later half of the chapter, I continue to examine the "Pinteresque Oedipal household," however, I arrive at it from a different angle: by looking at the psychology of Meg as a childless-wife.

"The Interrogation of Petey"

At the start of the play, we see the *first* "interrogation scene." This time, though it appears benign and thus easy to dismiss as trivial, Meg is "interrogating" Petey with questions. His responses are simple. However, these questions are generally of a very different nature than Goldberg and McCann's questions. Many of Meg's questions try to elicit a subjective response. As Gale points out, "Both people are talking, yet neither divulges any meaningful data and each continues talking in a circular fashion as though the other were not answering."[22] When Meg asks Petey the simple question, "Are they nice?"[23] referring to the cornflakes she gave to Petey, Meg is searching for Petey's reaction to the world around him. This is evidenced by the fact that she already *knew* his answer but just needed whatever subjective response she could get from Petey, however trivial it was: "PETEY. Very nice. / MEG. I thought they'd be nice."[24]

The first four and a half pages proceed in such a manner: Meg asks a question trying to elicit a personal response and Petey provides a one-to three-word or so objective "inform."[25] The pace is choppy and short because all dialogue becomes trivial due to its brevity. However, Meg's desires for subjective communication become known when Petey actually asks *her* a question: "You like a song, eh, Meg?" Meg jumps at the opportunity to speak.[26] Her response is much fuller and lighter than any communication we have seen thus far, but her thoughts turn to Stanley's piano playing and then taking care of Stanley, as a mother waking up her lazy son.

In Stanley, Meg sees something in herself, some attempt at human interaction. The very first word spoken by Stanley is, "Morning."[27] The word functions as almost an agreement to start a conversation.[28] Stanley, then, backs this up by asking Petey a series of questions much like Meg asked Petey. And then, finally, Stanley and Meg engage in a playful conversation about getting a cooked breakfast. The problem is that 1) Stanley is not *even* her son, but a grown lodger and 2) most of Meg's sensual/sexual, feminine energy goes toward Stanley and not her husband, Petey. This is the skewed Oedipal complex that Pinter creates.

However, unlike in *Oedipus Rex*, there is no meta-investigation into the problem. The investigation comes, literally and metaphorically, from outside (Goldberg and McCann), not from an inner look into the situation and themselves. Meg never turns to Petey and says, why don't you really talk to me, tell me how you feel, etc. Stanley never says to Meg, why do you treat me like a child, why are you flirting with me, etc. Instead, rather than confronting and revolting against their "absurd" situation—where nobody gets what they want—the characters prefer to let these "absurd" conversations continue. Similarly, nobody really finds out why McCann and Goldberg are there, what their intentions are and why or where are they taking Stanley. Because these characters, especially Meg, Petey, and Stanley, cannot investigate an everyday situation (their kitchen setting and relationships), how can they investigate a situation where there is a threat present? This is why the second "interrogation" scene, with Goldberg and McCann, is so violent and dangerous.

What could equally be billed as "The Interrogation of Petey," the opening lines could also be read as Meg yearning for affirmation that she exists and is worthy, *despite* the fact that she is not a mother (or at least appears to be childless):

> MEG: Is that you, Petey?
> *Pause.*
> Petey, is that you?
> *Pause.*
> Petey?
> PETEY: What?
> MEG: Is that you?
> PETEY: Yes, it's me.
> MEG: What? (*Her face appears at the hatch.*) Are you back?
> PETEY: Yes.
> MEG: I've got your cornflakes ready. (*She disappears and reappears.*) Here's your cornflakes.[29]

Meg begins the play with three questions: 1) "Is that you, Petey?" 2) "Petey, is that you?" and 3) "Petey?" Especially since there are "*pauses*" after questions number one and two, we can almost feel Meg's desperation to know that she is not alone, especially in the metaphorical silence. Her first question is structured in such a way that the main question and independent clause—"is that you?"—is written so that "Petey" modifies "you." This is the least personal of the three questions since "you" can be anyone who is there in the room and the question shows the least certainty that it is Petey whom she

hears. Meg, then, yearning for Petey and to define herself, if not as a mother, at least as a wife, starts the next question by calling out to Petey, but the following question at least addresses the possibility that it is not Petey. After another pause, Meg directly addresses Petey. Though we can infer that Meg is asking the same question as before, the question—"Petey?"— may be an entirely different type of question. Given that Meg and Petey had no lodgers since Stanley arrived, it seems as though there are very people who would be coming in the door of their house, other than Stanley or Petey, whom she knew was out, as she asked "Are you back?" It is possible that the question— "Petey?"—has more of a connotation of *Petey, why aren't you answering me?* or, metaphorically, *Petey, where are you?* This rings true when Petey answers, "What?" and Meg responds with, "Is that you?" as Meg no longer needs to be personal once she hears his voice, which gives her the satisfaction not only that Petey exists, but that Meg exists as his wife.

In a sense, Meg's initial three questions went from an objective question to a subjective question: from fact-gathering to sentiment-seeking. Meg subconsciously became more and more interested in verifying that Petey, her husband, is a metaphorical reality. In this regard, we can hypothesize that once Meg became more certain that the noise did, in fact, come from Petey, she needed to hear that he metaphorically existed, which would at least make her a "wife" within the silence of the house. Her pronouncement— "Petey?"—was not for him, but for her.

The question—"is that you?"[30]—is a curious question to be repeated so many times and inserted in such a prominent place in the play (i.e., right at the beginning). As an intransitive verb, to be, "is" cannot take an object. There are two observations about this: 1) it is even more meaningful that Petey answers colloquially: "Yes, it's me" rather than the awkward-but-grammatically-correctly, *Yes, it is I,* and 2) it is also significant that "is it you?" is absent, but implied in the third question, "Petey?" while "Petey" is absent when the question is stated again for the fourth time.

The first observation is that Petey uses a contraction of the intransitive verb, to be, minimizing the emphasis of the state or action of *being* and the impossibility that *being* can take an object. This is highlighted by the use of the *objective case*, "me," even though it is accepted speech. Petey— linguistically, philosophically, and metaphorically—calls himself an *object*, rather than *being a subject.* To think of oneself as a metaphorical grammatical object, Petey cannot "be." In one sense, the world acts on Petey, rather than him being in the world. In another sense, Meg acts upon Petey, in that in "interrogating" Petey's presence and identity she metaphorically positions Petey as an object: Meg (subject) interrogates (transitive verb) Petey (direct object). This metaphorical construction places Meg in the position of power

while Petey has no control over what is done to him. Like in a master-slave relationship, the master (Meg) continues his or her mastery because the slave (Petey) thinks of him or herself as a slave, as a literal and metaphorical object. A slave, as well, is made to think that he or she needs the master. A direct object, similarly, cannot exist without a subject and transitive verb. Petey—a direct object—needs Meg and her actions. Petey literally and metaphorically needs Meg to exist (for sustenance and *being*), but like in a master-slave relationship, Meg needs Petey and Petey's dependence on her to prove to herself that she exists and is worthy.

The second observation—the swing from a personal to impersonal question, from "Petey?" to "Is that you?"—also has to do with Petey's identity (both from Petey and Meg's perspective). The question—"Petey?"—is the most personal of the four questions. Meg is naming, literally, what she is literally and metaphorically looking for. As Meg's questions hone in on a more specific object of her desire (Petey), Petey responds only when the question is meant specifically for Petey. However, Petey's responds with—"What?"—either 1) a non-human interrogative pronoun, or 2) an interrogative determiner. In other words, 1) Petey's understands "Petey" as a non-human entity (which shows he thinks quite little of himself and/or has little awareness of himself as an individual/human); or 2) Petey, in order to establish the referent, is asking, not for adjectives that describe the attributes of the proper noun, but for the context (e.g., number, location, quantity, etc.). In this second sense, Petey's context is created in relation to Meg. The follow-up question—"Is that you?"—shows that Meg subconsciously recognizes Petey's inability to respond as a unique subject.

When Petey responds with, "Yes, it's me," Meg responds with her own, "What?" In the sense of "What?" being a non-human interrogative pronoun or an interrogative determiner, the fact that Meg does not understand Petey's casual response, which is understood to mean, *yes, it is I, Petey,* further demonstrates the fact that neither Meg nor Petey think of Petey as a unique subject.

After Meg asks Petey, "Are you back?" the simple affirmation by Petey, "Yes," explains the point of the above linguistic exercise. Affirmation is all that was metaphorically needed by Meg. Once Petey establishes his presence (both literal and metaphorical) by affirming that he is back, Meg metaphorically feels secure and responds, "I've got your cornflakes ready." The affirmative "yes" enables Meg to metaphorically understand the objects that she *does* have (which is her husband, Petey, or Petey's cornflakes, or the ability to prepare Petey's cornflakes for him). The affirmation that Meg received here, told her that she is not alone and that her actions are not meaningless (even though Petey is an object and not a subject, in both of their eyes).

The Interrogation Scene

Dramatic realism can be defined, almost entirely, by the fourth wall. We, the audience, peer into the lives of characters, as they live them, as if the fourth wall of a room was simply removed and we get to peak in. Part of the work of the realistic dramatist is the mastery of exposition. Exposition is an ancient playwrighting technique that establishes the context of the characters, setting, time of play, etc. Playwrights, if they are good, can seamlessly insert important facts about the context to give the audience members their bearings without the dialogue sounding forced or contrived. If the playwright is inviting us into the living room of the Tyrones or the Wingfields, then we need to know why we are here and who these people are.

However, I believe the famous interrogation scene in *The Birthday Party* exposes the audience to a different type of a fourth wall that is commonly found in the plays characterized as absurd (and may even be the absurd's *most* defining characteristic): I describe this phenomena as jettisoning the exposition, or *entering and exiting the fourth wall of obscured intention*. In other words, Pinter (and the far-reaching implication is that this is what, I believe, the other "absurd" playwrights do, as well), decontextualizes the literal and figurative entrances and exits and, in doing so, decontextualizes each character's intentions. In a sense, we, as humans, in general, enter for a purpose and leave when either that purpose is fulfilled or we realize that the purpose cannot be fulfilled at that time. Pinter dramaticizes that the purpose of others is unknowable. Since, as other scholars have aptly observed, Pinter obfuscates the subtext, the audience is always unaware of the characters' purposes. So in a large sense, the comings and goings of the characters, both literally in space and place and in conversation, in particular, *seem* illogical/absurd since their actions seem to not have an observable purpose. We do not fully understand what is going on with the characters, but neither do they: in part, because the purpose of others is unknowable, but even more importantly, because on top of that, Pinter's characters do not know themselves.

We do not know why Stanley is there to begin with. And we certainly do not know exactly why Goldberg and McCann come and then why/where they are going. *The Birthday Party* literally has arc of Goldberg and McCann coming and going. Likewise in Pinter's *The Dumb Waiter* (another more obvious example), why are Gus and Ben there? why does Gus keep leaving to go to the bathroom? and how do we make sense of the comings and goings of the dumb waiter, itself? Both plays are the holding ground for the moments in between coming and going; that is where the tension abounds. In a sense, the stagnation of being in the room—Pinter's favorite

setting—only heightens the tension of coming and going. Besides the literal physical movement of entering and exiting in *The Birthday Party*, a look at three excerpts from this interrogation scene demonstrates the *linguistic comings and goings* of a typical "absurd" conversation.

First, the questions in the interrogation are frequently *non-sequitors*. In the passage below, the second two questions by Goldberg are in no way related to Goldberg's first question; McCann's question, as well, does not relate at all to the three previous questions:

> GOLDBERG: Why do you treat that young lady like a leper? She's not the leper, Webber!
> STANLEY: What the—
> GOLDBERG: What did you wear last week, Webber? Where do you keep your suits?
> MCCANN: Why did you leave the organization?[31]

These questions, in and of themselves, are totally logical questions. This is one fact that frequently gets lost in absurd drama. The absurdity, then, of these questions is, why are they introduced and where are these questions leading? In a sense, just like the audience does not have a real sense of why Goldberg and McCann physically come and go in this play, we have little sense of how Goldberg and McCann linguistically move in and out of a conversation.

Goldberg and McCann are not unable to have a logical responsive conversation. In the following excerpt, when Stanley's answer did not quite answer Goldberg's question, Goldberg and McCann adapted and responded to Stanley:

> GOLDBERG: Why did you stay?
> STANLEY: I had a headache!
> GOLDBERG: Did you take anything for it?
> STANLEY: Fruit salts!
> GOLDBERG: Enos or Andrews?
> STANLEY: En— An—
> GOLDBERG: Did you stir properly? Did they fizz?
> STANLEY. Now, now, wait, you—
> GOLDBERG: Did they fizz? Did they fizz or didn't they fizz?
> MCCANN: He doesn't know!
> GOLDBERG: You don't know. When did you least have a bath?
> STANLEY: I have one every—
> GOLDBERG: Don't lie.
> MCCANN: You betrayed the organization. I know him![32]

Goldberg and McCann follow up each question, at the beginning of this passage, with a more specific and logical follow-up question. It is only in the last two questions, that we lose our sense of how and why Goldberg and McCann are communicating with Stanley. Why leave the fruit salts conversation when they did? Did Goldberg and McCann get what they wanted out of their questions about fruit salts? Why did Goldberg, right at that moment, want to know when Stanley last had a bath? Why did McCann feel as though it was the time to reintroduce the fact about betraying the organization?

We may, however, get a metaphorical suggestion as to what Pinter is arguing in the following passage:

> GOLDBERG: Speak up Webber. Why did the chicken cross the road?
> STANLEY: He wanted to—he wanted to—he wanted to . . .
> MCCANN: He doesn't know!
> GOLDBERG: Why did the chicken cross the road?
> STANLEY: He wanted . . .
> MCCANN: He doesn't know. He doesn't know which came first!
> GOLDBERG: Which came first?
> MCCANN: Chicken? Egg? Which came first?
> GOLDBERG and MCCANN: Which came first? Which came first?
> Which came first?
> STANLEY *screams*.[33]

Stanley's scream is the last we hear from Stanley other than various types of grunts. In a sense, this question—which came first, the chicken or the egg?—is the metaphorical question *par excellence* of absurd theatre. We are confounded, like Stanley, because the question is the ultimate question of context and the impossibility of answering the question based upon the fact that we were not there. This is also the ultimate metaphorical question about life entering into the world.

I argue that Pinter in this interrogation scene suggests that we cannot know desire without context; we cannot know context without desire. In a sense, we can only, truly, know our own desires and our own contexts; we can only, truly, know ourselves. Pinter, here, suggests that because Stanley does not know himself, he is exposed to the obfuscated intentions of two outsiders.

Interrogation Out of Control:
The Birthday Party and the "Rape" Scene

After being "interrogated" by Goldberg and McCann, Stanley's birthday party begins. A birthday party is a time to celebrate a person, many times

with reflections. This birthday party is no exception. However, the delivery of the birthday party tells a lot about the characters and furthers the inter-rogation metaphor. And there are two notable things missing in this party: Stanley speaking and Petey.

More or less, the party begins with a toast that is engineered by Goldberg who ensures that everybody has a drink. Goldberg asks who wants to do the toast, but quickly he simply decides on Meg. Her response is, "But what do I say?"[34] This is the question that has plagued this Oedipal household. Because speaking subjectively about a person is not commonly practiced in the home, even though Meg desires this, she is lost and bound only to ques-tions. Goldberg has to tell her the obvious: "Say what you feel."[35] But before this is done, the spotlight literally turns to Stanley. Goldberg asks McCann to turn out the lights and "shine [a "torch"] on the birthday boy."[36] With the lights off, now, all eyes are him. However, given that he is totally silent, he cannot speak for himself and he becomes an object of someone else's percep-tion. Meg, who in her speech says she knows him "better than all the world," says, in effect, nothing about him other than he has lived in the house a while and has not left.[37] The occasion of this toast, normally as a time to reflect, yields simple objective facts.

As the party continues, it no longer seems like a birthday party. Stanley is told what to do by Goldberg and all talk about Stanley ends. Goldberg takes over the conversation once Lulu, a neighbor, arrives. Goldberg flirts with Lulu, who sits on his lap, as Goldberg stays the center of everybody's attention. Then they begin to play a game, Blind Man's Bluff. After Meg goes first, Stanley is directed to play. McCann takes Stanley's glasses and breaks them when Stanley, blindfolded, is taken across the stage. Stanley's toy drum, a gift from Meg for his birthday, is placed in front of Stanley, who trips over it. He rises, walking over to Meg with his foot still in the drum, and starts to strangle her. A blackout follows, with confusion all around. When the lighter is finally found and shone on the table, "LULU *is lying spread-eagled on the table*, STANLEY *bent over her*."[38]

In some ways, before Stanley "rapes" Lulu, he was metaphorically raped, himself. Stanley and his desires are, effectually, silenced by the interrogation and he is left powerless to speak up against Goldberg and McCann. This is doubled by the fact that Stanley literally replaces Petey in the home at the birthday party and as the subject/object of Meg's "toasting" (metaphori-cally). Once this actual replacement occurs, Stanley has both literally and metaphorically been rendered speechless, much in the same way that Petey was almost silent in the beginning of the play. Just as Meg never inquires about Petey's reticence, never investigates what appears to be a problem, Meg does not even seem to notice the fact that Stanley has not said one word during his own birthday party.

Furthermore, the toy drum serves as the metonymic paradox of the play. Stanley is both hindered and freed with the toy drum, as the drum is a child's toy, but it still gives him a voice, a beat, a way to play music, as he used to play the piano. In some ways, even though the gift was thoroughly childish, Meg giving Stanley a present on his birthday was the one kind, thoughtful act of the entire play. Something more than a toy drum is transferred with a birthday present. Usually, a present results in joy. For Stanley, when he got the drum earlier, his drumbeats became *"savage and possessed."*[39] It is as if Meg was finally truthful with Stanley and the present showed him that she thought he was a child and Stanley, now fully enraged by this understanding, becomes a child pounding away at a child's toy drum. Thus, when his one safe outlet of expression breaks, when the toy drum breaks, Stanley breaks.

Once Stanley breaks, Act III is more or less a forgone conclusion, considering how non-existent the "question voice" is in this *family*. Goldberg and McCann take Stanley away. Even though the audience has a sense that Petey is worried about Stanley, because of the unhealthy Pinteresque household that has developed, Petey lost his "questioning voice": either it was silenced (by Meg, Petey, or their relationship) or he lost his will in the face of apparent futility.

Meg's Play

The interrogation scene functions as a parable-within-the-larger-parable. The breakdown of communication, where objectifying trumps subjectifying, most obviously in the interrogation scene, yields unhealthy relationships. Because Petey only responds with simple objective statements, which cannot yield further conversation, Meg, who desires human interaction, just keeps asking subjective questions, hoping to spark a meaningful dialogue. Petey, who does not ask questions himself, kills each potential conversation. Therefore, each new question that Meg asks is an attempt to start another meaningful conversation. This creates an unbearable style and cycle of communication for both of them because Meg ends up appearing as though she is nagging Petey with so many questions. And the more questions she asks, because she needs some human interaction, the more terse Petey's answers become, because he feels as though he is being nagged. Because Meg is denied the opportunity for a meaningful exchange with her husband, Meg attempts the same thing with Stanley, trying to replace the role of her husband with a surrogate son. This creates a Pinteresque Oedipal household: the mother replaces the father with the son. But unlike *Oedipus Rex*, this cycle is not doomed by Fate. Pinter, instead, suggests that objective communication dooms relationships. If the mode of communication changes, then the relationships change.

However, there is another way altogether to arrive at a Pinteresque household that does not involve interrogation. This dynamic, instead, centers *entirely* around Meg. It can be argued that this is Meg's play. Meg starts the play; Meg ends the play. And it is Meg's actions or inactions that set the play in motion. After all, the birthday party itself only happens because Meg claims it is Stanley's birthday (even though Stanley says it is not). Stanley's range of possible actions, on the other hand, are meaningless because they could not have an affect on the action of the play: Stanley is surrounded and attacked by two more powerful (verbal) attackers. There was little, if anything, that Stanley could have done in this situation. He was outmanned and outgunned, in a sense.

This other line of inquiry—looking at the play as Meg's play—will suggestively play off another (albeit slightly later) seminal "absurd" play: Edward Albee's *Who's Afraid of Virginia Woolf?* (1962). I want to be clear that, in establishing this parallel, I am not in any way suggesting lines of influence. Though numerous differences apply, most notably the tone of the spousal relationship, both plays, arguably, examine the identity and self-identification of a *childless-wife*. In Albee's play, Martha clearly takes out her anger/sorrow on her husband, George (not to say that George does not fight fire with fire, himself). But Martha (still during the time of the play) finds *some* solace in having a made-up son. Eventually, that son is *killed off* so that the two can move on with *their* lives, with George comforting Martha at the end of the play. Very similar to this, in *The Birthday Party*, Meg appears unhappy and acts as if Stanley is her son. Stanley gets taken away (possibly to be killed, as the wheelbarrow suggests) and the two—Meg and Petey—are left at the end of the play with Petey comforting Meg. For the purposes of this chapter, as we are not going to compare and contrast the two plays, we can just state their basic similarities: an unhappy childless-wife has a bad relationship with her husband, mostly due to the fact that they are childless, and turns to a fake son to find comfort; the fake son is then symbolically *killed* and the husband is there at the end of the play to provide comfort. Stating the plots similarly, as above, is not to suggest that, necessarily, these plays are similar. However, I am suggesting that, although the dynamics of the two relationships are different, much of the psychology is shared between Martha and Meg. In other words, by establishing a parallel in two similar playwrights during similar periods of their careers, I am able to look at the psychology of the *archetypal childless-wife* in Pinter's *The Birthday Party*.

As I noted earlier, at the end of the section on "The Interrogation of Petey," Meg finds some self-worth in bringing Petey his cornflakes. Meg tells Petey, "I'll get his cornflakes," after the young-motherly and flirtatious jaunt

up the stairs to wake Petey (13–14). She acts like a young mother scolding her young child: "I'm coming up to fetch you if you don't come down! I'm coming up! I'm going to count three! One! Two! Three! I'm coming to get you!" (13). However, just seconds later, it is easy to read sexual innuendo into the following: "He's coming down. (*She is panting and arranges her hair.*)"[40] It is important that this confusion between son and lover is established at this point, for moments later, Meg asks Stanley a very similar question that she asks Petey: "What are the cornflakes like, Stan?"[41] Taking pleasure from affirmation, Meg asks Stanley a question that she knew would be affirmative and knew the answer to, or at least she thought. When Stanley responds, "Horrible," Meg just assumes that Stanley must be teasing her: "Those flakes? Those lovely flakes? You're a liar, a little liar…"[42] In this brief passage, Meg probes Stanley just like her husband Petey and then she also teases him like a "little" boy. It is Stanley's response, though, that metonymically sums up this alternative reading of the play: "The milk's off" or rather, *Meg's milk is off.*[43]

The metonym of Meg's spoiled milk establishes the theme of Meg being a childless-wife. More so than any formula, a mother's milk is the most nutritious for very young children. In a sense, Meg's spoiled milk provides metaphorically unhealthy sustenance to Stanley. But metaphorically offering Stanley her breast is unhealthy because neither Meg nor Stanley are in a healthy position to be lovers. Petey, when he tastes Meg's milk, does not notice anything wrong with it, or at least was too nice to say anything about it. But that makes sense, as Petey is her husband and there is nothing wrong with Petey metaphorically tasting Meg's milk, or receiving her breast. But at the same time, though, there is something wrong. If Meg's milk is, in fact, off, then why does Petey not say anything? Where is the "questioning voice"?

The key here is that Petey has no "questioning voice" because maybe Meg presents little to question. Though Beckett's Winnie in *Happy Days* can be seen to embrace life and the necessity to use reason to make life purposeful, maybe Willie also retreats because of Winnie's inability or unwillingness to look at life as it really exists: to feel, to question, to grieve. Winnie, if she let herself feel and grieve, could ask Willie for support, and in return Willie will feel as though his life and his help are meaningful. In *The Birthday Party*, like in *Who's Afraid of Virginia Woolf?*, neither Meg nor Martha admit to their husbands that they are sad. There is an unwillingness to be vulnerable in this regard: in Meg and Martha's eyes, how is a woman to define herself (assuming that woman wants a child)? But most importantly, how can they admit their feelings to their husbands when they cannot admit them to themselves.

Conclusion #1: A Pinteresque Oedipal Household

Pinter's trademark is the ever-present pauses and silence in his work. It is interesting to consider the metaphor of muteness in his first full-length play. The failure of speech, much like the archetypal failure of eyesight in *Oedipus Rex*, fills *The Birthday Party* with the failure of the senses. But just because one of the senses does not work, it does not mean that the play purports the senselessness of the human condition. Rather, the failure of speech only demonstrates the necessity of meaningful communication and the need for us to make sense of our situation.

The skewed Oedipal familial structure that Pinter intentionally or unintentionally riffs on plays off the greatest hopes and the greatest failures of the basic familial unit (mother, father, and child). A family begins, one must hope, with an unstated contract: parents are responsible for the care of their young. In one possible reading of *Oedipus Rex*, the disasters of the family were fated once the contract was originally broken: the abandonment of young Oedipus, left for dead. Though raised by the shepherd, symbolically, the absence of his parents lead to a violent revolt (which happened by chance and symbolically to be against the father, whose death opened up the tragic opportunity for Oedipus's ill-fated ascendancy of the throne). In traditional family units, there is another unspoken contract: the offspring take care of their parents when they get old. The initial broken contract in Oedipus's family lead to a perversion in the second contract: Oedipus *took care* of his parents (i.e., Oedipus *took care* of his father—killing him—and *took care* of his mother in a perversely sexual role).

In *The Birthday Party* the presumed inability or lack of desire to form a familial unit (with the birth of a child) metaphorically deconstructs the familial contract: Meg and Petey do not take care of their surrogate son, Stanley (who offered them a chance at familial satisfaction), and because of this there was no one to take care of Meg and Petey. In another sense, Meg and Pete could not take care of their young, Stanley, because they could not take care of themselves.

Conclusion #2: Fate and Existentialism

Two of the most important questions of the play that have not been addressed yet are McCann's question to Stanley, "Who are you, Webber?" and Goldberg's follow-up to that question, "What makes you think you exist?"[44] These are two of the great philosophical quandaries that existentialism, in particular, examines. Unlike the fate that exists in *Oedipus Rex*, these characters are not doomed to their fate. Pinter, I argue, asks the audience to

be okay with uncertainty and not knowing everything because not everything is knowable without a proper context, which we can never have since we are looking at the world through a subjective lens. I argue that Pinter suggests that the only thing we can know is ourselves, and that is what we can change, understand, and will make us happy.

But Pinter is *not* suggesting that we view the world in a phenomenologically existential manner. If Pinter was suggesting that we view these characters through a Sartrean existentialist lens, then Pinter would have to give us a sense of who these characters are by showing us what these characters did, and do, and will do in life. But facts are not stable in this play because humans and our nature are not stable. Without an omniscient being, nobody can define anybody after their life is complete and they are what they did, according to Sartrean existentialism, because full context and interior subjectivity (desires, worldviews, etc.), as Pinter suggests, are unknowable. The only thing we can know is what we interrogate; and most importantly, we must interrogate ourselves before someone does it for us. In a sense, Goldberg and McCann existentially try to define Stanley for him by what he did in the organization, presumably. But Pinter will not let Goldberg and McCann existentially define Stanley, as Petey's final words to Stanley suggest: "Stan, don't let them tell you what to do!"[45]

Doing is unimportant in this play, as facts and context (represented by seemingly illogical entrances and exists) are unknowable. It is *being*, and more importantly, understanding who you *are*, that Pinter cares about. The entrances and exits of the play are clear in what is important to Pinter as the play begins and ends, respectively, with the verb *to be*: "Is that you, Petey?"[46] and "I know I was."[47] Meg, unfortunately for the entire "family," much like Amanda Wingfield in Tennessee Williams's *The Glass Menagerie*, might define herself by her past, as she "was the belle of the ball,"[48] and is unsure of her present as the metaphorical interrogation of Petey's *being* can suggest. (And, like Amanda, given the uncertainty in this play, we have no way of knowing what is true.) The tragedy of the play, and the reason that Stanley is metaphorically victimized, is that every character must ask (especially Meg), not "Who are you?"—and this is the trap that the audience typically falls into in absurd drama (e.g., who are Goldberg and McCann and what do they want?), but the most important question, "Who am I?"

CHAPTER 3

The Parable of the White Clown: The *Use* of Ritual in Jean Genet's *The Blacks: A Clown Show*

Similarly to many of Jean Genet's plays, the plot of *The Blacks: A Clown Show* is a "complex hall of mirrors."[1] This play is made up of a series of three rituals: a funeral, a sacrifice, and a trial. A group of Negro actors re-enact the murder of a white woman for a *white* Court (black actors wearing white masks) in order for the *white* Court to pass judgment upon them, so the reasoning goes in the play. After the opening ritual of throwing flowers on the catafalque of the white woman who was murdered, behind the *scenes*, in reality (whatever that may actually be), a black traitor is tried and killed. The white Court passing judgment on the blacks is a cover-up to the blacks' own execution of a "traitor" to their own cause offstage. After the ultimate torture of their white oppressors, only two blacks are left on stage, Village and Virtue, who are in love. Martin Esslin sees this play as "entirely ritual" since he argues that "meaning is expressed by the repetition of symbolic action."[2] Esslin suggests that although the blacks have been denied "the dignity of man" and, thus, "the emotions of the real world," it is possible to establish genuine human contact through love" as Virtue and Village have literally turned their backs to illusion at the very end of the play.[3] I argue, instead, that Genet merely uses rituals in a subversive manner to create a parable on race relations and personal ethics.

This play is commonly read as a ritual. However, I am arguing that this *play* is not a ritual, but a parable. Genet, I contend, uses the rituals of sacrifice, funerals, and trials to create a parable about the absurd contradiction of desire: desire, even for the whites, cannot be met by the reality of the

situation that they, themselves, created. The tragedy of the play, and the reason for the continued absurdity of the situation, has to do with the failure of communication. As W. F. Sohlich says, the action of the play makes "communication between blacks and whites impossible."[4] However, it was the whites who created the situation. Thus, the ultimate failure is the failure of the whites to investigate themselves. It takes the blacks in the play to physically remove the white masks. The uncomfortable and metaphorically violent act of removing the white masks forces the whites to confront their own contradictions that they created.

In 1960, Wallace Fowlie characterized Jean Genet's play *The Blacks: A Clown Show* as a "parody of a ritualistic crime."[5] Genet's "theatre of ceremony," Fowlie argues, is comparable, in its high dramatic moment, to the Elevation in Catholic Mass.[6] Fowlie and Esslin's two early readings of *The Blacks* as incorporating ritual set a path for future scholars: most notably Richard C. Webb and Loren Kruger. I want to show, rather, how Genet uses "ritual" and turns the entire play into a parable. Whereas a ritual is something one should *believe* in, the significance of using rituals in this play is that the rituals in this play are rituals *for* someone else or others: they are performative in their self-awareness and artificiality. Ritual is used in this parable about colonialism to highlight the lack of self-awareness of the whites. Ultimately, I argue, Genet subverts the rituals in this play because he suggests their performative nature. And in doing so, the performative nature of the rituals makes the white audience (for this play is for a white audience) confront their own worldview.[7] Read as such, *The Blacks* becomes an ethical guide for *clowning* around. This move to Camusian ethics provides the play a language with which to talk about colonialism in a new way, but also to better understand how the paradoxical nature of the figure of a clown in this play encourages the audience to make meaning in their own lives.

Current criticism surrounding *The Blacks* has moved away from issues of ritual and has focused, instead, on issues of race. In "'What Exactly is Black?': Interrogating the Reality of Race in Jean Genet's *The Blacks*," Debby Thompson discusses the white gaze as a dialectical structure that has to be considered with issues of white guilt.[8] Understood this way, Thompson concludes that Genet suggests that race is not a given and that his purpose was not to understand blackness, but to dramatize, "whites' investment in the question of racial ontology. Most radically, he offers up a form in which to entertain white guilt."[9] Bénédicte Boisseron and Frieda Ekotto look at the "colour coatings" of the play and suggest that various layers of color coatings destabilize readings of the play.[10] They argue that the figure of the black "as a clown and an automaton" is central to *The Blacks*.[11]

Like Thompson, I believe that voyeurism is central to the participatory nature of the play, and, as Boisseron and Ekotto note, the figure of the clown is at the heart of the play. However, they argue that it is the figure of the black clown. I suggest, as no indication is made of the clown's race in the title, that the clown is, in fact, white. If we once again take seriously the nature of this play as a ritual and read it as a parable on race, we can connect the scholarship from the late 1970s to the early 1990s to the current scholarship of the early twenty-first century. This is an important scholarly move as these two main branches of scholarship on this play have never really been fused into one. Hence, I argue that Genet uses both ritual and conceptions of race to write a parable about understanding the racial dynamics at play in colonialism.

In order to make my argument that Genet uses ritual in a subversive manner to create a parable that forces whites to confront themselves, I have two tasks at hand. First, the play, written by Jean Genet, a homosexual and a thief who spent time in jail, was written at the time of the Algerian War and the Negritude movement. Thus, the play concerns itself with colonialism and being an insider and an outsider. Much attention has been given to the role of race, specifically blackness. However, given that the play is subtitled "A Clown Show" and no race is specified, I argue that it is the whites who are, in fact, the clowns of the play. Though no "clowns" are actually present in this play, I suggest, Genet ultimately argues that it is the whites who are metaphorically the clowns who have to hide their foolishness and self-disgust behind a mask. The task of this play is to both literally and figuratively remove the whites' "masks." Given the history of France's involvement in colonialism and the Algerian War, this article argues that if we understanding the figure of the white clown as a potentially ethical being and part of society, we can read the disasters of colonialism alongside idealism in *The Blacks*. In order to understand this historical and philosophical moment of the play, I turn to theories of colonialism (Edward Said and Homi Bhabha) and revolt (Franz Fanon, Sartre and, ultimately, Camus) to show how the text, through Camus, can be read as a parable that forces the audience to confront its worldview.

Second, once I develop my theoretical frame around the revolt posed by Camus, I examine Webbs's understanding of ritual in *The Blacks* to establish how the play has been understood as a ritual. Given that Camus's understanding of revolt is an internal one, I show how the rituals, in this play, have performative natures that, ultimately, subvert the impact of the ritual. In order to demonstrate the performative nature of the play, I look at two specific instances of *performance* within the play: the first line of the play, "Ladies and Gentleman...," and the laying of flowers on the catafalque to

illustrate the way in which the idea of the performative nature of the play undercuts any attempt at ritual. Making the audience aware of the artificial nature of the play forces the audience, much like in a Brecht play, to try to make sense of the contradictions presented. From there, I demonstrate how Genet used rituals and turned the entire play into a parable by looking individually at the three "rituals" found in the play: the sacrifice, the funeral, and the trial. After offering a conclusion on the significance of the white clown, I turn to Peter Stein's production of *The Blacks* to offer some further final thoughts.

Unlike in ritual, which generally reinforces societal norms, *The Blacks*, as a parable, forces the audience to confront the Camusian absurdity of race relations, where peoples' desires are constantly thwarted by the realities of the world. Faced with the horrors of this contradiction, the audience must find a way to make life meaningful despite this absurd situation. By trying to make sense of the figure of the white clown, I argue, we learn how to laugh in our Camusian call to contemplation.

Genet, Camus, and the Algerian War

In a Foucauldian examination, Edward Said argues that the "Orient" is a discourse with cultural institutions and an ideology that was almost invented by the Europeans for the Europeans to rule their colonies.[12] Said says Orientalism was a "Western style for dominating, restructuring, and having authority over the Orient."[13] Though Said's *Orientalism* was important in starting the conversation on the conversation, it was through Homi Bhabha's work that colonialism was more fully explained. Bhabha argues that the relationship between the colonizer and the colonized is not just a simple top-down power relationship. The master-slave relationship is an ambivalent one. Bhabha explains the process of identification/misidentification between the two:

> Both colonizer and colonized are in a process of miscognition where each point of identification is always a partial and double repetition of the *otherness* of the self—democrat and despot, individual *and* servant, native and child.[14]

This process of identification happened fallaciously through orientalism on one hand and on the (mis)understanding of authority on the other. For the colonizer, two questions emerge:1) *"Tell us why you, the native, are there"*;[15] 2) *"Tell us why we are here."*[16] Orientalism becomes a discourse to answer both of these questions. The task of the colonizer—to spread civility and

learning—is somewhat of a self-reflexive task. In their, as they see it, uplifting of a downtrodden people, they will make themselves better people. The more that they uncover about the colonized, the more they uncover about themselves.

However, in this play, the whites are unable to uncover their masks: it is the blacks who do it for them, as it is the blacks who are the actors in the play. The failure in this play is the inability for self-reflection of the whites. Though, the whites are good at creating a discourse, a nostalgic idea, about the blacks, progress cannot be made, because of a lack of self-reflection. Thus, the task of forcing self-reflection is left up to Genet. Genet creates a play where not only do the blacks have to destroy one of their own, but the "whites" end up dead, as well. Literally and figuratively, the failure to contemplate their absurd situation leads to a cycle of violence.

Since this is a violent play, it is important to note that violence was in the minds of French intellectuals and college students, in particular, as the Negritude movement picked up and the French were involved with the Algerian War. While Frantz Fanon might appear to be natural philosopher to turn to continue the conversation on colonialism, Fanon's call to political action does not fit in with Genet's sensibility of the theatre. As Una Chaudhuri aptly argues, "Genet creates a politics of theatre—as opposed to politics in theater."[17] Plus, *The Blacks* premiered in 1959,while *The Wretched of the Earth* came out in 1961 (therefore Fanon could not have influenced Genet). A preface by Sartre in *The Wretched of the Earth* underscores the need to turn analysis into political action. Furthermore, where Sohlich says that Fanon is appropriate to understand the play because the ritualistic act of murder nigrifies themselves to earn the demeaning label of savages,[18] this does not take into account the *self-aware choice* that the blacks had and that the murder only helped further their own cause. The blacks in this play used the label of *savage* to their advantage as a means to an end.

A more appropriate philosopher to turn to is Camus. Sartre and Camus had a great public debate, especially, over the question of the Algerian War. One year after the publication of Camus's *The Rebel*, with Camus simultaneously becoming more and more reticent about the political situation in Algeria, Sartre publicly sided with the French Communist Party. And then in 1956, Sartre broke with the party following its support of the Soviet invasion of Hungary, which led to Sartre becoming an even more anti-colonial radical.[19] Camus, though seemingly legitimately faulted for his paternalism over Algeria and his inability to imagine an independent Algerian state, preferred to resist all political orthodoxies.[20]

Similar to Camus, though admittedly Genet supported the Algerians somewhat unlike Camus, Genet did not align himself with particular

political movements. Though David Bradby can read politics in Genet's work in an article about Genet and the Algerian War, Bradby clearly reminds the reader that Genet consistently resisted any attempt to read him as a political writer, especially a political playwright. Bradby writes, "... [Genet] claims that theatre should not attempt to resolve problems that belong to politics, he was even more insistent that his dramatic work had no positive or constructive function in the political domain."[21] Like for Camus, I argue that Genet's revolt was not a political one, but an internal one.[22] For Camus, colonialism and the like were merely images of the absurdity of "oppression in any garb."[23] For Bradby, Genet's characters in *The Blacks* do not ever represent the reality of colonialism, etc., but only the image, as they are "reflections of the images of these things in the minds of the audience."[24] In effect, then, the only reality that Genet portrayed was the reality of discourse in the audience's head. Genet's revolt, the self-confrontation that Genet forced, began with accepting the presence of the prevailing discourses. Genet does not rebel, per se, but tries to undo the power of the threat by symbolically removing the "masks" of the whites. In this way, Genet uses theatre only as a means to, as Chaudhuri states, "dispense with a preexisting belief system."[25] Viewed in such a manner, Genet simultaneously accepts and refuses the presence of absurd colonial discourse.

Similarly—much like the necessity to accept one's absurd situation in order to revolt against it through contemplation and defiance—in Camus's *The Rebel*, humans both accept and refuse a threat, in that they set their own limits of rebellion to ensure that the rebellion does not undermine its own cause and ensuring that the threat does not sweep away the rebellion.[26] Sohlich argues that, in the act of murder, "the perpetrator chooses by his act to refuse the label of negro and become a terrorizing nigger."[27] However, the "true" action of the play is the execution of a "traitor" to the black cause. In this sense, the "refusal" is not of a label, but a refusal to let their rebellion die. In choosing this refusal, the blacks accept the reality of the situation (i.e., the whites think the blacks are savages) and use that reality to further their own cause, their rebellion. As we will see from the play, the blacks perform a guarded rebellion. Their rituals in front of the white Court are a mere diversion for a very serious trial of a traitor to their own cause. And they do not kill the whites, but kill the white "masks," in that they kill the "masks" that have been literally placed upon their heads through colonial discourse and language. With the masks on, the whites are clowns. The removal of the masks forces the whites to confront themselves and the situation that they created.

The Use of Ritual in The Blacks: *The Move toward Performance*

In order to begin my examination of the play and, ultimately, show how Genet uses ritual in this play to write a parable, we must first show how the play has been understood as ritual. In his article "Ritual, Theatre, and Jean Genet's *The Blacks*," Webb, in 1979, contends that although numerous scholars have associated Genet's theatre with ritual, the word *ritual* had various meanings for them. Webb grouped these readings into seven categories: ritual as repetition, ritual as formality, ritual as access to a superior mode of existence, ritual as make-believe or game, ritual as contained revolt, ritual as psychotic phenomenon, and ritual as aesthetic category or dramatic style.[28] Without referring to leading scholarship on "ritual," the works of these past scholars were imprecise. Webb looks to anthropology and sociology to foreground his analysis of ritual.

Webb explains that the difference between ritual and theatre is a difference between "manifestation and mimesis."[29] Ritual is about *actualizing* a god, a spirit, etc., in the body of the actor: "In this sense, something *happens*."[30] On the other hand, there is something *fictitious* about theatre: an actor *represents* a character. This dichotomy can be furthered when the participants and audiences of both events is taken into account: "The participant at this ritual *believes* whereas the spectator at the theatrical performance 'suspends his disbelief.' "[31] These dichotomies are at play at all times in *The Blacks*.

It is exactly because that there is a dichotomy between belief and suspension of disbelief that the "rituals" in this play are not rituals. The rituals that we see in this play are done not for oneself, but for the sake of others. That is why, ironically, the sacrifice, the funeral, and the trial are in this play. Genet highlights the performative nature of each of these "rituals" in order to undermine their power. Instead, Genet shows how these rituals are simply a means to make an audience feel better about themselves.

The performative nature of the play increases its power of confrontation toward and for the audience. For Kruger, the ritual existent in the play causes the audience to re-examine itself by understanding that they, themselves, are the subject of the parody. This move to disorder and self-analysis and confrontation fit much more with the genre of parable than that of ritual. Kruger sums up the play as follows:

What Genet does is to repoliticise the myth. He does this by using familiar white ritual—which the audience takes for granted to communicate

(black) concepts opposed to the ritual's original significance and so to transform it into a counter-ritual.[32]

Kruger identifies the play's almost-carnivalesque reappropriation of white power, and in doing this, repoliticizes the myth of "justice." This "counter-ritual," as Kruger calls it, deconstructs the safety of the original significance of the ritual. The ritual becomes weapon like and destructive by "challenging audience preconceptions."[33] This move to self-confrontation echoes Kirkwood's pronouncement of what a parable accomplishes.

Not only do these rituals make the audience confront their own world-views because of their performative nature, but these rituals also create conflict and contradiction rather than solving them. This structural mode is in line with parables rather than rituals. Webb explains that the basic structural mode of the play is at odds with the general movement found in ritual as defined by Claude Lévi-Strauss and Émile Durkheim. Whereas ritual is generally *conjonctif* for Lévi-Strauss and cohesive for Durkheim, *The Blacks* is *disjonctif* and divisive:

> The action of the play does not aim to resolve the conflicts of the initial situation; rather, it tends to exacerbate them. It may create unity among the acting company on the one hand, and perhaps some group identity for the spectators on the other, but the performance does not draw these two groups together.[34]

The movement from order to disorder is at the heart of this play, which is also at the heart of the parable for Crossan. The metaphorical judgment of a ritual murder moves toward disorder and forces the audience to confront their own values and then come up with a "verdict," as the word is so appropriate for a dramatic *trial*.

Not only is there an actual trial in the play, but the very idea of being on trial, but more importantly, weighing the absurd situation, becomes metaphoric for the entire play. Somebody being put on trial is a liminal rite of passage, in a sense. As Gene A. Plunka suggests, the rituals in *The Blacks* are structured as liminal rites of passage.[35] The isolation, degradation, and self-abasement that an individual goes through helps the neophyte return to a social structure with new experiences that will revitalize oneself and the community at large.[36] As Plunka quotes Victor Turner, "Liminality may be partly described as a stage of reflection."[37] This "state of transition" affords individuals pathways to create bonds that are not dictated by societal norms.[38] Plunka describes this change for the characters in the play:

The blacks engage in self-immolation and humiliation. As Victor Turner has discussed, the celebrant can be born anew only through degradation, hatred, and shame. The blacks learn to relish stereotyped attitudes that whites have of them and become childish, violent, primitive murderers succumbing to an overwhelming sex drive. Thus, the blacks want to be judged by the white Court, which will deem them to be criminals, thereby accentuating their negritude. By sharing their guilt, the black performers develop communitas, which provides the impetus for the next phase of ritual, the violation of traditional norms. The blacks subsequently degrade, mock, then finally annihilate the white Court and all remnants of the dominant order...At the conclusion of the ceremony, the blacks move our of liminality to aggregation where they develop their own sense of Being. Dispossessing themselves from white authority and power, the blacks establish their own identities and begin to make their own judgments, which are manifested by the offstage trial of a black traitor.[39]

The move toward self-confrontation literally takes place in the need to strike a verdict for one of their own. The blacks are confronted by a worldview, the "stereotyped attitudes that the whites have of them," and the enactment of the verdict is their way of dismantling this worldview. The need for judgment, which we can also call interpretation, forces each character to take on the metaphor of the trial. Liminal rites of passage become, here, enacted and performed.

However, it is the whites who are, ultimately, on trial and they are the one's going through the liminal rites. From Genet's notes, if there is a black audience and only one white person is in the audience, then the spotlight must be shown on him or her, the "symbolic white."[40] Going even further, into the realm of humiliation, if there are no whites and the blacks refuse to wear white masks given out as they enter the theatre, then "let a dummy be used."[41]

The Play

Archibald, the M.C. of the evening, speaks directly *to* the audience throughout the performance, highlighting the nature of artificiality in the play. There is a Brechtian, performative disconnect happening here:

> We embellish ourselves so as to please you. You are white. And spectators. This evening we shall perform for you...[42]

The play becomes self-aware of its nature of performing *for* someone. There is a movement back and forth between a suspension of disbelief and a straight-on awareness that this *is* a play. We are told, in one instance, that the love between Virtue and Village is real. In the very first line of the play, on the other hand, there is a call to the audience: "Ladies and gentlemen..."[43] This recalls both the master of ceremonies at a circus ("ladies and gentlemen, what you are about to see...") and an attorney's speech to a jury ("ladies and gentlemen of the jury..."). This cross-hybridization of a circus and a courtroom shows the mercurial nature of language and its "absurd" nature for signifying two very opposite things. Language and, therefore, the believability of the play, get questioned in this opening call to the spectators: Archibald signals that they will make "communication impossible."[44] Two readings come out of this hybridization. 1) The law is like a circus; spectacle, danger, and laughs dominate. 2) The circus takes on a legal nature; there is order in spectacle, danger, and laughing and our society resembles this property.

This tension of meaning and the self-awareness of performance only heighten the fact that there exists an audience and in this play, as Webb and many other scholars argue, the audience is under attack. Webb calls *The Blacks* a "ritual of outrage" because the audience tends to reaffirm its own values when faced with such an attack.[45] Webb looks to a letter Genet wrote to his publisher where he said, "All that would be necessary would be to discover—or to create—the common Enemy."[46] Webb sees the play as the enemy and the audience becomes the threatened community. Loren Kruger agrees: "...ritual becomes a weapon used against the audience."[47] Explaining that ritual is usually reassuring, Kruger's comment shows how Genet's use of ritual departs from its traditional use. I will discuss the three rituals in detail.

The Funeral

The opening stage directions set the ritual into action. Three Negroes in evening clothes and Newport News in a woolen sweater and barefoot dance with four Negresses in front of a catafalque to a minuet by Mozart. What is important here is that the dresses, "suggest fake elegance, the very height of bad taste."[48] The mourning ritual is enacted with the glory of Mozart, but with the fakeness of "costume" dress.[49] The "costume" suggests an inherent insincerity in the ritual and that there is an audience that will suspend their belief. The ritual is made more complicated by the fact that each character takes a flower and lays it down at the catafalque. This is done to both honor the dead and make the giver feel better about him or herself, as the dead will

never be around to appreciate it. But this gesture is wrapped up in appearances, as well. During the opening stage directions, a suspension of disbelief exists. One would assume, for the characters, that there is some genuineness to the act of laying down flowers. But as soon as Archibald addresses the audiences directly, the suspension of disbelief has been withdrawn and the audience questions whether or not they laid down flowers for our benefit, to *show* sadness (for whom at a funeral would want to be the one without flowers?):

> BOBO: The flowers, the flowers! Don't touch them!
> SNOW (taking an iris for her bodice): Are they yours, or the murdered
> woman's?
> BOBO: They're there for the performance...[50]

Genet makes the audience aware that they are an integral part of the ritual. This brings us back to the point that Webb made. There is a constant juxtaposition in belief and disbelief: thus, the performative aspect prevails.

What heightens the performative power of the funeral ritual is that we later find out that the catafalque is empty. This suggests that it is even possible that the black perpetrator did not even kill the white woman in the first place, but that the catafalque is merely 1) a fabricated diversion so that the blacks could distract the white Court in order to further the cause of their own rebellion by killing a "traitor" and, 2) a symbol for how this *play and performance* kill the oppressor.

The Sacrifice

The sacrifice, the re-enactment of the murder of the white woman in the catafalque, is marked most especially by the self-awareness of its setup: the sacrifice is performative in that the sacrifice is neither a ritual which is believed in nor a "play" where there is a suspension of disbelief. The audience sees Village, the perpetrator, not only as an actor in this re-enactment, but as a director, as well. Village is self-aware of both the impact of his performance and how he and the other blacks are viewed by the whites:

> ...Now that she's dead, do you want me to open the coffin and repeat what I did with her when she was alive? You realize I'm supposed to re-enact it. I need a straight-man. This evening, I'm going through the whole thing. This evening, I'm giving a farewell performance. Who'll help me? Who? After all, it doesn't much matter who. As everyone knows, the Whites can hardly distinguish one Negro from another.[51]

In this speech, the audience sees the inner workings and the philosophy behind the re-enactment of the murder, which alerts us to the artificiality of the forthcoming re-enactment. The verisimilitude of the re-enactment is immediately thrown into question as Village suggests that any black can play any of the parts as the whites would not be able to tell the difference. Once this is established, then Village's role, as well, could be played by any of the black actors. Therefore, the "farewell performance" is not a farewell performance for Village, but it becomes a farewell performance for the *black savage*.

The Trial

The Court in this play is utterly ineffective. It is the blacks who must try one of their own. Part of the ineffectiveness of the white Court is the fact that they cannot keep up a normal conversation. Their speech is marked by random outbursts that lead the trial nowhere. One reading of this can be that a white Court cannot understand and make sense of a black crime. They are too far removed from the situation of the black. All of their comments seem random in that they are nonsensical because they are so disengaged from the blacks' reality. Another reading can be that the trial is the ritual and it is ineffectual because all of the parties involved *believe*, to go back to Webb's analysis of ritual, that justice is impossible for the blacks. The ritual is the embodiment of the ineffectual. Reliving an ineffectual trial is the degradation that educates those involved in it.

The madness of the stage is so convoluted and the whites are so seemingly disorganized that a formal trial never really takes place. This suggests two almost opposite things. 1) The whites are ineffectual. 2) Trials are circus-like events for blacks, as justice is an imaginary construct if one is black. Throughout the play and during the trial, it is the whites who are utterly ineffectual at communicating, most especially with themselves. The whites of this play speak mostly through off-subject interjections. Not only does this suggest that the whites cannot formulate answers (to the problems), but it also suggests that the whites either have no desire and/or do not have the ability to listen. Meaningful communication and the resulting practical resolutions are impossible when conversation is conducted in such a manner.

The Trial of the White Clown

In the play's movement toward judgment and verdict, the liminal state of transition oscillates between the carnivalesque poles of royalty and

clownery. Plunka argues that, "The black performers gradually substitute royalty for clownery."[52] What is important here is that this ascension came out of *play*. As Johan Huizinga so famously said in *Homo Ludens*, "All play means something."[53] The clown becomes the metaphor of self-defacing play. Clownery is liminal, and as such, play—in *The Blacks*—becomes something public and performative: *transformation* is enacted and realized in front of, first, the Court and, then, the audience.

The figure of the clown recalls the metonymic paradox of the play. Boisseron and Ekotto argue that the clown is central to the meaning of the play and exposes the "mixture of fear and laughter"[54] that the clown paradoxically evokes: "In Genet's play, being white or black is not funny."[55] What is so telling about this quote is that the role of the clown is a public one and that laughter, and fear, too, are meant to be had by an audience. The self-confrontation of the blacks only makes the audience turn inside that much more. The audience has to ask oneself, am I to laugh or to cringe?

To answer that question the audience must also ask, am I part of the play? Genet wrote the "audience" into the play:

> This play, written, I repeat, by a white man, is intended for a white audience, but if, which is unlikely, it is ever performed before a black audience, then a white person, male or female, should be invited every evening. The organizer of the show should welcome him formally, dress him in ceremonial costume and lead him to his seat, preferably in the front row of the orchestra. The actors will play for him. A spotlight should be focused upon the symbolic white throughout the performance.
>
> But what if no white person accepted? Then let white masks be distributed to the black spectators as they enter the theater. And if the blacks refuse the masks, then let a dummy be used.[56]

Derek F. Connon says simply, "…the audience finds itself playing an 'audience.' "[57] Chaudhuri explains what the (white) audience has at stake:

> In *The Blacks*, the audience is constantly reminded of an aspect of its "personhood" that it considers irrelevant to its role as spectator, an attribute of its personal identity which it usually thinks it has left behind at home: its Whiteness.[58]

Just as Carl Lavery says that, "The spectator must question the reasons for the sham spectacle," and discover that "…the Negro's identity is not his own: it is a construct, a European fantasy,"[59] the audience becomes aware

that its own (white) identity is a construct, as well. With this learning curve, Chaudhuri argues that the mode of the play shifts:

> Its metacommunicative message (or "frame," to use Goffman's term) changes from the initial "This is play" to an intermediary "Is this play?" to a final "This is *not* play—this is a serious political confrontation."[60]

Public play becomes a public and private self-confrontation.

The question that this plays ultimately asks, though, is "How is one to act in a paradoxical world?" The paradoxical world is represented as "a clown show." Race becomes something simultaneously to fear and to laugh at. But clown shows are defined by their silence. In a world of pantomime, the "absurdity" of the play is its insistence on the impossibility of communication: specifically, although not stated, the impossibility for whites and blacks to communicate with one another. What becomes ironic, then, is that clowns are very good communicators. They are expressive. The "clowns" in this play are twofold. First, the blacks are the performers there to entertain the white audience. This would suggest that it is the blacks who are the metaphoric clowns. However, I contend that it is the "whites" who are the clowns. Because of their masks, they have one "face" just like a clown. Their speech makes them nonsensical, so that one must read their body language and actions as one would read a mime. And they are ultimately the ones we are to laugh at, but also to fear. Clowns incite laughter because they are constantly on the verge of catastrophe. The true catastrophe here is that the whites cannot or choose not to enter into any dialogue with the blacks. Since the trial cannot be judged by a Court, the blacks must destroy one of their own. In killing a person for every show, the blacks must condemn their own race over and over. Whereas most read the play as a ritual that becomes a performance, it is also true that the performance becomes a ritual in its cathartic murder-punishment loop of self-destruction for the black race. This ritual becomes a didactic metaphor in the fact that a continued expectation of black savageness will produce black savages, which in turn hurt not only the white race, but cause a need for self-purgation and self-destruction of that harmful element in the black society. The paradox of the play, the idea that a clown incites both fear and laughter, turns language into silence and silence into language. The audience must walk away from the play and interpret the behavior of a clown and ask him or herself, "What can I learn from a clown?" *Clowning around* is the key to our survival, in our need to laugh, and a recipe for near catastrophe. The play becomes a commentary of clowning around in our contemporary, race-conscious world.

If we understand the clown in *The Blacks* as black, then we look to the subversive nature of clowning and we align the clown with the resistance of the colonized. As I said elsewhere, it is the body of the clown that becomes the focal point and not the speech. We focus on their makeup and actions. And it is in their action that the clowns grow and renew themselves. "Clowns operate through degradation, but also by overcoming degradation until they do it correctly…In the face of degradation, clowns triumph over folly."[61] Mikhail Bhaktin speaks to the rebirth following degradation:

> Degradation digs a bodily grave for a new birth; it has not only a destructive, negative aspect, but also a regenerating one. To degrade an object does not imply merely hurling it into the void of nonexistence, into absolute destruction, but to hurl it down to the reproductive lower stratum, the zone in which conception and a new birth take place. Grotesque realism knows no other lower level; it is the fruitful earth and the womb. It is always conceiving.[62]

However, in *The Blacks* the clown is white. The clown's routine is marked by its unevenness and otherness. Simultaneous unlearned and haughty, the clown is in the continual process of teaching and self-betterment.

Clowns get into relationships with either someone more *civil* or someone even more foolish then themselves, but always marked by their otherness. The coming together of unequal parts creates a social situation where the clown can thrive. Unevenness springing from an unequal hybridity, then, is the clown's hetertopia. Tobin Siebers imagines the borderland as a heterotopic place: "The borderland is, of course, heterotopian in its desire to assemble people and things that do not normally go together, while it is fetishistic in its claim to satisfy the most divergent desires."[63] A colonial nation is a dystopic borderland, while postmodern utopia is heterotopic in its gathering of difference creating borderlands of hybridity. However, for the clown, their happiness and comfort in their relationships is predicated on being either the *civilized* or the *uncivilized*: always uneven, but always the *other*.

Some Final Thoughts: The Blacks *in Production*

I want to look at a production of *The Blacks* to conclude my investigation into how the performative nature of the play creates a parable to uncover the whites' masks. David Bradby, in "Blacking Up—Three Productions by Peter Stein," discusses Stein's 1983 production of *The Blacks* at the Schaubühne. Bradby writes that the production was a straightforward interpretation of the text, however, it had three departures. 1) Because the cast was white, the play

began with the audience witnessing the characters in the process of blacking up.[64] 2) Instead of having the sound of firecrackers offstage when Ville de St. Nazaire re-enters to announce the execution of the traitor, "Stein provided a complete firework show which dazzlingly filled the whole stage space and led into a mood of common celebration."[65] 3) The production ended "with the display of an enormous map of Africa divided into those territories that are independent and those still under the colonial heel. In front of this, the cast performed not a Mozart minuet (as in Genet's stage direction) but an aggressive dance to African drums."[66] Bradby explains what went wrong in the production: "The mistake was not to suggest a political dimension but to misunderstand the force of the work's political thrust, presenting it as a call to action instead of a play of image and reflection."[67] There are two points worth making here: the first having to do with the blacking-up and the second having to do with the celebratory nature and call to arms—both points having to do with white clowns.

The process of blacking-up in front of the audience at the beginning of the show demonstrates the transparency of the theatre and the performative nature of the performance. This brings me to my last concept. Jon McKenzie argues in *Perform or Else: From Discipline to Performance* that the mode of power and knowledge of the twenty-first century is the mode of performance. Through a system of monitoring dispersed throughout and up and down a company, power and knowledge get regulated and proliferated through the mantra "perform—or else."[68] The "or else" is "you're fired!"[69] The world that Stein and Genet imagine is a world of performance. This world, however, has very significant consequences. The motto of white clown to themselves and to the blacks is "perform—or else." For the white clown, there is failure and a possible bump in the head as clowns tend to fall if they do not "perform." For the blacks, the situation is that much worse. The blacks are judged by the clowns if they do not "perform" (both entertain and live by the white clowns' teachings). However, judging by the incompetence of white clowns, who wants to let them judge what is good and what is bad? Thus, the only thing to do in regards to "performance" is maybe go back to what Bhaktin says: subvert and laugh at the utter *absurdity* of the white clown.

The final point has to do with the fireworks. The fireworks are offstage because they exist in that other reality, the fake "real" one created by a group of actors. The celebration can never be had in our reality, or even our portrayal of reality (the play). It has to be relegated to the imagination of a play because as long as the white clown exists, ethics is put into a quandary. And without ethics, where do we turn for guidance? The call to arms is not a call to end colonialism, but a call to explore a parable, a call to turn inward to

the self, explore our absurd situation, and ask what is ethical? This is a coming out party for heterotopia. The coming together of different ethics poses threat to relativism. Black and white clowns coming together do not jibe in a relativistic world. As Herbert Blau says, we have one of two choices: we have the ambivalence of faith and/or laughter.[70] The clowns invoke menace, but in their tying to making sense of their "orderly disorder," to quote William W. Demastes, and our parallel attempt, we must, ultimately laugh to make progress, however temporal or nonlinear it may be.[71]

CHAPTER 4

Berenger, The Sisyphean Hero

The plot of Eugene Ionesco's *Rhinoceros* is as simple as can be: one by one, the townspeople of a small French village turn into rhinos and only one man, Berenger, remains human at the end of the play. Maybe because of the simplicity of the plot, scholars have, generally, equally understood the play in the terms of a simple parable condemning totalitarian regimes and trumpeting the individual. Martin Esslin, to his credit, complicated this reading by discussing the absurd stalemate that plagues humanity—the contrasting desires between individuality and conformity—by highlighting Berenger's ambivalence at the end of the play about whether he wants to turn into a rhino or remain a human.[1] I think Esslin was on to something in his idea of ambivalence, but his understanding of absurdity limited all meaning-making readings. Rather than ambivalence, I think the idea of ambiguity (which I discuss in detail in dealing with the title) complicates the play in a much more profound way.

Rhinoceros has a history of being read as a parable. In his article "New Plays of Ionesco and Genet" in 1960, a year after the play was first produced, Wallace Fowlie begins by saying, "The parable of Eugene Ionesco's new play, *Le Rhinoceros*, is simple and obvious."[2] Complicating this notion slightly, Fowlie discusses Berenger's refusal to submit to collective mania: "The parable is on the sacred individuality of man."[3] Defining a parable as "a story which teaches," he claims that this play will have a far wider public than previous plays. Fowlie captures the mostly agreed-upon meaning of the play and, interestingly enough, prophetically predicts the play's success based on its parabolic nature. True, it does teach, but by its nature, the lessons in a parable are not "simple and obvious." The parable makes the audience work at finding meaning.

In "Ionesco's Political Itinerary," Emmanuel Jaquart describes some early writings of Ionesco before he gets into his analysis of *Rhinoceros*, which ultimately concludes, also, that the play is a parable. Writing in "Expérience du théâtre" in 1958, Ionesco says that "plays that illustrate [some particular political attitudes] will die with the ideology that inspired them."[4] Jacquart argues that instead of working off of the temporariness of political themes, Ionesco had a belief in transhistoricism and the universal nature of humans. Ionesco, Jacquart contends, does not believe that theatre is an adequate form for conveying ideology.[5] Ionesco wrote, "Problem plays, *piéces à thèse*, are rough-hewn pieces of approximation. Drama in not the idiom for ideas. When it tries to become a vehicle for ideologies, all it can do is vulgarize them."[6] Because the theatre is bound to "formal laws," Jacquart explains, it can only simplify "systemic thinking."[7]

These words only intensified during a controversy that began on June 22, 1958. British critic Kenneth Tynan, who introduced Ionesco to the English public, changed his opinion and warned that the success of *The Chairs* was leading to a cult. Tynan argued that Ionesco only represented an escape from the likes of Osborne, Chekhov, Brecht, and Miller. Ionesco, Tynan observed, was regarded "as the gateway to the theater of the future, that bleak new world from which the humanist heresies of faith in logic and belief in man will forever be banished.[8] Upset at being even mentioned with the likes of the above dramatists, for they represented propaganda and *théâtre à thèse*, Ionesco shot back: "A work of art has nothing to do with doctrine."[9] The controversy continued until it ended with an unpublished letter from Ionesco to the paper where Tynan's comments first appeared. Jacquart explains how Ionesco thought society and art's purpose "is not equated with improving man's lot."[10]

Jacquart describes the whole situation as "puzzling" given that, at about the same time, Ionesco wrote *Rhinoceros*, a play with a "definite social content."[11] Jacquart argues that *Rhinoceros* and Ionesco's philosophy do not just support individualism, but serve "as a counterpoint to the preposterous remarks of the brainwashed villains and puppets"[12]:

> Jean flouts ethics: "*La morale! Parlons-en elle est belle la morale! Il faut épasser la morale.*"Yet, the founding of a code of ethics was no luxury in the history of mankind, but the very cornerstone of society... In this context, Jean's contempt for man and the past, and his will to break boundaries, are based on ignorance as much as on irrationality.[13]

Jacquart argues that Ionesco stands in stark contrast to this. Ionesco "holds on to time-honored values": democracy, "civilization," and the need for

warmth and freedom.[14] Taking into account the various interpretations of the past, Jacquart concludes, "In brief, without being an abstraction, *Rhinoceros* is a parable of sorts condemning all totalitarian regimes."[15]

When imagining a parable, however, one must imagine how a parable can"improve man's lot." Jacquart is ignoring the parable's didactic quality, a quality that Fowlie understood. David B. Parsell notes *Rhinoceros*'s "tidy French didacticism."[16] In an interview with Richard Schechner, Ionesco says that "Berenger destroys his own clichés as he speaks. And so, he sees beyond them. His questions no longer have easy answers."[17] As Esslin describes the conflicting images and messages of the Theatre of the Absurd, Berenger embodies these contradictory messages. Schechner argues that Ionesco writes "universal contradictions" along the same lines: there is a dialectic created between characters' "scholarly heavy tone" and the "weightlessness" of what they say.[18] This dialectic makes the audience need to be an active participant in making meaning. Questions remain at the end of the play. As Parsell says, "The loose ends are not tied but left hanging; it is for the spectator to decide whether Berenger is a man with a nightmare or the hapless control in a senseless and deadly experiment."[19] As I argue, the "loose ends" are the result of a loose and faulty syllogism constructed by Ionesco.

Like the syllogisms created by the logician in the play, I argue that *Rhinoceros* employs a faulty syllogisms. In hopes to "improve man's lot," Ionesco presented the faulty syllogism as a garbled Kantian categorical imperative. Ionesco paints an absurd picture by presenting, in the Kantian sense, the necessity of a maxim being universizable. Kant's categorical imperative, thus, becomes something profoundly correct. However, as I examine *rhinoceros*, both as the animal and the title, Ionesco discusses how tenuous and fine a line it is between universizability and conformity. In this sense, Berenger is painted as the Sisyphean Hero, who is able to tread this very fine line. I conclude this article by looking at a Barbara Damashek production of the play to offer some final remarks.

The Play: The Setting

The play is written in three acts and in four scenes. In a fascinating, but easy to miss, dramatic move, Ionesco has mirrored the spreading of rhinoceritis with the public-private setting of the play. The first act is outdoors, in a public square. Act Two, Scene One, takes place in an office: semi-private space. Then Act Two, Scene Two, and Act Three take place in Jean and Berenger's apartments, respectively: thoroughly private spaces. In a sense, rhinoceritis enters into the public's imagination early into the play. At first, the appearance of the rhinos are mere curiosities to the townsfolk. Pages

are spent arguing about how many horns the rhinos have, whether it is the same rhino that they are seeing or there are more than one, and whether the rhino(s) is/are African or Asiatic. In Act Two, Scene One, in the semi-private world of the office, we see the first affects of rhinoceritis spreading: the husband of one of the character's, Mr. Boeuf, has turned into a rhino. And Mrs. Boeuf reacts in a very human manner: "My poor darling, I can't leave him like that, my poor darling."[20] In Act Two, Scene Two, we are now in the private world, Jean's apartment. Here, we finally see one of the character's, themselves, turn into a rhino. Lastly, in Act Three, Berenger is left all alone as a human in his apartment. Thinking about the move from public to private in regards to the play's setting metaphorically suggests a fundamentally different approach to interpreting this play as a commentary on mass hysteria, social conformity, and the like: the move from public to private and the subsequent increasing impact of rhinoceritis suggests that turning into a rhinoceros is less an act of public mass hysteria and more of a private decision with private consequences.

We see this dramatic move also mirrored in the first and last lines of the play. The Grocer's Wife is the first character to speak. She peaks out of her shop into the public square to look at a passerby whom she does not like, merely to gossip to her husband. Gossip is the ultimate conflation of public and private knowledge: they intermingle in exciting and dangerous ways, much like the spread of rhinoceritis in this play. The Grocer's Wife speaks about the something that should be private and makes it public to others, yet in a private manner. On the other hand, Berenger ends the play all alone, yet making a large pronouncement (seemingly to whoever will listen [i.e., the audience], since there is nobody left). The tragedy of the play, represented by this move between public/private, is, in part, precipitated by the fact that what should remain private does not and what should be made public remains private.

The Syllogism

LOGICIAN: A syllogism consists of a main proposition, a secondary one, and a conclusion.
OLD GENTLEMAN: What conclusion?[21]

The town is carefully described: this is not just any town, but a specific town, with specific characters. There is too much detail for this to be so universal: one would expect more of an *Our Town* feel if this was to be so universal. However, how is anyone alienated here? The town takes the proceedings in stride; at times they debate, but they never panic. Their sense of irrationality

may be piqued, and they may answer it with irrationality of their own, but it is hard to call alienated characters who get into a debate over whether the rhinoceros is African or Asiatic. What may be alienating, instead, is the idea of dysfunctionality and misuse. James Mills argues that the décor and stage directions function as role characters and are major thematic metaphors.[22] The pervasive theme in this play, as I argue, is the faulty syllogism. The décor in this play that best represents it is the fallen staircase. Like the faulty syllogism that does not link A to B to C, the staircase no longer links the ground to the second floor. A faulty syllogism exists:

Landings connect stairs
Stairs connect floors
Landings connect floors.

The faulty reasoning behind the conclusion of the syllogism exists in the play: "...*the staircase landing is seen to be hanging in space.*"[23] What is significant here is that the syllogism, in practice, not theory, works. Landings, of course, are a *part* of what connects floor A to floor B. The isolation of a part of the whole exposes the weakness of the syllogism.

The landing becomes a reminder of the connective fabric of society. Landings do not transport humans from point A to point B, but they are holding grounds and places to prepare oneself for movement. This is significant that this is all that remains. The place of movement, the stairs, is what has disappeared. The stairs carry you from point A to point B. The ascent or descent can be very metaphorical. Look at what is on the first floor versus what is on the second floor in this play. The first floor, the outside world, is the characters' connection and pathway to home. The second floor, the inside world, is the office. The battle in this play is over being in the outside world versus being in the inside world. Everyone besides Berenger either chooses to be, or is forced, into the inside world, the world of rhinoceritis. But the inside world is also the world of business and capitalism or bureaucracy. A world like this does not have space for someone like Berenger, who is never on time.[24] The paradox of the play extends from the metonymic syllogism of the landing. The landing is both 1) essential, but utterly useless and, 2) helps change direction, but is directionless itself. This is Berenger. Berenger, then, becomes a paradox, like the landing. As Ionesco says, "Berenger destroys his own clichés." Doing one thing and saying something else represents the "assembly" of voices of heterotopia and the parable.

The character of landing, existing also as a faulty syllogism, takes on the metaphor of the play: hanging in space. This is itself is a relational phrase. The perception of hanging, when the landing rises, is only inverted through

the suggestion of the word *hanging*. This is quite paradoxical. The forward movement of the play toward total rhinocerits is juxtaposed with the backwards movement of humanity. The hanging landing is doing what Berenger does. Berenger hangs on to his grip of self in a relational reality with the town overrun by rhinoceroses while inverting downward/upward-progress.

Faulty Categorical Imperatives and the Faulty Syllogism

You ought to/must become a rhinoceros is the maxim/major premise of Ionesco's play. Read through Alfred E. Haefner and Immanuel Kant's ethical syllogisms, two very different ethical suggestions emerge.[25] If we put the maxim into the Haefner model, we get something like the following syllogism from the perspective of Berenger:

> Major Premise: I believe that praiseworthy humans, when everyone else becomes a rhinoceros, must become a rhinoceros.
> Minor Premise A: I am not a rhinoceros.
> Minor Premise B: I want to be known as a praiseworthy human.
> Conclusion C: Therefore, I must become a rhinoceros.

Berenger's ethical decision is made based on his understanding of the social norm and how acting in such a way is praiseworthy. He assesses his position outside of the social norm and his ethical decision is based on fitting into the social norm. This play comments on the fallacy of the praiseworthiness of societal norms. The problem with this formula for determining ethical behavior is that universal law does not fit into the model.

If we understand the situation, instead, through the Kantian model, we understand the problem of the maxim not being universal law: *When others are turning into rhinoceroses, I will become a rhinoceros, as well.* The problem with the maxim/major premise/syllogism of the play has to do with the impossibility of the maxim/major premise being a universal law. Berenger is the only one in the play to see the cracks in the categorical imperative/syllogism. If we turn this maxim into a universal law, then the whole world will become rhinoceroses and, then, what happens to humanity? A mode of operation becomes an analysis of life's contradictions in logic. *The world is a faulty syllogism*, Ionesco argues. This is the contradictory world of the parable. Because Berenger speaks through an "assembly" of voices, literal, figurative, emotional, and physical, the contradictions in this world of *Rhinoceros* are explored through Berenger's speech and actions. Taking a pessimistic view of society, Ionesco argues that people can only figure out correct action through seeing faulty logic and faulty action. Berenger becomes the true

logician in seeing the madness of the faulty syllogism; he sees the necessity of universizability. It takes something illogical to illuminate the ethical path. The general movement of the parable takes place in its movement from order to disorder. It is in its moment of disorder that the parable disorients the viewer and forces them to reassess their worldview. When everyone in the play becomes a rhinoceros besides Berenger, Berenger stands in for each audience member and asks the basic question, should I become a rhinoceros? This play is highly performative in the sense that the ethical syllogism or Kant's categorical imperative operates throughout. The audience member imaginatively enacts either the ethical syllogism or Kant's categorical imperative to make sense of the world. The ethical syllogism is a personal guide to ethical behavior. The audience puts themselves in the shoes of Berenger and develops a personal ethical syllogism. However, Ionesco confronts the audience with the simultaneous possibility of ethical behavior and maxims becoming universal law. What would happen if everyone performed the societal norm, Ionesco ponders. Do not perform societal conventions or be left as the only human, the play suggests. However, the play also comments on the fallacy of this remark. The need for a categorical imperative in determining ethical behavior ensures that we do not all become rhinoceroses, leaving humanity behind.

Rhinoceros: The Title/The Animal

If this play is, indeed, about, at least, in some ways, individuality (as most scholars, including me, are in agreement), then an interesting tension is created if one considers the (potentially) eerily similar results of conformity and universizability. As I will argue, Ionesco creates a play that explores the fine line in this distinction. Because of the title and the choice of animal, Ionesco creates a play where the relational reality of words to perception varies among the audience members, based upon their understanding of the singular "rhino," or the plural form of the word.

The first question, which has been largely unexplored, is, why rhinoceroses? Obviously, a lot of the "absurdity" comes from having such a seemingly random, out-of-place animal running through a small French town. But if this is a play so commonly argued about totalitarianism, why not sheep, or some other easily herded and docile animal? Much of the success of totalitarian regimes is the generalcomplacency of the masses. But rhinos have no known predators (except humans) and are probably one of the last animals one would think could be herded. They are exploited for their horns, but the (legendary) aphrodisiac that is made from them (and technically they are not horns, but tightly packed thick hairs) has been (from a medical, not

placebo, effect) at least scientifically proven ineffective. Given that the only practical way to get their "horns" is to kill them, rhinos are a non-reusable expendable entity. Cows and sheep, for example, continue to produce usable goods. Part of the success of the Nazis was how they used the masses to generate more and more hate and propaganda. The success of the Aryan Nation did not just depend upon the elimination of the least desireable, but in the continued propagation of the Aryans. Hitler would never want a "herd" made up solely of species he needed to kill to exploit: he would have no herd left to control. I think, then, we have to assume that there is some other reason as to why Ionesco chose rhinos.

I believe that two reasons emerge, both of which highlight ambiguity. First, there is the issue of the word itself. In the first French edition, the proofreader added the definite article, "le" to "Rhinoceros" while Ionesco was out of Paris (i.e., the title read as *Le Rhinoceros*). On Ionesco's request, the "Le" was removed from subsequent editions.[26] This is significant because the word, *rhinoceros*, or plural, *rhinoceros*, stays the same. This irregularity (e.g., the word *cat* in French is *le chat* in its singular form and *les chats* in its plural form) enables intentional ambiguity in the case, allowing for the reader (in French, particularly, and even in English as the plural can be either rhinoceroses, rhinoceri, or simply, just rhinoceros, as well) to imagine either one rhino or multiple rhinos. Obviously, this complicates the notion of individuality in a group environment. Is it possible to be an individual in a group, one reading could suggest. Or, another reading, is a group solely bound to the individuals that make it up?

I will attempt to not lose the irony of (the absurdity of) the play and choice of rhinos, however, the second aspect of ambiguity found in rhinos is in their behavior. As the townspeople make such a big fuss over what species of rhino it is, it should be noted that different species can display remarkably different social traits, ranging from solitary to gregarious, more group-friendly, behaviors. Again, this confusion generates an ambiguous relationship between the individual and the group (if a group even exists at all, in this case).

This ambiguity can be found both in the text and in, especially, the Damashek production. Early in the play, near the first and second sightings of the rhino(s), the townsfolk debate whether the second spotting of the rhino they saw was the first one or whether it was a different rhino:

GROCER: It went past my shop a little while ago.
JEAN: [*to the* GROCER] It wasn't the same one!
GROCER: [to JEAN] But I could have...
GROCER'S WIFE: Yes it was, it was the same one.

DAISY: Did it go past twice, then?
PROPRIETOR: I think it was the same one.
JEAN: No, it was not the same rhinoceros. The one that went by first had
two horns on its nose, it was an Asiatic rhinoceros; this only had one,
it was an African rhinoceros![27]

Or Telory W. Davies'sreview of Damashek's production speaks about times
where the rhinos appear alone or in groups:

Actors traipse in and out of this diamond area, responding with varying
degrees of panic or consternation to the influx of rhinoceroses, who are
represented by trumpeting sounds, hoof beats, and a cloud of dust from
offstage. These sounds change direction with each rhino sighting, and
the actors follow the imaginary animals' movement with their eyes. With
each rhino entrance, at least one prop is dropped, spilled, or broken to
mark the disruption.[28]

This ambiguity over singularity and plurality subtly affects the entire read-
ing of the play. The word *rhinoceros* creates a relational reality of words to
perception. Does the audience member see individual rhinos or does he or
she think more of the rhinos as a pack (or *crash* as a group of rhinos is techni-
cally, and appropriately for this play, called)? This can be suggested at by the
director, in part, over how the rhinos are blocked. Does devestation, then,
occur by singular rhinos or by the group?

I think that Ionesco is not focusing on the need for individuality, per
se, in the face of a totalitarian regime (or its metaphorical equivalent), but
I think, rather, he is facing a much more complex issue that deals with
individual/group dynamics. If this is a play about an individual standing
up against a totalitarian regime (signified by Berenger's last stand), then
I think Ionesco's play has to leave us with a pretty bleak outlook. How is
Berenger going to take on a town of rhinos? Ionesco wrote this after the
Second World War, after the defeat of totalitarianism. How did this defeat
occur? Throughthe Alliance! Through pooling strength! This play is less
about the loss of the individual and more about the failure of the masses to
confront rhinoceritis.

The ambiguity between the individual and the group alerts us to our
absurd situation: how does one maintain individuality within a group that
needs to act as one? The result moves us simply past Kant's categorical imper-
ative to suggest that there is a dangerous mix and overlapping between con-
formity and universizability. But in this absurd situation, maybe Berenger
offers us a suggestion of how we are to cope with this sometimes futile

aspiration of individuality. Berenger takes on a Sisyphean purpose. Berenger is ultimately the "superior man" that Jean describes as having "willpower" and a "man who fulfills his duty."[29] Though we will always be bound to lose ourselves in our absurd situation, where our desires cannot be met by the realities of the world, we can make our lives meaningful through our revolt and creating a purpose by which we can live by.

Berenger: The Sisyphean Hero

In the opening scene of the play, we find Jean and Berenger at a café. The subject of the conversation quickly turns to Jean admonishing Berenger for Berenger's seeming malaise. Berenger explains that he gets bored in the small town and that working eight hours a day is taxing on him since he does not feel cut out for the work. For Jean, this is a sign of Berenger lacking willpower, and Jean uses himself as a counterpoint: "My dear man, everybody has to work. I spend eight hours a day in the office the same as everyone else. And I only get three weeks off a year, but even so you don't catch me... Will-power, my good man!"[30] Following this pronouncement, Jean presents a paradox: the "superior man" is one who "fulfills his duty...as an employee."[31] The paradox is that the "superior man" is the man who does the "same as everyone else." In that sense, if "everyone else" goes to work, as Jean says they do, everyone is "superior," which, of course, is an illogical statement, since superior assumes something above the ordinary. For Jean, conformity is superior, which is illogical. On the other hand, Berenger seems unimpressed with willpower and duty being equated with having duty to one's employer. Berenger's line, "Oh yes, his duty as an employee...," signals an brushing-off affirmation, but the fact that he trails off shows hesitation and the lack of elaboration shows he is ready to move on to another subject and is not moved by such an idea.

In fact, the audience *is* led to believe that Berenger does lack willpower. Berenger is portrayed as a drunk. In Jean's eyes, Berenger, "can no longer control [his] movements, [he has] no strength left in [his hands]...[he is] destroying [himself]."[32] Berenger's answer is typical, however, it is typical from the eyes of a therapist. Berenger says, "I drink not to be frightened any longer...It's a sort of anguish difficult to describe. I feel out of place in life, among people, and so I take to drink. That calms me down and relaxes me so I can forget."[33] Berenger—though he does not yet have an effective means to deal with the world, which does not offer him what he wants—is self-reflective and acknowledges the world for what it is and he understands his place in it. The first step, Camus argues, is to acknowledge the world for what it is. Berenger sees the absurd situation, but he has not yet figured out his purpose; therefore, he drinks to forget the absurdity of the world.

However, though Jean claims that Berenger speaks in "stupid paradoxes,"[34] Berenger merely points out the true contradictions in life, the source of the feelings of absurdity. And it takes a man who acknowledges that contradictions do exist to be able to find meaning in a contradictory world.

When confronted with rhinoceritis, Berenger finds a twofold purpose in life: confronting rhinoceritis and loving Daisy. It is love, for Berenger, and for the play as a whole that represents the connective tissue of society. In the world of business, in the mundane, the connective fabric of society is symbolized by the landing. The landing moves people from one place to another, but nobody wants to reside on the landing. Therefore, the mode of connection is worthless in and of itself. Whereas, for Berenger, at the end of the play when he and Daisy are left alone to confront the onslaught of rhinoceritis, Berenger sees love as providing the means in which to preserve their humanity: "our love is the only thing that's real."[35] Daisy, too, seems to be on the same page as Berenger, as she views duty, not as a duty to one's work, but as the "duty to be happy in spite of everything."[36] The important point is that Daisy, like Berenger, acknowledge their absurd situation, but they refuse to let others or the world interfere with their own happiness: "Nobody has the right to stop us from being happy…"[37] The two seem perfect for each other in their acknowledgement of the situation. Their love is what kept the two from becoming rhinos for so long. However, Daisy succumbs to rhinoceritis and the question is why?

The difference between Daisy and Berenger is that Berenger does not only acknowledge the sitatution, as Daisy does, but he wants to do something about it. Berenger wants to revolt against their absurd situation: "Listen, Daisy, there is something we can do. We'll have children, and our children will have children—it'll take time, but together we can regenerate the human race."[38] Berenger's revolt takes the ultimate form of being human: mentally, making a choice and biologically, making more humans. For Berenger it will take courage, but Daisy does not see it the same way. Daisy does not want to have children, but even more indicting is Daisy's response to, "How can we save the world, if you don't [want to have children]?": "Why bother to save it?"[39] For Berenger, it seems to me, the world is worth saving precisely because of the possibility of love and the possibility of human revolt.

In the end, Berenger displays willpower when it really matters: in revolting against an absurd world. Berenger says something really telling in the last few lines of the play that appears, at first, to be contradictory to the point of the play: "People who try to hang on to their individuality always come to a bad end!"[40] With having Berenger, the outcast, left alone at the end of the play taking on the world, the play appears to tout individuality. However, this statement furthers the logic of the ethical syllogism of

the play. One *ought* to, or one *needs* to, be human, as the syllogism goes, is very different from the passive "hang on to their individuality." Instead of fighting for his individuality, as he literally is the only individual left in the play, as Berenger is prepared to do, others merely try to hang on. Even when love is not present, as Frankl suggests, Berenger still finds something worth fighting and living for: his place in the world, despite what the world is like. However, most importantly, he fights for the fact that he gets to decide his own fate: "I'm not capitulating!" is the last line of the play.

Conclusion: The Rhinoceros in Performance

I have made use of the Damashek production throughout this article, but I want to turn to two previously unmentioned details of the production to offer some final remarks. The first detail worth noting is that the entire set "transforms into a rhinoceros horn."[41] The fact that the world, itself, is affected by the actions of humans/rhinos, constitutes the lasting impact that humans have on the world. This also highlights the absurd nature of the world, that the world cannot give us what we want. But even more so, this heightens Berenger's struggle. In Ionesco's play, Berenger *only* has to revolt against his fellow human/rhino. In Damashek's production, Berenger has to revolt against an absurd world, as well. This isolates Berenger even more, but makes his struggle and the fact that he is standing up to it that much greater.

The second point has to do with how each rhino enters the stage: 1) the rhinos are imaginary, as the actors follow the movement of the rhinos with their eyes, and 2) "With each rhino entrance, at least one prop is dropped, spilled, or broken to mark the disruption."[42] The fact that each rhino is imaginary only highlights the fact that this is an internal struggle. The rhinos are something which we cannot see, but we understand. We, the audience, must imagine our adversary. As a way at offering a conclusion, the second point, the fact that something drops with each rhino entrance, alerts us to the fact that it is not the *crush* of rhinos that do damage, but that each rhinoceros transformation is damaging in and of itself. The effect of this staging is that Berenger's task is not to revolt against the rhinos, in a plural sense, but that he must individually confront each rhino. Though this seems to make his task infinitely long and impossible, confronting each individual rhino is the means by which to reverse rhinoceritis. Damashek gives the audience the tools for confronting mass conformity: revolt takes place within *each* individual, not by confronting the masses.

Conclusion:
Theorizing a "Female Absurd" in Beth Henley's *Crimes of the Heart* as Means of Reassessing the Theatre of the Absurd

Celeste Derksen contemplates the idea of a "feminist absurd" in the Canadian playwright Margaret Hollingsworth. Part of the purpose of her article is that "to consider Hollingsworth as absurdist is at once a challenge to the male exclusivity that is a defining feature of absurdism and an argument for revitalizing absurdism as a contemporary critical term."[1] Derksen does this through an examination of the subject position. Both Derksen and I agree that "the subject of absurdism can be constructed and read from a more overtly political, socially engaged standpoint."[2] Though it is very possible to read traditional political ideology into the work of female absurdists (such as, specifically, Hollingsworth and even Beth Henley, in this instance), I believe that there is less of a standard political project going on and more of a contemplation of *being female*, which has *local* political implications in, specifically here, Henley's play, *Crimes of the Heart*. In examining two important and influential plays (Jean Genet's *The Maids* and Beth Henley's *Crimes of the Heart*), I want to argue that Genet's *The Maids*—a *representative* of the ("standard") *male* theatre of the absurd—is more concerned with the philosophical, universal question, what is it *to be human?* The conclusions of *The Maids* are contradictory, fully satisfied with destabilizing gender, not worried about bodies, per se, most likely because the "white male body" is the metaphoric default body. Since white male absurdists do not have to worry about their own subject position, as white masculinity is the hegemonic norm, they have the luxury, if

you will, to philosophize about universal bodies and problems. Not exactly a question of what it is to be human, per se, Beth Henley's *Crimes of the Heart*—representing one *type* of *female* theatre of the absurd—asks the question, what is it *to be in a female body*, in the *local* sense (and in relation to others, as well)? In general, Genet's *The Maids* deals with making meaning out of a universal, absurd position; Henley's *Crimes of the Heart* deals with the absurdity of one's specific female subject position and offers a call to action. Though, I hope to and appear to be making a differentiation out of the male and female absurd, via Genet and Henley, both absurdisms, if you will, are in dialogue with an up-to-date reading of Camus's philosophy of the absurd. These two plays specifically speak to each other in the ways they look at gender and its absurdity.

By necessity, I am using, unfairly, *The Maids* and *Crimes of the Heart* as representative plays of each of their respective *gendered absurdisms*. I hope the reader will view this conclusion as a prolegomenon to a larger project (that cannot just be accomplished by myself, given the potential magnitude of this line of inquiry). I invite other scholars to continue the conversation: applying it to other female playwrights, arguing who should be in this canon and who should not be, and most importantly, should we even label these female playwrights as absurd, since as I demonstrated in this book, it is a very problematic term even for those playwrights we traditionally read as absurd (forgetting even the fact that playwrights such as Beckett, Ionesco, Genet, and Pinter, for example, never said they were absurdists). Trying to avoid the same categorizations by Martin Esslin that pigeonholed so many male absurdists, I am attempting a balancing act of being inclusive and recognizing difference, but doing so without producing a reductive taxonomy.

Jean Genet's The Maids

Before I turn to *Crimes of the Heart*, however, I want to turn back to perhaps the earliest "absurd" play: Jean Genet's *The Maids*, first performed in 1947. What is significant about this play is not just the play itself, but the fact that Jean-Paul Sartre—Camus's intellectual friend, but kind-of adversary—wrote the Introduction to the play. Sartre's conclusion is that "appearance is revealed at the same time as pure nothingness and as cause of itself."[3] This would suggest a "standard" absurd reading: purposelessness, meaninglessness, and senselessness. However, given Sartre's comments earlier in the Introduction on the nature of the theatre, the role of "appearance," "nothingness," and "non-being" create a glorious vision of the theatre, modeled after Brecht and Bert O. States, and the indisputable productive power of performance that sound much more like Camus than Sartre and Esslin.

The form of incongruity is present right away in *The Maids*. As Sartre points out, the "extraordinary faking" that is to dominate the stage is carefully not revealed to the audience at the outset: we see a familiar scene of:

"an impatient and nervous young lady who is rebuking her maid."[4] But just like that, when Claire says that the Madame will be back, the appearances slip away and the audience is aware that "everything was fake; the familiar scene was a diabolical imitation of everyday life. The entire scene was prepared in order to impose this deception upon us."[5]

The Maids metaphorically deconstructs the notion of (unmarried) womanhood. Dressed up as a maid and a madame, the costumes themselves are metonymic paradoxes. When playing the role of the servant and master, Claire and Solange, surprisingly, serve not their master, but themselves through play that yields an emotional release. It is only when they remove the clothes that, paradoxically, they become slaves to the madame. Their disorienting transformation puts the audience in a state of confusion. We must make sense of their "new" roles at the pronouncement that the Madame is returning. This forces the audience member to confront our own expectations we placed upon them when they were dressed as servant and maid. Likewise, once our understanding of the situation is disoriented, we then question not only them as maids/servants, but, metaphorically, we question their maidenhood.

Here the play takes on a deeper meaning from the domination of life by mere appearances than Sartre suggests. In Sartre's own words, though unknowingly, the layering of appearances sets up the ultimate act of Brechtian alienation. Sartre purports Genet's theatre as a performance that makes the audience understand the paradoxical nature of the actor-character:

In short, the illusion is prevented from "taking" by a sustained contradiction between the effort of the actor, who measures his talent by his ability to deceive, and the warning of the placard. Thus, Genet betrays his actors. He unmasks them, and the performer, seeing his imposture exposed…[6]

Understanding this play coming out of Brechtian parabolic drama casts the ideology that Sartre suggests in this play in a very different light. It is neither suggested that Brecht was an absurdist playwright nor was a follower of Sartre or Camus. If Brecht's theatre, with its obsession of metaphor, didacticism, and audience interpretation, is thought of as the intellectual progenitor of, at least, *The Maids* (if not all of the Theatre of the Absurd, as both

theatres are parabolic), then the focus is less on "nothingness," and more on the potential for change brought about by *performance*.

Genet's heady play deconstructs the idea of gender in a parabolic and Brechtian way so that the audience must walk away from the play, not emotionally involved, but grappling with the social construction of gender. This focus on reordering reality in order to examine social constructions comes from the tradition set forth by Brecht and the world of the parable. But the world of appearances, theatrical and otherwise, shows the glory of the theatre and the very nature of our absurd situation. Sartre says the following about appearance in *The Maids*: "appearance borrows its being from being."[7] Speaking about 30 years later, Bert O. States says the same thing but casts it in a very uplifting light: "The illusion has introduced something into itself to demonstrate its tolerance of *things*. It is not the world that has invaded the illusion; the illusion has stolen something from the world in order to display its own power."[8]

Illusion is something magical that has a paradoxical but productive relationship with reality. What *The Maids* ushers in is a Brechtian-like heterotopia, with its clash of differing viewpoints, its contradictory, even paradoxical views of reality. *The Maids* calls in a new theatre in which heterotopia becomes a place where the very nature of reality and the act of living in it must be considered in light of paradox. This reading aligns itself much more with the philosophy of Camus than Sartre. Since not just the theatre, but everything is in some ways illusory, this theatre, then, becomes a place, not of "nothingness," but a place of production and meaning-making.

However, though this reading is quite uplifting, the play's message almost comes across at the expense of women. *The Maids* is a philosophical treatise deconstructing the notion, in part, of womanhood altogether, offering up few solutions. Henley's *Crimes of the Heart*, on the other hand, contemplates the troubles of womanhood (best represented in the corporeal metonymic paradox of Lenny's defective ovary), its paradoxes and its absurdity, to use Camus's strict definition, but ultimately creates a lasting image in the last scene of the joys of womanhood and sisterhood. Not as outwardly political as Churchill's *Cloud 9*, Henley's *Crimes of the Heart* suggests a path for women to regain their power and sense of self: through sisterhood.

Beth Henley's Crimes of the Heart

Unlike Genet's play, which deconstructs the notion of gender by destabilizing almost everything in its path, Beth Henley's *Crimes of the Heart* tries to find stability in an unstable world through an examination of gender. Gender is not something, necessarily, that exists or imaginarily exists only in the

realm of societal appearances (and then dissolves once those appearances are exposed as fraudulent), but Henley portrays how gender is really and actually felt and experienced by women. These are not abstract metaphors, but specific women who live in a real town and in a specific historical moment. The plot of Henley's play centers around, largely, Babe, one of three sisters, who shoots her husband because she "didn't like his looks!"[9] Just as important, if not more, is the relationship among the three sisters. Babe is married and the youngest at 24. Meg is an almost-washed-up 27-year-old aspiring actress who lives in Los Angeles. The eldest, Lenny, at 30, is haunted by a bad ovary, which makes her, apparently, barren. I am by no means the first scholar to suggest that Beth Henley is an "absurdist." William W. Demastes, in *Beyond Naturalism: A New Realism in American Theatre*, suggests that in *Crimes of the Heart*, Henley, "has taken domestic comedy and infused it with an absurdist perspective."[10] Demastes's remark echoes Scot Haller, who argues that Henley, "has mated the conventions of the naturalistic play with the unconventional protagonist of absurdist comedy."[11] Playing off of both of these comments, I would like to suggest that Henley is writing about an *absurd domestic situation*. In another sense, though, I argue that each sister is in a *typical everyday* absurd situation. We do not see rhinoceros running through their house, nor do they spend their days unrealistically on a barren country road. Demastes notes the inherent realism of the play:

> [Henley's] work escapes the intellectual detachment of the French absurdists and existentialists, and because it takes the horrors of life out of the lecture halls and puts them in a kitchen, it argues that the absurd has an immediacy and relevance to daily existence that other works can't claim to argue.[12]

As such, by placing this play in a real town, located contextually in a real historical event (five years after Hurricane Camille), Henley shows that the absurd is not a universal philosophical predicament, but that absurd situations locally plague women in real towns. Though their situation might be absurd, sisterhood provides a relief from the absurdity of these typical female lives. Henley, Demastes argues, gives us, "a sense of inevitable triumph over despair."[13] And maybe more importantly, Henley provides a means to overcoming despair: family, in this particular case (or loved ones, more generally), fills the sisters with a sense of purpose in life.

Babe is in an eerily familiar situation. One gets the feeling that Henley is stirring up the ghosts of Susan Glaspell and her seminal play on gender roles in marriage, *Trifles*. Babe is stuck in a poor Southern town—Hazlehurst, Mississippi—with seemingly conservative values, and trapped in an

unloving marriage. Her desire for life outside of the marriage is symbolized by a psychologically unhealthy affair with Willie Jay, a 15-year-old "black boy; a colored boy; a Negro."[14] Just like the young Willie Jay, Babe is a "babe," a child. Babe has not metaphorically grown in her marriage: there is nothing edifying about her emotionally solitary existence. Instead, Babe is emotionally stilted and her choice of sexual partner reflects her inability to have a partnership with an adult. In a sense, being the youngest of the three sisters when her mother committed suicide, Babe never had the guidance of an adult woman. Babe's husband, then, not only metaphorically replaced her father (who left the three sisters after their mother committed suicide), but also replaced her mother as the only adult in the *family*, if you will. If Babe cannot have a healthy marriage, then her absurd situation forces her into an illegal and an unethical relationship (and totally immoral through the eyes of the still-mostly-segregated South).

Meg is truly in an absurd situation felt by anyone who tries to crack into an ultra-competitive job. While Meg is supposedly a good actress, she simply comes face to face with the reality of the competitive world of acting: too many people for too few positions. Meg has the looks, supposedly, and the work ethic as she keeps plodding away, but there are simply too many just like her. She is, by all means, deserving, but the realities of the world will never match her desires. Meg has just simply not had the lucky break that so many successful actors and actresses had. There is an element of luck in the play. In a sense, the three sisters were born into bad luck: three strong-willed sisters with little-to-no parental support born in an impoverished, conservative Southern town would certainly constitute bad luck.

Whereas Meg's lack of luck is a sign of the world we live in, Lenny is born with bad luck: Lenny is traumatized by her defective ovary, a loaded corporeal symbol. Using the ultimate metaphor of a woman *not being able to do* what women *do* (i.e., she's a metaphorically womanless-woman, a contradiction, a paradox), Lenny thinks herself as being defined only by her ability to give birth. We see something innately similar in Pinter's Meg and Albee's Martha. In a literal and metaphorical sense, though she should be able to still find *pleasure*, both in her body and in life, she cannot *enjoy* herself (she is possibly a virgin) because of her inability to have children. She cannot live today because she cannot dream of tomorrow.

Though this story has all of the potential for a tragedy, this play has a constructive happy ending, mainly because Henley and the bonds of sisterhood will not allow this to become a tragedy. They stand up for each other, encourage each other, and give each other advice. These less-than-perfect-individuals make up a perfect family, in a sense. And with their father

leaving and losing their mother, who committed suicide, this is not a family that was instructed on how to work, from the top down, but these sisters form an almost organic grassroots-organization of support. At the end, each character, with the support of her sisters, gets what she wants. Babe is free, Meg rediscovers that love is possible, and Lenny gets the guy.

Conclusion: Exposition and Un/Certainty

Henley's *Crimes of the Heart* shares very little in common with the classically categorized absurd plays in its rhythm, plot, language, and especially exposition. As opposed to plays such as *Godot* or *The Birthday Party*, for example, that have seemingly no ending (and not really a beginning either with any exposition), *Crimes of the Heart* is about as much of a living-room drama as any other classic living-room drama. Much like the first great female living-room drama, *Trifles*, which also takes place entirely in the kitchen, *Crimes of the Heart* is a masterpiece in, particularly, exposition. The facts and histories surrounding each character slowly emerge, providing the audience a fuller and fuller portrait of how and why they are in the situation they are in; this is fundamentally different than, say, *The Birthday Party* or *Rhinoceros*, whose parabolic structures leave these plays full of contradictions and holes.

On one hand, then, it would make no sense to classify Henley's play as absurd. The play and plot and context are fully logical. The end of the play wraps up neatly; contradictions, if any even really existed in the first place, disappear into the joyful family moment that ends the play. On the other hand, we have three characters who simply need each other. These are three nice, attractive women, why are they not happy? The absurdity of their situation is that they do not need that much (simply each other), but the absurd world (via Camus) that they live in—the world of Hazlehurst and Los Angeles at the time of the play—is not hospitable to *female desire*; the world never gave Babe, Meg, and Lenny what they wanted or needed. This play *revolts* along with Babe: if the male world does not satisfy your desires, then turn to the world of sisterhood with its support systems.

There is one last observation that I want to state, though it will be more of a suggestive remark. There is something so unsure about so many of the men (in canonical male absurdists' plays with decidedly male protagonists) and something so sure about the women in *Crimes of the Heart*. One only has to look at some of the male protagonists in plays like *Waiting for Godot*, *The Birthday Party*, and *Rhinoceros*. Vladimir, in search of answers, arguably, turns to philosophy to console. Estragon turns to Vladimir's philosophy.

Berenger is an unsure mess until the last couple pages of the play. Stanley, especially, is unsure of himself the whole play, especially when interrogated by Goldberg and McCann. But look at the three women at end of play in *Crimes of the Heart*. They have overcome their absurd situation, are happy, sure, and laughing in the company of those whom they love and who love them.

Addendum #1: Defining the Parable

This addendum came about a number of years ago after a series of conversations about parables with four professors at the University of Massachusetts, Amherst: Joseph W. Donohue (English), Jenny S. Spencer (English), Robert A. Rothstein (Comparative Literature) and Adam Zucker (English). Being the parable scholar of the group, I explained to them the history of parable criticism and gave to them the many definitions of parables of various scholars. I used such words and phrases as "metaphor," "paradox," "self-confrontative," "reversal of expectation," and "turn." But each conversation led to the same response: "that sounds like almost every piece of literature ever written." At first, I shrugged it off. I assumed that the four were not very well-read in parable scholarship or that I was not explaining the definitions well. But the more that I conversed, the more that I started to see that they were right. Spencer told me to think about when most of these definitions were written: 1960s to the 1980s. That was the time period of Rudolf Bultmann and Gerhard Ebeling and Ernst Fuchs, when scholars began to de-emphasize the Bible as a work of Christian theology and began to look at it as a piece of literature. As a piece of literature, they emphasized its inclusive nature. Gone were the strict theological definitions, in were the general literary definitions. Gone was the idea that parables were the contracted mirror image of the Kingdom of Heaven, in was the idea that parables were paradoxes formed into stories. I, with the help of these four professors, realized that the definitions of parables had become so generalized that the definitions were no longer helpful and needed to be more exclusive once again.

As I will define the parable, a parable is a performative didactic metaphor that usually contains both a metonymic paradox and an open-ended dilemma that calls for interpretation from the audience. Usually the dilemma

comes out of the metonymic paradox. A parable at its most basic is a didactic extended metaphor. However, a parable contains a few more elements than just that. First, a parable is performative. A parable is a story in the act of teaching. A parable is performative in that something is actively being done to an audience. The parable transforms the audience's beliefs by overturning their prior assumptions. There is an agenda of transformation. This is also how the parable is didactic. The audience believes they know one thing, but the parable teaches them another. "The Prodigal Son" surprises the reader when the father forgives the son. When the audience believes that the son deserves nothing, for after all his epithet is "The Prodigal Son," the father turns around to forgive him. The prior assumptions of the audience are subverted and overturned, in order to replace them with the lessons taught by the story.

Whereas all parables are performative didactic (extended) metaphors, there are two more elements that are found in most parables: metonymic paradoxes and dilemmas that are left open-ended. When the father decides to throw a feast for the "prodigal" son, the father's other son asks the father why he has not thrown a feast for him, since he has been a good son all of these years. The only answer that the father can give the son is "for this thy brother was dead, and is alive again; and was lost, and is found" (Luke 15:32). In this question and answer there is both a metonymic paradox and a dilemma that is left open-ended. And as in many parables, it is the metonymic paradox that leads to the dilemma.

By metonymic paradox, I mean that there is a paradox present in many parables that works metonymically. The two most common definitions for paradox are a reversal of expectation and a contradictory statement. In parables, either one or both of these definitions apply. And by metonymic, I am referring to the part of the story that works as a metonymy. As opposed to metaphor which works by similarity, metonymy works by contiguity: a part replaces the whole, as opposed to something analogous, parallel, or similar. For example, in "The Prodigal Son," the other son's question to his father and the father's response, noted above, can capture the emotional and intellectual gist of the whole story. In this question and response, the emotional and intellectual thrust behind the story is captured in just a few lines. The part can sum up the whole, as the following analysis demonstrates. The question of the other son—why did you never throw a feast for me (to paraphrase)—captures the anger, disillusionment, and jealousy of the other son not found anywhere in the rest of the story. Maybe more importantly, in his father's response, we see the reasoning behind why the father forgave the "prodigal" son. The father did not care about the money. He thought his son was dead. And when the son came home, there was reason to rejoice.

In this interchange, both a reversal of expectation and a contradiction arise. Whereas the audience of the story expects the father to be angry at the son, we find that he has nothing but joy and forgiveness for him. It is in its contradiction, though, that this story takes on an even deeper meaning. In the father's act of throwing a feast for one son, he manages to alienate the other. Throwing a feast produces both joy and anger simultaneously. "The Prodigal Son," then, asks how is it possible to please two people at once. Or, especially, how, in the case of sibling rivalry, is it possible to please two children? As pointed out before, this metonymic paradox opens up a dilemma for the audience that has no apparent answer. The dilemma is left open-ended. But what is even more important for a parable is that this dilemma calls for interpretation from the audience. This didactic metaphor does not teach by simply saying, but by demanding interpretation. The audience, themselves, will have to figure out the teaching.

Defining the parable is earning praise for the parable like the praise awarded to a sonnet. For centuries, scholars have been asking, "What is poetry?" But scholars have never asked, "What is a sonnet?" The sonnet has been praised because there is a clear and identifiable structure to it. Those poets that can express themselves through that constrictive structure earn the praise of scholars and readers alike. Why, then, has the parable not been conceived in such a way? There are many clear, giveaway elements that, taken in combination, constitute a parable. When a writer can satisfy all of those elements, a parable is born. I set out to define the parable, not so the parable can be a piece of writing of exclusivity. I set out to define the parable so that when a parable is encountered, the total meaning of the parable can be weighed against its combined elements. Even more so, the structural definition explains and gives justification to the thematic definitions over the years.

When attempting a definition, one usually starts with the *Oxford English Dictionary*. It is imperative for a paper discussing parables to consult it, not for what the definition adds, but to understand how out of touch the definition is with parable studies. The definition reads, "An allegorical or metaphorical saying or narrative; an allegory, a fable, an apologue; a comparison, a similitude."[1] Unfortunately, the definition in the *Oxford English Dictionary* is most off-base because of the inclusion of the word allegory. This article will begin by showing how allegory and parable differ, but this is not the main focus. This article offers up a summary of the state of parable research[2] and then redefines the parable using the parable of "The Prodigal Son." The field of parable studies, after seeing its heyday in the 1960s to 1980s, has been relatively stagnant in offering up new ways to conceptualize the parable. Since there is much agreement

as to what a parable is, I will draw on the works of many scholars to come up with an amalgamated definition: a parable is a narrative that works by extended metaphor that finds the extraordinary in the ordinary and contains either a paradox, a reversal, or a turn. This addendum aims at offering up a new definition.

A parable, as I see it, is a performative didactic metaphor that usually contains both a metonymic paradox and an open-ended dilemma that calls for interpretation from the audience. What has been termed paradox by Heinz Politzer[3] or reversal by John Dominic Crossan[4] is none other than the parable's need for reconciliation of a contradiction.

I say dilemma because the parable usually ends with not everything answered or cleared up. There are still unresolved issues, or at least issues that personally affect the characters and will have a lingering effect. If the parable is neatly concluded and a conclusion can be made about it, then it is not a parable. A parable is a metaphor and a metaphor can only be expressed one way. A concluding remark can take the place of the parable and the metaphor of the parable would not be necessary. This is why so many Jewish parables are not really parables. The *mashal* is the "parable," but in actuality it is an analogy for the *nimshal*, or the explanation. Most Jewish parables are illustrative and, therefore, have only one point.[5] However, there are many that are still true parable. They are stories where the narrative cannot be reduced to anything simpler. But at the same time, the meaning multiplies. An inexhaustible metaphor without a neat conclusion takes on multiple interpretations.

The forefathers of modern parable studies, Adolf Jülicher and C. H. Dodd, saw "one point" coming out of each parable. Every parable of Jesus is, at base, a metaphor of what it means to be something in a contradictory world. This new definition may account for why people have the misconception that a parable is a story with a moral. As William G. Kirkwood aptly notes, parables are self-confronting.[6] I agree that they are self-confronting because, as I see it, there is a call (from Jesus) for responsibility; however, it is a call where responsibility is at times impossible. But each parable is an investigation not just into responsibility, but into the responsibility of specific parts of a fractured self. As is the case with metaphor, which is inexhaustible, a parable such as "The Prodigal Son" muses on the possibility and impossibility of being responsible as a son, a father, and being responsible with money. As we move away from the parables of Jesus, we move away from the theme of responsibility, for Jesus was, after all, a moral and spiritual leader. Modern and postmodern parables become more general metaphors on the need for people to resolve contradictions present in the world. In the portrayal of the world of the parable, it is in a contradictory

world where the "conflict" comes to a head. Conflict needs resolution; but in a contradictory world, true resolutions become illogical: how can a seemingly contradictory situation be resolved by one action? By taking place in a world that seemingly mirrors our own (the parable is realistic) and being faced with a nonsensical quandary, our own world is turned upside down and we must reevaluate our own world. This is what Ricoeur is getting at when he says discourse orients, disorients, and reorients.[7] In orientation and disorientation, the work is done by the parable. However, the job of reorienting is left up to the reader or listener of the parable. The reader or listener must pick up all the pieces of our now deconstructed world and put them back together to try to reinstate order, stability, and sense. This is why all parables are performative: they demand immediate action from the reader or listener. As A. M. Hunter says, "Every parable of Jesus was meant to evoke a response and to strike for a verdict."[8] I want to first return to the *Oxford English Dictionary*'s definition and then take a lengthy walk through the scholarship that has been done so far on parables.

Allegory and Metaphor

What is at issue in the *Oxford English Dictionary* definition is the inclusion of the word allegory. The major figure in parable versus allegory research is Adolf Jülicher, who with his seminal book *Die Gleichnisreden Jesu* (1888–1889) de-allegorized the parables of Jesus.[9] James Champion explains Jülicher's contribution: "Where Augustine, in a classic example, had interpreted The Good Samaritan allegorically—the traveler is Adam, Jericho is the moon, the thieves are devils, the Samaritan is the Lord, etc.— Jülicher finds a pedagogical development of Jesus's ideal of the compassionate neighbor."[10] C. H. Dodd came along in 1935 and furthered Jülicher work. Taking "The Good Samaritan" as an example, Dodd would say that the idea of "the compassionate neighbor" would present "one single point of comparison."[11] In order for a metaphor to present a story, each detail works in conjunction with every other detail. The different details form a web of significance and no detail can stand on its own. On the other hand, in allegory, each detail works independently from the others. Each detail is an independent metaphor that has its own significance. John Dominic Crossan explains allegory along similar lines as Dodd, though much later and as a structuralist. Crossan also focuses on details' dependent and independent nature for exacting meaning. He says that figurative language is in effect when A=B. Literal language is in play when A=A and B=B. Allegory, Crossan argues, is an example of literal language.[12] The signifier, "A," would yield a more complex (or just different) sign, "B," in figurative language.

Whereas, in literal language the signifiers "A" and "B" yield only signs that correspond with their signifiers: "A" and "B," respectively. As Crossan is arguing, allegory's meaning relies on other texts. Going further than Crossan, I would argue that meaning may be generated out of an allegory without the pre-knowledge of the text it is alluding to, but the author's full intent will obviously not be grasped. Allegory demands pre-knowledge from its readers, as Dan Otto Via Jr. points out:

> An allegory, then, communicates to a person what he already knows, though it communicates it in symbolic and altered fashion. The other side of this is that it conceals its intended meaning—unless there is an appended interpretation—from those who do not have the necessary knowledge to decipher it. In short, an allegory does not say what it means nor mean what it says, which is what Jülicher meant when he referred to allegory as inauthentic [*uneigentlich*] speech.[13]

An allegory "does not say what it means nor mean what it says" because it is trying to say the same thing as another text. It does not "say what it means," because allegory works by indirection. The writer of allegory indirectly rewrites the text that it is alluding to. The text does not "mean what it says" in that the text is a referent for something else. The reader of allegory indirectly "reads" the text that the allegory is alluding to by reading the allegory. Geraint Vaughan Jones continues where Via left off. Jones returns to Jülicher, noting how he characterized "authentic" and "inauthentic" speech and how these terms help to differentiate between metaphor and allegory:

> Jülicher begins by distinguishing between metaphor and allegory, the essence of the parable being similitude. He distinguishes, too, between what he calls "authentic" and "inauthentic speech": the former, which means what it says and does not conceal its terms but uses them as pictures, is the method of parable; inauthentic speech, which hides the meaning in code or allegory, and means something other than what it manifestly says, is allegorical.[14]

Jones, through Jülicher, is contradicting what Crossan is saying. Jones and Jülicher are arguing for an almost literal reading of the parables: A=A in parables and A=B in allegory.

The *Catholic Encyclopedia*, however, complicates this equation: it seems to agree more with Crossan than with Jones and Jülicher. The *Catholic Encyclopedia*'s simple definition sounds a bit similar to the *Oxford English Dictionary* and what we can pull out of Crossan's definition: "The word

parabolē (Hebrew *mashal*; Syrian *mathla*; Greek *parabolē*) signifies, in general, a comparison, or a parallel, by which one thing is used to illustrate another."[15] The *Catholic Encyclopedia* complicates this definition by seemingly invoking both "authentic" and "inauthentic" speech:

> As uttering one thing and signifying something else, it is in the nature of a riddle (Heb. *khidah*, Gr. *ainigma* or *problema*) and has therefore a light and dark side ("dark saying," Ws 8:8; Ecclus 39:3), it is intended to stir curiosity and calls for intelligence in the listener, "He that hath ears to hear, let him hear" Matt 13:9. Its Greek designation (from *paraballein* to throw beside or against) indicates a deliberate "making up" of a story in which some lesson is at once given and concealed.

Sallie McFague, a contemporary of Crossan, Via, and Jones, furthers particularly what Jones is arguing and solves the seeming discrepancy between Jones and Jülicher and the *Catholic Encyclopedia*. McFague notes how the meaning of a parable is contained within the story itself, but not limited by the story, whereas the meaning of an allegory is found outside of the text: "A parable is an extended metaphor. A parable is not an allegory, where the meaning is extrinsic to the story...Rather, as an extended metaphor, the meaning is found only within the story itself, although it is not exhausted by that story."[16] In an allegory, the reader must have knowledge of the outside text that this text is mimicking. Or maybe another way of putting it is that elements of an allegory are in a one-to-one correspondence with an outside text in order to generate a reinterpretation of the non-allegorical, original text. In her explanation of allegory and metaphor, McFague seems to directly contradict Crossan. Whereas Crossan argues that figurative language works on an A=B model, because McFague says that "the meaning [of metaphor] is found only within the story itself," McFague seems to be advocating, again, that A=B in allegory. And in the same respect, A=A in figurative language for McFague. But the equation is not so simple for McFague. Almost harkening back to the definition of the *Catholic Encyclopedia*, McFague argues that "the meaning of a parable is contained within the story itself, but not limited by the story." In other words, there is both "authentic" and "inauthentic" speech being employed and the meaning of the story is both "given and concealed." Meaning is not solely limited to the story itself. Although it *does not rely* on an outside referent, its meaning is not "limited by the story." I think Crossan was trying to say the same thing as McFague, but his equation failed to take into account the irreducible nature of the metaphor. As Dodd says, "Any attempt to paraphrase its meaning is both less clear and less forcible than the saying as it stands."[17]

Part of the reason that metaphors are irreducible is that in the juxtaposition of A and B, both A and B are dependent on themselves and each other. There are only, at base, two objects and each object still contains its own meaning, even in the face of this juxtaposition. Northrop Frye explains how A is identified with itself and with B:

> In ordinary descriptive meaning, if A is B then B is A, and all we have really said is that A is itself. In the metaphor two things are identified while each retains its own form. Thus if we say "the hero was a lion" we identify the hero *with* the lion, while at the same time both the hero and the lion are identified *as* themselves. A work of literary art owes its unity to this process of identification *with*, and its variety, clarity, and intensity to identification *as*.[18]

Robert W. Funk complicates this notion of identification *with* and *as* an object or subject:

> The poetic predilection for metaphor and symbol is not at all arbitrary. If A stands for the fresh insight that beckons the poet mutely, and B stands for the available language fund, a fund that has acquired conventions and is presided over by tradition, the poet must allow A to come to expression *through* and *out of* B. A is not "there" except as it enters language, but it cannot, because it is a fresh insight, be merely accommodated in conventional language. A is raised to cognitive status in language only as the linguistic tradition undergoes some modification.[19]

For Funk, A is not just identified *with* B, but *through* B. As McFague beautifully put it, "A metaphor is a word used in an unfamiliar context to give us a new insight; a good metaphor moves us to see our ordinary world in an extraordinary way."[20]

It is Mary Ann Tolbert, however, who provides the best and most complete explanation of how metaphor works in a parable.[21] Tolbert combines both I. A. Richards's terms "tenor" and "vehicle" and Philip Wheelwright's terms "epiphor" and "diaphor," from his book *Metaphor and Reality*, to explain metaphor. For Richards, in a metaphor, a well-known object is compared to a less well-known object. The well-known object for Richards is the "vehicle"; the less well-known, the "tenor." For Wheelwright, epiphor is the comparison aspect of metaphor; diaphor is the juxtaposition to create new meaning: Tolbert says, "When epiphor and diaphor are combined, as Wheelwright asserts they practically always are in every metaphor, epiphor remains the comparison element within the metaphoric unit. Diaphor on the other hand expands its function outside of the metaphoric unit to combine

that unit with its surroundings."[22] Tolbert uses the phrase "God our Father" as an example. In this case, father is the vehicle—the well-known thing—and God is the tenor—the less well-known thing. The epiphor shows the similarity between the vehicle and the tenor, father and God, respectively. Diaphor is the juxtaposition of father and God, from which new meaning is created. Thus, all parables show both similarities with their surroundings and are juxtaposed with them at the same time to create new meanings.

I will mention one final, and the most recent, explanation of metaphor (and metonymy, in this case). Ruth Etchells, in *A Reading of the Parables of Jesus*, turns to David Lodge to explain metaphor and metonymy, which she argues constitutes parables. Lodge uses the words *selection* and *combination* to describe these two literary devices. Selecting "[brings] together the *disparate* in order to indicate the essential *likeness*." Combination refers to coherence—to how things relate to each other (to what belongs to what). Lodge's combination alters metonymy's generally accepted definition of a part replacing a whole. Etchells uses selection and combination as tools to read the parables of Jesus.[23] Lodge's idea of selection generally combines the ideas of Wheelwright's epiphor and diaphor, though with less detail. However, Lodge's description of metonymy potentially does more harm than good. Lodge described a real literary phenomenon in his discussion of combination, but by labeling it metonymy, how then does one describe an instance when a part actually replaces a whole? Does Lodge suggest that another word is needed to describe this previously acknowledged literary device? In some sense, combination is not far off from contiguity, a word commonly used to describe metonymy. However, though coherence and contiguity are contiguous, they are certainly not similar: they are not metaphors or similes. By adopting the language and ideas of Lodge, Etchells may say that she sees the metonymic in the parables of Jesus. She is seeing, though the phenomenon itself is not bad, Lodge's combination: not a part of the whole. Again, she is not doing anything wrong by observing Lodge's combination in the parables. She, however, is an accomplice in altering a word that has a perfectly acceptable and working definition. A scholar, who is trying to discover the metonymic in the parabolic (and in this case, me) might have a problem with the misuse, say, of the word. Her claim that there is metonymy in the parables of Jesus, then, does not lay the groundwork to Crossan's or my claims.

Example Stories

Besides a few solitary voices, most scholars agree on about everything when it comes to parables. However, there are three separate camps when it comes to the genre of "example stories" and how they fit or do not fit with

parables. Although this is a slight and very brief tangent, it would be irresponsible of me not to include this short detour in a paper that has as one aim summarizing the research done on parables. There are three important articles.

First, in 1972, Crossan published an article called "Parable and Example in the Teaching of Jesus," in *New Testament Studies*. His argument was that all of Jesus's parables are parables; none of them are example stories. He reminds his readers that all parables have two readings. There is both a surface-level reading and a metaphorical one. In these "example stories," only the surface level has been read. What this, in fact, does is equate the literal reading with a moral reading. Crossan argues that the metaphorical level readings have just simply been missed and he provides new metaphorical readings on texts that had previously been regarded as example stories.[24]

The next year, Dan O. Via Jr., countered with an article in *Linguistica Biblica*, "Parable and Example Story: A Literary-Structuralist Approach." Via argued directly against Crossan, saying that example stories are just examples. Via sees each story as autonomous and says that what Crossan did was take each story and combine it with the surrounding discourse, thus getting a layered reading.[25]

Twelve years later, Kirkwood argued for something in the middle. He said that there are two types of parables: parables that work as metaphors and parables that work as examples. He claimed that parables that worked as metaphors reveal extraordinary things in the ordinary and that parables that worked as examples "portray extraordinary actions to dramatize familiar moral precepts."[26] He made three observations about metaphors and examples:

(1) Metaphors are irreducible, but examples are expendable.
(2) Examples reinforce pre-knowledge, while metaphors can transcend it.
(3) Metaphors demand participation and personal decisions from listeners; examples are less confrontative.[27]

To weigh in on the issue, I believe that example stories are just example stories and not parables because there is only one possible reading that can be elicited from these stories. What can a reader get out of "The Good Samaritan" other than the injunction to be like the Good Samaritan, a reduced statement of the original story? Parables, however, are like metaphors and they are irreducible and their meaning is inexhaustible.

Defining Parables

The word *parable* comes originally from a translation of the Hebrew word *mashal*. David Stern notes how *mashal*'s root is related to likeness and similarity. In use, it came to have a number of meanings. In the Bible, *mashal* referred to a number of different kinds of language (from figures of speech to proverb and allegories). However, in Rabbinic literature, *mashal* was used to denote the parable or fable something like we know it today.[28] When the Hebrew Bible was translated into Greek in the Septuagint version, *mashal* was translated as *parabolē* (and from this we got *parable*).

The fact that *mashal* has many definitions, most claim around five—riddle, proverb, analogy, allegory, and parable—has been well demonstrated. What has not been argued is that scholars assume that the Septuagint translation of *mashal*, *parabolē*, refers to only "parable" proper. The "parables" of Jesus are riddled with analogies (or similes), example stories, and allegories. There are certainly not 60 or so proper parables.[29] Who is not to say that *parabolē* is a catchall word just like *mashal*? When Jesus spoke his parables, he was telling analogies, allegories, example stories, and proper parables. There has been so much scholarship on defining parables because the one word "parable" can represent four distinct literary genres. We have words for analogy (or simile), example story, and allegory. Parable is the only word for parable-proper. Craig L. Blomberg,[30] then, is partially right: many "parables" are allegories (because the word parable, like the word *mashal*, can mean allegory and a number of "parables" are really only allegories). Blomberg is categorically wrong in saying that *all* parables are allegories. Yes, all parables can have allegorical readings, and allegories can only have allegorical readings—for they offer a one-to-one correspondence with an outside text—but parables are not limited to their possible allegorical readings; they work as metaphors, not as allegories, and are inexhaustible in their interpretation. There has been around a century of scholarship and different readings on the parables. Obviously, if there are hundreds of interpretations, they cannot be allegories, which should yield one-to-one parallel readings. Based on the myriad of interpretations, B. B. Scott must be right: there is no one meaning to the parables.[31] Where Blomberg errs is when he says the major debate between parable scholars is a parable versus allegory debate. This is not the fundamental debate. Almost all scholars say that parables are metaphors and, thus, the real debate, fundamentally, is over metaphors versus allegories. Again, a metaphor may have an allegorical reading, but it is not limited to this allegorical reading. The metaphor is inexhaustible, as evidenced by a plethora of readings. Only allegory is limited to allegorical readings.

To continue to refute the work of one other school of parable studies, I will address those in search of the historical Jesus. There are two scholars who factor prominently in this quest: Joachim Jeremias and Norman Perrin. Jeremias, in *The Parables of Jesus*, attempts "to recover the original meaning of the parables."[32] He calls for the retranslation of the parables into "the mother-tongue of Jesus"[33] and argues that every effort must be made to find the parables "definite historical setting."[34] Expanding on Jeremias's book, Perrin, works as a historian who, in his book *Rediscovering the Teaching of Jesus*, contextualizes his subject, the historical Jesus, in order to separate what he said from the doctrine of the early Church and first-century Judaism. Perrin works off of the work done by Dodd, Jeremias, and Bultmann, who all take up that same quest. The quest for the historical Jesus is ambitious and important. It is important to know that, "The teaching of Jesus was set in the context of ancient Judaism, and in many respects that teaching must have been variations on themes from the religious life of ancient Judaism. But if we were to seek that which is most characteristic of Jesus, it will be found not in the things which he shares with his contemporaries, but in that things wherein he differs from them."[35] Context is a good thing; however, it can limit the power of literature. Literature has the potential for generating multiple interpretations and truths. In the case of Perrin, most especially, his task of finding the historical Jesus limits what Jesus had to say and moreover limits the very definition of parable:

> The secret in interpreting a parable, then, is to find the analogous situation and so come to understand the point of comparison... This is the parabolic method: to tell a story which turns upon a point which has its parallel or analogy within the experience of some of those to whom it is addressed.[36]

Perrin reduces the power of Jesus's teaching to mere analogy or allegory. Because Perrin needed to find a historical equivalent for the "analogies" of Jesus, they become expendable. I say analogy because a story moves beyond its literal meaning. Analogy and allegory work on a one-to-one basis with an outside reality. Metaphor and parable use reality to create something new. They are referents to an outside reality. The power of parable is its ability to reveal the extraordinary in the ordinary. Perrin tries to locate the ordinary in the ordinary by trying to contextualize the parables and link them so closely to the historical Jesus.[37] Via argues that any literary work, which he says the parables of Jesus are, is autonomous; it is independent of the author.[38]

It is appropriate, here, to begin to define parables with the work of the first scholar to really attempt to read the parables of Jesus as works of

literature. Amos N. Wilder, in his seminal book *Early Christian Rhetoric: The Language of the Gospels*, originally printed in 1964, was the first to really define the type of metaphor found in parables: "These are only one kind of metaphor, extended metaphor."[39] Viewing parables as extended metaphor laid the foundation for almost all future scholars. I could cite the words "extended metaphor" in almost every single scholar cited in this article.

There are two other lines of thought that Wilder initiated. First, Wilder noted how "deeper dimensions are married to such ordinariness and secularity."[40] Ricoeur, most notably, followed up on this. He argued that there was an "extravagance" stemming from the paradox and hyperbole found in the parables when comparing human actions to the Kingdom of God; this he described as "the extraordinary in the ordinary."[41] This is also a favorite expression of McFague.

Second, Wilder argued that the parables "are shaped more consistently towards a direct personal appeal or challenge."[42] This challenge that Wilder saw was along the same lines of Hunter's point, cited earlier, that parables are meant to force the listener to reach a verdict. Wilder's point was picked up on most notably by Kirkwood. Kirkwood argues that parables are self-confrontative. Kirkwood argues that "parables are told to arouse both sympathetic and hostile listeners to recognize and overcome those thoughts, feelings, attitudes, and action which impede their spiritual growth."[43] When successful, "Storytelling can briefly override auditors' immediate defenses and introduce views of life which would otherwise have been rejected before they could prompt self-examination."[44] As cited earlier, Ricoeur noted how the parables orient, disorient, and then reorient. It is in the disorientation that the challenge is posed, and the challenge continues for the audience to reorient their reality. In their self-confrontative mode, parables disorient the reader, leaving it up to the reader/listener to put reality back in order.

In his book, *Parables as Subversive Speech: Jesus as Pedagogue of the Oppressed*, William R. Herzog II turns to the social sciences and, both directly and indirectly, addresses the self-confrontative. Herzog poses the following question in his book: "What if the parables of Jesus were neither theological nor moral stories but political and economic ones?"[45] Using Paulo Freire's pedagogy of the oppressed, Herzog reads the parables as codifications:

> ...the interpreter must pay attention to the scenes they encode and attempt to understand how they could generate conversations that enhanced the hearers ability to decode their oppressive reality, or how they encode limit situations depicting limit acts that are intended to challenge the boundaries of their closed world.[46]

It is the shifting back and forth of encoding and decoding that forces the hearers to faces their "oppressive reality." It is only in doing so that their "closed world" will be challenged and begin to open up.

Coming from the field of psychology, Richard Q. Ford views the parables as promoting the art of listening. The act of encoding and decoding that Herzog describes, or the self-confrontation that occurs that Kirkwood describes, works like a patient-therapist relationship. The parable and listener and patient and therapist relationships "offer stably unstable processes in which new experience may be created through difficult collaboration between two connected but unequal participants."[47] This creation of "new experience" gets at the heart of Wheelwright's diaphor. This tension in the metaphor itself is mirrored in the process by which the audience processes the metaphor.

In a final line of thinking, Politzer, in his article entitled "Franz Kakfa and Albert Camus: Parables for Our Time," argued that "the modern parable differs, however, from its traditional model in that it no longer carries a clearcut message, but it is built around paradox."[48] Crossan most notably took that definition and made it central to his definition of parables. He argued, however, that biblical parables are also built around paradox. Crossan defined the parable as such: "*paradoxes formed into story by effecting single or double reversals of the audience's most profound expectations.*"[49] He uses the parable of Jonah to explain. He says the normal prophet story would be that the prophet is called, responds, and then is met with rejection. However, in the Jonah story, we witness a "double reversal:" the prophet flees God's summons and ends up in a place where his message is met with total conversion.[50]

I believe that a specific type of paradox, not only the one defined by Crossan, is central to the definition of parable. What I am arguing for, and where my definition departs from the work of other scholars, is that parables dwell on a type of paradox. Crossan has argued both that, following Politzer, "parable is a paradox formed into story" and that "biblical and contemporary parables agree in posing a metaphysical challenge,"[51] perhaps following up on Wilder's claim that parables pose a "direct personal appeal or challenge."[52] However, Crossan and I seem to be using different definitions of paradox. Crossan never defines paradox, but when speaking about the Jonah parable, he says, "The parable offers a paradoxical double or polar reversal. We expect prophets to obey and pagans, especially Ninevites, to disobey Yahweh, God of Israel. But the story presents us with a most disobedient prophet and with some unbelievably obedient Ninevites."[53] *Paradox*, for Crossan, is defined by the first entry found in the *Oxford English Dictionary*:

"1a. A statement or tenet contrary to received opinion or belief, *esp.* one that is difficult to believe." Crossan in no way intends paradox to have the self-contradictory definition that I am using: "2a. An apparently absurd or self-contradictory statement or proposition, or a strongly counter-intuitive one, which investigation, analysis, or explanation may nevertheless prove to be well-founded or true."

Addendum #2: Parables in Drama

There are uncountable scores of books and articles theorizing the form of drama and, though not as many as one would think, a hefty number of books and articles theorizing the form of parables. There are, in addition, numerous articles and just a few books that read plays as parables. However, besides two book chapters spread apart 30 years that only indirectly explore this form, there is almost no scholarship exploring this hybrid form in sustained detail.[1] I will spend this section exploring the implications of this form.

In 1962, in a book entitled *Contemporary Theatre*, G. W. Brandt wrote a chapter called "Realism and Parables: from Brecht to Arden." The book was released without an editor and this chapter, especially, has seemingly been lost to both time and memory, with it rarely, if ever, cited in future scholarship. Maybe part of the reason that Brandt's chapter was not cited in the future is that his definition of a parable is only partly in line with those of preeminent parable scholars. To be fair to Brandt, in 1962, parable form-criticism was only just beginning to take shape, and this happened only within a very small academic circle. Brandt came only a couple years short of 1964, which saw the publication of Amos N. Wilder's seminal book, *Early Christian Rhetoric*, on parables that fully argued that parables should be read and analyzed like any other piece of literature, pose a challenge, and are not, in fact, moral tales at all, but just stories. Also, in 1964, Geraint Vaughn Jones published his book, *The Art and Truth of the Parables*, which argued many of the same things. The rest of the 1960s and 1970s saw an explosion of form-criticism on the parable, as relayed in Addendum #1.

Brandt did not cite any of these sources within this small, but soon to be bourgeoning field, but at the same time, he was not so off base. Like many future parable scholars, Brandt started his chapter with an analysis of how parables differed from allegories: "Like allegory, the parable teaches by means of stories, images, conceits. But whereas allegory tends to be abstract

and philosophical, the parable tends to be earthy, concrete and sensuous."[2] Brandt went on to argue that, like the thesis play, the parable is didactic, but oblique and poetic. Brandt is right on target with some of his observations, but not with all of them.

Brandt is right in observing that parables are earthy and concrete. Parables are thoroughly human tales that are concrete in that, as A. M. Hunter says, "the story-parable describes not what men commonly do but what one man did."[3] In this way, parables describe, not general, but very concrete and specific human actions and interactions that take place in an "earthy," thoroughly human realm. Speaking about the parables of Jesus, Wilder noted how human and realistic they were, even going as far as saying that one could speak of their secularity.[4] This secularity is distinctly "earthy" as opposed to otherworldly and divine. Paul Ricoeur, in a much quoted essay, "Biblical Hermeneutics," put this realism into different words: words picked up by Sallie McFague that became central to her scholarship. Ricoeur commented, following the lead of others, that the parables presented the "extraordinary in the ordinary."[5] His reasoning behind this statement was that the parables are full of paradox and hyperbole, yet all of the tales are realistic. However, since the actions of humans (specifically in the parables of Jesus) are somehow compared to the Kingdom of God, there is "extravagance" present in these ordinary tales.[6] Maybe Brandt saw this extravagance and labeled the parables, instead, as sensuous.

Brandt spent the majority of his chapter reading plays with this less-than-perfect definition. He should be much admired for taking a stab at defining a genre, however, particularly at the time when he did, for he did not have a lot of scholarship to consult. Based on Brandt's (mis)understanding of parables, he created a statement at the end of the chapter that he probably did not realize how right he was:

> If we regard the parable as a mathematical demonstration, the equation never quite works out, without for that reason being wrong. Apart from what they may teach us about how to order our lives, the Wise and the Foolish Virgins stay with us as an image.[7]

What is missing, as I already observed, in Brandt's definition, to name one thing, is the idea of metaphor's central role in parable. What Brandt does not realize that he is describing here is metaphor and extended metaphor. The importance of the image, or the metaphor-image, is key to my understanding of how parables work in drama, as you will see briefly. Brandt's chapter, then, helped to establish what parable was and how parables can be expressed in theatre.

Jenny S. Spencer, 30 years later in 1992, in her book on Edward Bond, entitled *Dramatic Strategies in the Plays of Edward Bond*, has a very important chapter on Bond's political parables. Spencer's chapter is so important because she begins to theorize how parable works uniquely in drama, as opposed to in its common narrative form. Spencer makes three separate observations about the peculiarities of parables in drama. First, she remarks how "the parable invites a particular interpretive stance from its audience."[8] As argued by almost every scholar since Wilder, parables leave the interpretation up to the audience. Wilder says, "The parables of Jesus, in addition to their revelatory character, are shaped more consistently towards a direct personal appeal or challenge."[9] This point has been taken up by John Dominic Crossan, who argued that parables confront the audience with a "metaphysical challenge"[10] and William G. Kirkwood, who argued that parables are self-confrontative.[11] Though Spencer is discussing Edward Bond, a decidedly Brechtian playwright whose aesthetic for the theatre was to challenge audience members by making them think and not feel, Spencer does not limit this insight to just Bond's political parables.

Second, Spencer notes how parables work by indirection. She explains how parables do not present their arguments directly, but indirectly. For, unlike example stories like "The Good Samaritan" where the audience is supposed to do as The Good Samaritan does, parables do not create exemplary characters whose actions are meant to be followed. As Spencer argues, parables do not present their arguments by what the characters necessarily do:

> As an art form, the parable does not impart knowledge directly, but through narrative, privileging the story as a method of learning. But in Bond, as in Brecht, what the audiences learn is not identical to what the characters do; and summarizing statements of "meaning" inevitably distort the dialectical nature of the "truths" being explored.[12]

Instead of the characters serving as examples, Bond and Brecht, for example, "truth" comes about in an oblique and dialectical manner. It is the clash of characters and the clash of actions from which meaning emerges. Though she does not say it, she could be speaking about metaphor. Metaphor works by indirection as we have heard already from Funk: metaphor intends much more than it says. And metaphor gets meaning from the clash of objects being compared, both in their similarity and difference. As Mary Ann Tolbert best explains metaphor, there is both a comparison aspect in metaphor where one thing is shown in similarity to another thing, and a juxtaposition aspect where two dissimilar things are brought together to create

new meaning.[13] Just as in metaphor where meaning is created in the clash of things, meaning in parables is created through the clash of characters and actions, not by the actions of just one character. Meaning is elicited *through* interaction, not by solitary existence.

Third, and finally, Spencer notes how parables are structured in order to subvert common beliefs and reorder our way of thinking:

> Like the New Testament parables, its narrative structure and evocative images are aimed at a "redescription of human possibility"—a method whereby ordinary ways of envisioning relationships are overturned and previously accepted values questioned in ways that the audience, when faced with their own ethical choices, might find useful.[14]

Going further than just demanding interpretation from the audience, parables are subversive narratives that "redescribe" the world. Ricoeur says that parables orient, disorient, and then reorient the audience, and in this process reality is redescribed through the necessary act of interpretation.[15] Kirkwood explains that parables are designed to force self-examination; they confront states of awareness and/or beliefs and attitudes.[16] In the process of interpretation, the audience has to confront their own beliefs to make sense of the parable. Unlike the myth, and by extension, the fairy tale,[17] where the narrative reinstate a sense of order and reinscribe the social mores of the time, Crossan writes that parables create a sense of disorder.[18] This disorder needs to be reordered in the mind of the audience and, thus, reality is redescribed through that reordering.

Spencer, given the fact that her chapter is not immersed in parable research, does a very commendable job at bridging the gap between the form of the parable and drama. Her observation about the need for interpretation from an audience clearly aligns the forms of parables and drama. However, there is one minor point in which she is at odds with parable studies, and two points which she does not stress that are integral to parable studies. First, though calling parables "less explicitly didactic than many of Bond's plays," Spencer does nothing to dispel the myth that parables are didactic and says that parables are "attuned from the beginning to moral argument."[19] As stated earlier, once scholars like Hunter, Wilder, and William A. Beardslee began to pronounce that the parable should yield a variety of interpretations just like the rest of literature, the sense that parables contained one moral, as argued by Jülicher and Dodd, began to fade. Parables are only didactic in the sense that all other literature is didactic: it offers a reading of reality. In the case of parables, the job of reordering reality is left up to the audience after the audience is left to interpret the text itself. What Spencer may have

done was conflate the specifically didactic playwrights, Brecht and Bond, and their parables, with the idea that all parables have a moral or a lesson or try to teach something.

There are three major properties that parables possess that remain unstated in Spencer's chapter. First, Spencer falls short of calling parables extended metaphors. Practically every parable scholar, most especially McFague, defines parables at base as metaphors. Spencer comes closest to this idea when she discusses the idea of indirection. However, as explained earlier, from Dodd on, parables are structured tightly as extended metaphors and are not just metaphoric, as literature tends to be. Second, Spencer does not argue that parables take place in an ordinary world. Also, as explained earlier, parable scholars, most especially Ricoeur and McFague, define parables as taking place in an ordinary world, though something extraordinary is conveyed through that ordinariness. And third, Spencer fails to notice the paradox, reversal, or turn present in parables.

Though I bring a more complete definition with some new elements to parables in drama, what I aim to do is explain why parables take their most perfect form in drama and how drama helps enlighten us about parables. I have four points to introduce. First, I am merely going to draw upon and expand the observations of other parable scholars who noted the dramatic quality of parables. Second, I will add that the presence of gesture in drama creates a metaphor within an extended metaphor, a mini-parable within a parable. Third, parables work so well in drama because the ontological paradox found in parables—the tension of the possibility and impossibility of being—is embodied in the phenomenological presence of all that is on stage. "The thing itself" is both possibly and impossibly the presentation, the representation and the real. And fourth, working off of performance studies' idea of performativity, I will argue that parables have an *agenda of transformation*, and that this makes them political, and accounts for the fact that parables are so often thought of as didactic, moral, and/or ethical tales.

First, drama makes us aware of the interaction between the author, the text, and the audience. Meaning cannot be recovered from the act of performance without taking into account the interaction between all three elements. Sallie McFague explains that a triangle is an apt way to show how meaning is also made in parables:

> ...the setting of the parable is triangular. The components of the triangle are source or author (Jesus as narrator), the aesthetic object (the parable narrated), and the effect (the listeners to whom the parable is narrated). This triangle pattern points to the original situation of the parables: Jesus

told stories to people. All three factors should operate in any analysis of the parables, for they cannot be abstracted from their source or from their listeners.[20]

The point that is being made is the play or the parable cannot be judged just on its own merit, but one must take into account that these are transmitted works that have an author and an audience. Ricoeur argues that because of this relationship, parables constitute a language "event," for the language is the medium of the speaker, a dimension of the world and its reality, and a dialogue between humans.[21] This dialogue is twofold in both drama and in parables. In drama, there is dialogue between characters and a metaphorical "dialogue" between the actors, the playwright, and the audience. The same holds true for parables.

Ric Knowles complicates this notion, offering up a more complex triangle in his book, *Reading the Material Theatre*. Knowles creates a triangle with "Performance," "Conditions of Performance" and "Conditions of Reception."[22] In order to elicit meaning from a performance, the interplay among these three elements must be analyzed. The "script, *mise en scène*, design, actors' bodies, movement and gestures, etc., as reconstituted in discourse" must be accounted for in studying the "Performance Text." Similarly, "the actor, director, designer training and traditions, rehearsal process, working conditions, stage and backstage architecture and amenities, historical/cultural moment of production, etc.," must all be thought about when reading the "Conditions of Production." And finally, "publicity/review discourse, front-of-house, auditorium, and audience amenities, neighborhood, transportation, ticket prices, historical/cultural moment of reception, etc.," all go into making meaning for the "Conditions of Reception."[23] Thus, for example, in order to analyze the meaning of a play, one cannot just look at the script, but must also look at the rehearsal process and the historical moment of reception, or cannot just look at the design, but must also look at the actor and the ticket prices. In fact, one must take into account every one of these elements in making meaning of a production. Offering a "materialist semiotics," Knowles cites Stuart Hall as providing a theoretical framework for understanding how meaning is transmitted in plays:

Hall's work is useful here for the ways in which, in application to the theatre, it provides a model for bringing together the cultural and specifically theatrical relations of the *production* of signs (what Hall calls "encoding")...with relations of *reception* (what Hall calls "decoding")...that frame "the entire theatre experience."[24]

It is the "encoding" and "decoding" process that is so important to both drama and parables. In two genres that rely on an audience, as Spencer noted, to make meaning, all factors that go into the "production" and "reception" of the text are important. However, although Knowles's work deserves a place here, a word of warning is merited. This "materialist semiotics" approach, though not with this title, has been attempted in two major works in parable studies. As mentioned earlier, Jeremias wrote a book on the historical Jesus that took into account the historical moment and the subsequent production and reception of the text. Likewise, later, in 1967, Norman Perrin wrote *Rediscovering the Teaching of Jesus* that had the same agenda.[25] Though in vogue for a short while, the project of "rediscovering" the original meaning that would have been gotten from Jesus's parables at the time when they were written was dismissed by almost the entire field of parable studies because these readings tended to limit the possibilities of interpretation. Like Perrin, if one were to only use a "materialist semiotics" approach, one gains a contextual meaning while possibly losing all of the possibilities of meaning that a text can generate. In studying parables, because their history is so closely tied to the parables of Jesus, one is always aware that there is a fine line between contextual and textual readings that can significantly alter the way the parable is received. Parables and drama share this same burden of navigating this tenuous ground.

Apart from dialogue and the interaction between the author, text, and audience, plays and parables rely on the plot to relay meaning. Dan Otto Via Jr. notes how parables and especially "literature of the stage" have a "dramatic quality...centered in encounter—characteristically involving conflict—and in dialogue." Via explains that the "primacy of plot in the parables makes the Aristotelean literary approach especially pertinent, for the heart of Aristotle's famous definition of tragedy is that it is the imitation of a serious action."[26] McFague observes, in this vein, that it is not who the characters are in parables that count, but what they do.[27] Beardslee argues that this action is forward-moving and has a dramatic structure because of this. There is a move to climax and resolution and "moving the participant, so to speak, into an open future."[28] The same can be said for drama. In sum, drama and parables share a triangle of meaning between author, text, and audience; they are language events; they both depend on plot, conflict and dialogue; and they are both in a present tense moving toward a future. Thus, we may apply many of the same techniques of literary criticism in evaluating both forms.

Second, when a parable is performed onstage, the presence of gesture takes on added significance. Alone, a gesture works as a metaphor. However, within the larger text, a gesture is metonymic. A part takes on the significance

of a whole and a parable is created within a parable in drama. Let me use an example to explain. Amiri Baraka's short play, "Great Goodness of Life: A Coon Show," is about an African-American postman who is on "trial" for harboring a murderer. The voice of the judge tires him out until he finally admits to something he is unaware of. The only way that he can go without punishment is if he kills the murderer with a gun provided by the judge. The murderer is led in and sits kneeling before the postman, about to be executed. Before the postman shoots, the "murderer" says," Dad." The play is a parable about the possibility and impossibility of African-Americans to survive in a world destined to make them destroy their own self-interests. This gesture, then—a father standing over his kneeling son with a gun pointed at his son's head—metonymically describes the situation of the parable, offering a mini-parable within the larger parable. Gesture, both metonymically and metaphorically, doubles as a means to convey meaning within the larger parable.

Third, the ontological paradox of being present in parables is doubled in the phenomenologically dubious presence of the actor (as well as scenery) onstage. Stanton B. Garner Jr. deals specifically with this subject in his book, *Bodied Spaces: Phenomenology and Performance in Contemporary Drama*. Garner writes, "Play, Derrida claims, is the disruption of presence, and nowhere is this more evident than in the play of performance, where presence (in the sense of the object's perceptual stability) is occluded, multiplied, feigned."[29] The body of the actor is both a real entity capable of even, let us say, dying, but at the same time is only both presentational and representational of a made-up construct. Garner argues that in order to view theatre, one must partially occlude the presentational to make room for the representational.[30] In the same respect, Herbert Blau comments that in theatre there is a "scandalous dividing line" between what is and what is not and that this interplay threatens "the possible domination of mere appearances."[31] This subject is most fully taken up in Bert O. States's already classic book, *Great Reckonings in Little Rooms: On the Phenomenology of the Theater*:

> The actor is living proof that the play is true: he takes the words from the poet's lips and gives them back, causing him to say, like Voltaire on hearing Clairon in his play, *"Did I really write that?"* In other words, the poet's copy falls into nature in the form of a demonstration. One might say that in becoming Hamlet or Juliet the actor throws himself into the gap between the hypothetical and the real.[32]

Being becomes something that is simultaneously real and fake, possible and impossible. The ontological paradox found in parables is phenomenologically

found in the body of the actor. The very nature of being is thrown into question.

And fourth, based on parable's performative nature, though not inherently didactic, moralistic, or ethical, these elements may be accounted for using the paradigm of drama and performance. Working off of Erving Goffman and Victor Turner, States, in his essay "Performance as Metaphor," argues that for something to be "essentially performative" it must yield an interaction with the spectator. A performative event, he says, "is the manipulation or mediation of empirical reality toward what is surely an artistic statement being made about reality."[33] Alan Read, in his book *Theatre and Everyday Life: An Ethics of Performance*, sees theatre manipulating reality in the same way. Read says, "Theatre is worthwhile because it is antagonistic to official views of reality."[34] Using this as a basis for the performative nature of theatre, we can say the same thing about parables. Parables, most especially, "redescribe" reality, as Ricoeur sees it. Read goes on: "In all situations the everyday has to be known before its theatre can be understood."[35] As we learned from parables, the extraordinary is taken from the ordinary. But it is the orientation and the following disorientation of the reality that we know that produces a necessary reorientation of the world. This reorientation is done by the "spectator" (the reader or listener) after the text has done the act of orientation and then disorientation. In this way parables are performative. States, however, sees the performative act as accomplishing something very specific. He argues that the performative is always transformative:

> … a theory of performance has to begin at the ontological floor where the human desire to participate in performative transformation begins.[36]

Performance "redescribes" a reality in order to bring a viewer or reader into another state of consciousness. Parables, most particularly, have, what I call, an *agenda of transformation*. Kirkwood discusses the self-confrontative nature of the parable. It is the parables job to offer up a reality that must be reordered in the minds of the listeners or readers; in this process, the notion of self and how that self acts in the world must be confronted.

Notes

Introduction

1. Jean Anouilh, "Godot or the Music-Hall Sketch of Pascal's Pensées as Played by the Fratenllini Clowns," *Arts* #400, January 27, 1953, *Casebook on Waiting for Godot*, ed. Ruby Cohn (New York: Grove Press, Inc., 1967), 12.
2. I have made this argument elsewhere: Michael Y. Bennett, "The Female Absurd," Comparative Drama Conference: Loyola Marymount University. 26 March 2010.
3. I have made this basic argument elsewhere: Michael Y. Bennett, Review-Essay: "Away from the Absurd?: The Critical Response to Beckett at 100,"*Kritikon Litterarum* 36.1/2 (2009), 230–238.
4. Martin Esslin, *The Theatre of the Absurd* (New York: Anchor Books, 1961), xix.
5. Marc Blanchard, "Before Ethics: Camus's *Pudeur*," *MLN* 112.4 (1997), 667.
6. For two very in-depth discussions of the history and variations of the word and concept of the Absurd, see Ramona Fotiade, *Conceptions of the Absurd: From Surrealism to the Existential Thought of Chestov and Fondane* (Oxford: Legenda, 2001), 2–4; and Neil Cornwell, *The Absurd in Literature* (Manchester: Manchester University Press, 2006), 2–32. However, although Cornwell complicates the notion of the Absurd, especially in his Introduction, Cornwell does nothing to challenge Esslin's conception of it in his chapter on the Theatre of the Absurd (126–157).
7. James E. Robinson, "Sisyphus Happy: Beckett Beyond the Absurd," *Samuel Beckett Today/aujourd'hui* 6 (1997), 345.
8. Brigette Le Juez, *Beckett Before Beckett*, Trans. Ros Schwartz (London: Souvenir Press, 2008), 13–14.
9. Ibid., 17.
10. Martin Esslin, *The Theatre of the Absurd* xx.
11. Ibid., xii.
12. Ibid., xiii.
13. Ibid., xviii–xix.
14. Ibid., xix.

15. Ibid.
16. Ibid.
17. Ibid.
18. Ibid.
19. Ibid.
20. Ibid.
21. Ibid., xx.
22. Ibid., xix–xx.
23. Ibid., xx.
24. Ibid.
25. Ibid., xxi.
26. Ibid.
27. Ruby Cohn, "Introduction: Around the Absurd," *Around the Absurd: Essays on Modern and Postmodern Drama*, Enoch Brater and Ruby Cohn, eds. (Ann Arbor: The University of Michigan Press, 1990), 1.
28. Enoch Brater, "Rethinking Realism and a Few Other Isms," *Around the Absurd: Essays on Modern and Postmodern Drama*, Enoch Brater and Ruby Cohn, eds. (Ann Arbor: The University of Michigan Press, 1990), 294.
29. Ibid., 295.
30. Telory W. Davies, Performance Review of *Rhinoceros*, *Theatre Journal* 54.4 (December 2002), 645–46; J. Chris Westgate, Performance Review of *Waiting for Godot*, *Theatre Journal* 56.2 (May 2004), 301–303; Vreneli Farber, Performance Review of *Waiting for Godot*, *Theatre Journal* 53.4 (December 2001), 653–55; Karen Bovard, Performance Review of *Peter and Jerry: Act I: Homelife, Act II: The Zoo Story*, *Theatre Journal* 56.4 (December 2004), 691–93; Alvin Klein, "Theater: Crazy But True, Ionesco at the Shakespeare Festival," *The New York Times* (20 August, 2000), 14NJ; Charles Isherwood, "Theater Review: *Waiting for Godot*: Those Two Tramps Again, Stuck in Place after 50 Years," *The New York Times* (26 October, 2006), E5; Leah Lowe, Performance Review of *The Birthday Party*, *Theatre Journal* 56.3 (2004), 508N10.
31. Naomi Siegel, "Theater Review: At a Party with a Dark Side, Menace and Peril Pay a Visit," *The New York Times* (1 October, 2006), 14NJ, 12; Jane Gordon, "Theater Review: An Albee Revival (and a Premiere)," *The New York Times* (6 June, 2004), 14CN, 5.
32. Ben Brantley, "Language, the Muse that Provokes Stoppard and Albee" *The New York Times* (18 February, 2008), E5.
33. Ibid.
34. The Theatre of the Absurd has had a resurgence of scholarship since 2000. At the time of composition of this article, 34 entries come up in the *MLA International Bibliography* between 2000 and 2007 for a search of the "Theatre of the Absurd." And all of the books recently written about absurdity are not included in this list. Besides the scholarship that continues to surround the "usual suspects," there is new interest in Latin American absurdist drama. What is significant about some of these articles is that, in each of their own ways, they—almost unknowingly—start to break down some of the assumptions

of the Theatre of the Absurd. Four of the recent articles have all be trying to make sense of what Esslin saw as the contradiction between what happens on stage and what is said. Phyllis Zatlin, Frédéric Serralta, Paul Simpson, and Darja Hriba all discuss, in a matter of speaking, the *incongruity* present in the plays of the Theatre of the Absurd: Zatlin talks about ambiguous endings; Serralta discusses the language of nonsense in the theatre; Simpson discusses lingual incongruity in the mismatch between strategy and context; and Hriba explores how, in Pinter, traditional forms of language used out of context create the sense of nonsense. See Phyllis Zatlin, "Greek Tragedy or Theatre of the Absurd?: Montes Huidobro's *Oscuro total*," Latin American Theatre Review 37.2 (2004), 115–126; Frédéric Serralta, "Sobre el teatro del absurdo (de Juan del Encina a Juan Mateu),"*Revista de Literatura* 67.133 (2005), 181–190; Paul Simpson, "Odd Talk: Studying Discourses of Ambiguity," *Exploring the Language of Drama: From Text to Context*," Jonathan Culpeper, Mick Short and Peter Verdonk, eds. (London: Routledge, 1998), 34–53; Darja Hribar, "Rewriting the Dramatic Convention of the Theatre of the Absurd in Slovene Translation*," On the Relationship Between Translation Theory and Translation Practice*, Jean Peeters, ed. (Frankfurt: Peter Lang, 2005), 141–149; Celeste Derksen, "A Feminist Absurd: Margaret Hollingsworth's The House that Jack Built," *Modern Drama* 45.2 (Summer 2002), 209–230.

35. Actually, Esslin, himself, addressed this idea in his Conclusion to The Theatre of the Absurd, "The Significance of the Theatre of the Absurd," and later in his 1965 book, *Absurd Drama*. In *The Theatre of the Absurd*, Esslin beautifully writes in his second-to-last sentence, "For the dignity of man lies in his ability to face reality in all its senselessness; to accept it freely, without fear, without illusions—and to laugh at it" (316). I include this quote here, rather than with the rest of *The Theatre of the Absurd*, because in many ways this understanding of the absurd is much more of an afterthought because it does not impact the theoretical frame that Esslin establishes in his Introduction and it does not really impact Esslin's reading of the plays in his book. Even more importantly, this last section did not seem to have any lasting impact on the field and obviously did not do enough to overturn the conception that Esslin establishes in his Introduction and the majority of the book that the plays of the Theatre of the Absurd purport the meaninglessness of life. Therefore, it took many years for some other voices to start echoing Esslin's sentiment about laughing in the face of absurdity.

 As I point out elsewhere, Esslin was not the first scholar to characterize Beckett's work as "absurd." (Bennett, *Away from the Absurd?*). In 1954, Edith Kern, in what appears to be the first academic article on Beckett, says that *Waiting for Godot* portrays, "the absurdly comical situation" of man's place in the universe" (45). As a comical world, Kern's Beckett envisions human tenderness as giving humans strength and replacing a God-like redeemer: "Beckett's characters in [*Waiting for Godot*] glorify rather the all-surpassing power of human tenderness which alone makes bearable man's long and ultimately futile wait for a redeemer and which, in fact, turns out itself to be the redeemer of

man in his forlornness (47). This reading stands in stark contrast to Esslin's Beckett, who imagines the world without a God and, thus, purpose. Kern's comical absurd lacks the existential overtones of meaninglessness in a world of nothingness.

Writing in 1997, James E. Robinson follows David Helsa, who in *The Shape of Chaos* argues that Beckett was pigeonholed as an absurdist. Robinson suggests that Beckett, at least in his later plays of the 1970s and 1980s, moves beyond the, "existential assumptions about being-in-consciousness and being-in-language," through Beckett's exploration of the contradiction of life and death. (343, 345). Though his argument is not detailed and he does not challenge Esslin, he does acknowledge, however, that for Camus there is life after absurdity (345).This is the question that Camus ultimately poses: So life is absurd...what do we do about it?

Martin Esslin eases his hard-line stance on the purposelessness of life in his 2001 article, "Beckett and the Quest for Meaning." Esslin argues that even though humanity exists in an unexplainable world, we can still be "filled with profound awe and wonder" (29). Esslin concludes the article by saying:

> ...once the illusory gratifications have been exposed as a sham, the real pleasures it has to offer can be truly savored; they become more precious the more we are aware of their precariousness. The world may be a catastrophe, yet the protagonist who has been manipulated to represent it, at the very last moment raises his head in defiance. And those who feel they can't go on, yet go on. (30)

As I will discuss later in my examination of Camus's *The Myth of Sisyphus*, "defiance" is key, first of all, in understanding Camus and to a new understanding of the Theatre of the Absurd plays.

Writing that Ionesco *engages* with the questions of faith and meaning rather than dismiss their possibilities, Herbert Blau, in "The Faith-Based Initiative of the Theater of the Absurd," argues that in the Theatre of the Absurd, particularly the theatre of Eugene Ionesco, offers the audience two possibilities to understand the plays: we can "take it on faith" and/or "laugh out loud" (4). With "the plenitude of unexpectedness, contradiction, and aleatoric calculation," the indeterminacy of the Absurd does not make sense if it is known that there is no divinity (4–5). Blau suggests that Ionesco constantly "returns to the tortuous question of whether or not there is meaning in the world"; Blau concludes that Ionesco refuses to accept that "the natural is incurable" (11). For Blau, even if the world was purposeless for Ionesco, "there is still in the texts the prospect of performance that is nevertheless enlivening...ebullient in negation" (12). "The vertigo of nothingness" reversed entropy and the "law of increasing disorder and evanescence" found in the Absurd, gave the universe its energy (12–13).

36. Martin Esslin, *The Theatre of the Absurd* (New York: Anchor Books, 1961), xix.

37. Albert Camus, *The Myth of Sisyphus and Other Essays*, Trans. Justin O'Brien (New York: Vintage Books, 1955), 96.

38. Richard Schechner, "An Interview with Ionesco," Trans. Leonard C. Pronko, *The Tulane Drama Review* 7.3 (Spring 1963), 167.
39. Ibid. ,163.
40. Eugene Ionesco, "Dans les armes de la ville," *Cahiers de la Companie Madeleine Renaud-Jean-Louis Barrault* 20 (October 1957), 3.
41. Ibid.
42. Ibid. ,4.
43. Esslin, *The Theatre of the Absurd*, xix.
44. Ibid.
45. Ionesco, "Dans les armes" 4. "...et ce but final ne peut se trouver qu'au delà de l'histoire, il est ce qui doit guider l'histoire humaine, c'est-à-dire lui donner sa signification."
46. Ibid.
47. Ibid.
48. Ibid.
49. Ibid.
50. Camus, *The Myth of Sisyphus,* v–vi.
51. David Carroll, "Rethinking the Absurd: *Le Mythe de Sisyphe,*"*The Cambridge Companion to Camus*, ed. Edward J. Hughes (Cambridge: Cambridge University Press, 2007), 53.
52. Charles Forsdick, "Camus and Sartre: The Great Quarrel," The Cambridge Companion to Camus, ed. Edward J. Hughes (Cambridge: Cambridge University Press, 2007), 119.
53. Ibid., 120.
54. Ibid., 121.
55. Albert Camus, *The Myth of Sisyphus and Other Essays*, Trans. Justin O'Brien (New York: Vintage Books, 1955), 23.
56. Ibid.
57. H. Gaston Hall, "Aspects of the Absurd," *Yale French Studies* 25 (1960), 27.
58. Ibid.
59. Ibid., 26.
60. Philip Hallie, "Camus and the Literature of Revolt," *College English* 16.1 (Oct. 1954), 26.
61. Ibid.
62. Camus, *The Myth of Sisyphus*40.
63. Ibid. As Justin O'Brien translates the line from the French—"*Il apparaît ici au contraire qu'elle sera d'autant mieux vécue qu'elle n'aura pas de sens*" (Albert Camus, *Le mythe de Sisyphe: Essai sur L'Absurde* [Gallimard, 1942], 78)—he uses the conditional "if" for the word "*qu'elle.*" Though the word "if" does not actually exist in the sentence, O'Brien captures the correct essence of the sentence using this word. This sentence is dependent upon the sentence before it, as it stands to contradict it, and the conditional is, thus, necessary to make sense out of the sentence.
64. Sir Herbert Read, Forward, in Albert Camus, *The Rebel: An Essay on Man in Revolt* (New York: Vintage Books, 1956), vii. For the purposes of this article,

it is not necessary to show where *The Myth of Sisyphus* and *The Rebel* diverge in the philosophy of Camus. For an excellent discussion of this, however, see the chapter "The Transition from *The Myth of Sisyphus* to *The Rebel*" in Avi Sagi, *Albert Camus and the Philosophy of the Absurd*, trans. Batya Stein (Amsterdam: Rodopi, 2002), 107–116.

65. Camus, *The Myth of Sisyphus*44.
66. Carroll, "Rethinking the Absurd" 54
67. Camus, *The Myth of Sisyphus*91.
68. Ibid.
69. Blanchard, 667.
70. Fotiade, 226.
71. Jeffrey Gordon, "The Triumph of Sisyphus," *Philosophy and Literature* 32 (2008), 184.
72. Jacques Ehrmann, "Camus and the Existential Adventure" *Yale French Studies* 25 (1960), 94.
73. Lawrence D. Kritzman, "Camus' Curious Humanism or the Intellectual in Exlie," *MLN* 112.4 (Sept. 1997), 552.
74. Ibid., 550.
75. Ehrmann, 94.
76. Ibid., 93.
77. Peter Royle, *The Satre-Camus Controversy: A Literary and Philosophical Critique* (Ottawa: University of Ottawa Press, 1982), 87. This characterization helps strengthen Beckett's interest in Descartes with Camus's philosophy: see my review-essay, "Away from the Absurd?: The Critical Response to Beckett at 100."
78. Debarati Sanyal, "Broken Engagements," *Yale French Studies* 98 (2000), 29.
79. Blanchard, 667.
80. For more on this, see my review-essay, "Away from the Absurd?."
81. Max Horkheimer and Theodor W. Adorno, *Dialectic of Enlightenment*, Trans. John Cumming (New York: Continuum, 1972), xiv.
82. Ibid., xv.
83. Tony Judt, *Postwar: A History of Europe Since 1945* (New York: Penguin Books, 2005), 86.
84. Ibid.
85. Ibid., 87.
86. Ibid., 93.
87. Ibid., 94.
88. Ibid., 97.
89. Ibid.
90. Jill Dolan, *Utopia in Performance: Finding Hope at the Theater* (Ann Arbor: The University of Michigan Press, 2005), 5.
91. Ibid.
92. Ibid., 10.
93. Ibid., 11.
94. Michel Foucault, *The Order of Things: An Archaeology of the Human Sciences* (New York: Vintage Books, 1970), xvii.

95. Ibid., xx.
96. William W. Demastes, *Theatre of Chaos: Beyond Absurdism, Into Orderly Disorder* (Cambridge: Cambridge University Press, 1998), xii.
97. Ibid., xiii. This is at odds with Gaensbauer's thought that, "The theater of the absurd is a theater of stasis and defeat in which the theme of death is omnipresent" (xviii).
98. Foucault, xviii.
99. See Jacques Derrida, "Différance," *Speech and Phenomena*, Trans. David Allison (Northwestern University Press, 1973) and "Plato's Pharmacy," *Dissemination*, Trans. Barbara Johnson (Chicago: The University of Chicago Press, 1983).
100. Ibid.
101. Tobin Siebers, "Introduction: What Does Postmodernism Want? Utopia," *Heterotopia: Postmodern Utopia and the Body Politic*. Tobind Siebers, ed. (Ann Arbor: The University of Michigan Press, 1994), 10.
102. Ibid., 20.
103. Here I disagree with Gaensbauer: "[The theater of the absurd] depicts an unshakable kind of alienation that does not lend itself to an intellectualized response. The theater of the absurd is not primarily a theater of dialogue and ideas but an immediate, gut-level rendering of rejection, isolation, and futility" (Deborah B. Gaensbauer, *The French Theater of the Absurd* [Boston: Twayne Publishers, 1991], xviii).
104. Esslin, *Theatre of the Absurd* xxi.
105. Blau, 10.
106. Aristotle, *Poetics* (Mineola: Dover Publications, Inc., 1997), 14.
107. George Wellwarth, *The Theater of Protest and Paradox: Developments in the Avant-Garde Drama*, Revised Ed. (New York: New York University Press, 1971), x.
108. Esslin, *The Theatre of the Absurd*, 316.
109. Albert Camus, *The Rebel: An Essay on Man in Revolt* (New York: Vintage Books, 1956), 4.
110. Martin Esslin, "What Beckett Teaches Me: His Minimalist Approach to Ethics," *Samuel Beckett Today* 2 (1993), 13.
111. Eugene Ionesco, "The Bald Soprano," *Four Plays*, Trans. Donald M. Allen (New York: Grove, 1958), 30.
112. Ibid.
113. Ibid.
114. Bert O. States, "Performance as Metaphor," *Theatre Journal* 48.1 (1996), 1–26.
115. George Wellwarth sees the theatre that he calls either "avant-garde" or "theatre of the absurd" taken the theme of protest and the technique of paradox (*The Theater of Protest and Paradox* [New York: New York University Press, 1971], x).
116. John Dominic Crossan theorizes that the main difference between myth and parable is their differing move to order or disorder. Myth moves to order; parable moves to disorder (*Raid on the Articulate: Comic Eschatology in Jesus and Borges* [New York: Harper & Row, Publishers, 1976], 98–101).

117. Paul Ricouer, "Biblical Hermenutics," *Semeia* 4 (1975), 126.
118. This contention is supported by recent scientific findings as reported in a recent article in *The New York Times* (Benedict Carey, "How Nonsense Sharpens the Intellect," *The New York Times*, 6 October 2009, D1, D7). When faced with the absurd, uncanny, and/or nonsense, researchers have demonstrated that subjects may turn outward to discover hidden meaning. For example, a study had twenty college students read Franz Kafka's "The Country Doctor" and then read through lists of seemingly-random, but subtly-arranged strings of letters. Tested later on whether or not they saw the same letter strings earlier, the 20 college students outperformed the 20 other students who read a different short story by about 30 percent and were almost twice as accurate. *The New York Times* article concludes: "... at least some of the time, disorientation begets creative thinking."
119. William G. Kirkwood, "Storytelling and Self Confrontation: Parables as Communication Strategies," *Quarterly Journal of Speech* 69 (1983), 65–68.
120. Ruby Cohn, "Introduction: Around the Absurd," *Around the Absurd* (Ann Arbor: The University of Michigan Press, 1990), 1.
121. Celeste Derksen, "A Feminist Absurd," *Modern Drama* 45.2 (Summer 2002), 209.
122. Ibid., 212.

Chapter 1

An early version of this essay was presented at the 2007 Comparative Drama Conference held at Loyola Marymount University. A later version is forthcoming in Samuel Beckett's *Waiting for Godot*, ed. Ranjan Ghosh (Rodopi). I would like to thank Jenny S. Spencer, Robert Combs, and J. Chris Westgate for their continued help and feedback particularly on this chapter.

1. Jean Anouilh, "Godot or the Music-Hall Sketch of Pascal's Pensées as Played by the Fratenllini Clowns," Arts #400, January 27, 1953, Casebook on Waiting for Godot, ed. Ruby Cohn (New York: Grove Press, Inc., 1967), 12.
2. Alain Robbe-Grillet, "Samuel Beckett or Presence on the Stage," Critique, February, 1953, Casebook on Waiting for Godot, ed. Ruby Cohn (New York: Grove Press, Inc., 1967), 16.
3. Alan Levy, Theatre Arts, August, 1956, Casebook on Waiting for Godot, ed. Ruby Cohn (New York: Grove Press, Inc., 1967), 74–5.
4. Jacques Audiberti, "At the Babylon a Fortunate Move on the Theater Checkerboard," Arts #394, January 16, 1953, Casebook on Waiting for Godot, ed. Ruby Cohn (New York: Grove Press, Inc., 1967), 14. Henry Hewes, "Mankind in the Merdecluse," Saturday Review, May 5, 1956, Casebook on Waiting for Godot, ed. Ruby Cohn (New York: Grove Press, Inc., 1967), 67. Norman Mailer, "A Public Notice on Waiting for Godot," The Village Voice, May 7, 1966, Casebook on Waiting for *Godot*, ed. Ruby Cohn (New York: Grove Press, Inc., 1967), 72. Brooks Atkinson, "Theatre: Beckett's 'Waiting for Godot,'" *The New York Times* (April 20, 1956), 21.

5. Martin Esslin, *The Theatre of the Absurd* (New York: Anchor Books, 1961), xix.
6. Atkinson, 21.
7. Esslin, *The Theatre of the Absurd* 1.
8. Ibid., 17.
9. Ibid.
10. Ibid.
11. Ibid.,17–18.
12. Ibid., 18.
13. Ibid.
14. Ibid., 19
15. Ibid., 26.
16. Isherwood, E5.
17. Westgate, 301.
18. Ibid.
19. Williams, Raymond. "A Modern Tragedy." In *Samuel Beckett:* Waiting for Godot*: A Casebook*, edited by Ruby Cohn (Houndmills: MacMillan, 1987), 110.
20. Brewer, Maria Minich. "A Semiosis of Waiting." *Samuel Beckett:* Waiting for Godot*: A Casebook*, edited by Ruby Cohn (Houndmills: MacMillan, 1987), 151.
21. Beckett is very conscious of the audience: "If waiting is the sole choice, then the audience's own waiting is the one activity shared by those off- and on-stage" (Sidney Homan, "Playing Prisons." In *Samuel Beckett:* Waiting for Godot*: A Casebook*, edited by Ruby Cohn [Houndmills: MacMillan, 1987], 181).
22. "Vladimir and Estragon are among those who have been prevented from finding; not because of their hypocrisy, but because of what they hear—the whisper, the rustle, the murmur of voices from the past which divert them and prevent them from thinking" (Ann Bugliani, "The Biblical Subtext in Beckett's *Waiting for Godot.*" *Journal of Dramatic Theory and Criticism* 16.1 (2001): 26). They may not have *found* "Godot," but they find that they are irreplaceable and, therefore, there is something there that keeps them from committing suicide and cause them to continue the "struggle" in a world where they (especially Estragon) suffer.
23. Holland Cotter, "A Broken City. A Tree. Evening." *The New York Times.* 2 December 2007, 1.
24. Ibid.
25. Ibid.
26. Ibid.
27. Ibid.
28. Ibid.
29. Ibid.
30. Ibid.
31. This and the following quotes referring to Anthony Page's *Godot* all come from, Michael Y. Bennett, "Review of *Godot*," *Theatre Journal* 62.1 (March 2010), 110–111.

32. Mary Bryden's *Samuel Beckett and the Idea of God* and the special issue of "Beckett and Religion" in *Samuel Beckett Today* attest to the fact that there is still much to be discovered in Beckett's writing about religious beliefs. Down to the minutest detail, Bryden carefully extrapolates mostly Christian themes and images from Beckett's entire oeuvre, showing how much religious topics are interlaced in Beckett's writing. Ann Bugliani, in her 2001 article, "The Biblical Subtext in Beckett's *Waiting for Godot*," accomplishes a similar task.

33. Shimon Levy, in "On and Offstage: Spiritual Performatives in Beckett's Drama," argues that though Beckett ridiculed simplistic and sentimental notions of "the spiritual thing," Beckett still advocated a quest for a "beyond" (*Samuel Beckett Today/Aujourd'hui* 9 [2000]: 17). Though this quest *may* be unattainable, Beckett's usage of offstage—that developed into a theatrical "'entity,' always 'there' as a present"—constitutes the "beyond" that the characters strive to reach (18–19). Similarly, Birgitta Johansson, in "Beckett and the Apophatic in Selected Shorter Texts," argues that Beckett's characters are in search of a "mystical Other." Even when they use methods of negative theology, Beckett's characters continue to articulate, "a never-ending desire for clarity and meaning in life" (*Samuel Beckett Today/Aujourd'hui* 9 [2000]: 56). Likewise, in "Dim When Unknown": Beckett and the Inner Logos," Jane Walling argues that the symbolism of the Crucifixion marked the point where Logos moved from being found outside the body to being found within each individual. Thus, each individual, after the Crucifixion, has the potential of freedom to realize and recreate Logos for him or herself and, thus, to develop a "separate, self-conscious and free self," that necessitates individual quest to find their own meaning in this world (*Samuel Beckett Today/Aujourd'hui* 9 [2000]: 106–107).

34. Building on what Esslin wrote about in terms of the Second World War's influence on the play, Suman Gupta insists that Beckett's habitation in France during the war and France's postwar response to the war had a heavy impact on *Waiting for Godot*. France's opposition to fascism, in spite of the "state machinery" employed in their colonies, brought up what A. Uhlmann called a "moral crisis" (cited in Suman Gupta, "Samuel Beckett, *Waiting for Godot*," *The Popular and the Canonical: Debating Twentieth-Century Literature 1940-2000*, edited by David Johnson [London: Routledge, 2005], 234–235). Eugene Ngezem also indirectly discusses this moral crisis in two recent articles. In "Disabling the Disabled," Ngezem argues that there are "no signposts for the disabled," as the "helpless" characters are exposed to a "menacing sternness" from other characters (*Notes on Contemporary Literature* 34.5 (2004): 13). Ngezem suggests that the handicapped are not just targets of cruelty, but may be sources of it as well, thus depriving the handicapped characters of their normally deserved sympathy (15). Additionally, in "Modern Marriage in Collapse," Ngezem describes that the homosocial reading of the play suggests that "life is soon moving to an ultimate end," in that the absence of the female and marriage signifies an absence of procreation (*Language Forum* 31.1 (2005): 100). Ruby Cohn writes that "*Godot*'s questions—questions, often unanswered, constitute about one quarter of the play's sentences—probe into a metaphysics undreamed of in our

physics" ("Waiting," In *Samuel Beckett's Waiting for Godot*, edited by Harold Bloom (New York: Chelsea House Publishers, 1987), 50).
35. Esslin, *The Theatre of the Absurd* xix.
36. I am, by no means, the only scholar to read this play as a parable. However, my reading is unique in that I examine the play through the structural elements of a parable in order to reach a conclusion about the play's anti-existential leaning.
37. The idea of "growth and purpose out of nothingness" works against the nihilistic existentialists (most notably Sartre) who see nothingness as negation. Heidegger, on the other hand, sees nothingness as an essential part of Being, and, therefore, possibility is always intertwined with nothingness.
38. Beckett, *Godot* 10.
39. Ibid., 7.
40. Enoch Brater discusses how the characters in the play are intimately tied to the land: Beckett's characters " 'study,' among other things, 'that tree.' And, as they do so, we do so, too; the landscape, initially taken as a given, is now placed in something like sharp relief, becoming the unexpected subject of mystery, even intrigue" ("Talk About Landscapes: What There is to Recognize." *Modern Drama* 49.4 (Winter 2006): 502).
41. Beckett, *Godot* 7.
42. Ibid.
43. Ibid.
44. Frankl, 106.
45. Bryden, 111.
46. Beckett, *Godot* 8.
47. Ibid.
48. Beckett, *Godot* 8. The missing "something" is the "heart," as Vladimir is misquoting Proverbs 12.13.
49. Robert W. Funk, *Language , Hermeneutic, and Word of God: The Problem of Language in the New Testament and Contemporary Theology*. (New York: Harper & Row, Publishers, 1966), 161.
50. Thomas Cousineau argues that the boots are, in fact, metonyms of Estragon, himself, and that the "distinction between metaphor and metonymy becomes blurred: metonymic connections possess metaphoric overtones and vice versa" (*Waiting for Godot: Form in Movement* [Boston: Twayne Publishers, 1990], 101). This is the property of Estragon's boots: they form both a metonymic paradox and also a metaphor. The maxims and paradox come out of his struggle and are enough to encapsulate the meaning behind the parable, while the *struggle* itself is metaphorical.
51. Bert O. States, *The Shape of Paradox: An Essay on* Waiting for Godot (Berkeley: University of California Press, 1978), 29. Before I discuss States's definition of myth, it must be addressed here that he seems to be describing parable much more than myth here. John Dominic Crossan argues that story is bifurcated into myth and parable: myth taking on elements of reconciliation and mediation and parable taking on elements of contradiction and reversal (*Raid on the*

Articulate: Comic Eschatology in Jesus and Borges (New York: Harper & Row, Publishers, 1976), 99).
52. States, *Paradox* 17. To further the notion of paradox in parables and in *Waiting for Godot*, David Bradby argues that "vividly paradoxical statements" are made at "moments of extreme tension," as illustrated when the two tramps are told that Godot will not come that day, Vladimir says," Down in the hole, lingeringly, the grave-digger puts on his forceps..." Bradby points out the "antithetical paradox" of the birth of existence and death with the same tool ("Beckett's Shapes." *Samuel Beckett:* Waiting for Godot*: A Casebook*, edited by Ruby Cohn (Houndmills: MacMillan, 1987), 115).
53. Beckett, *Waiting for Godot* 7.
54. Ibid., 13.
55. Ibid., 14.
56. Ibid.
57. Ibid.
58. Ibid., 17.
59. "Temperament," *Oxford English Dictionary*. 2nd ed. 1989.
60. "Disposition," *Oxford English Dictionary*. 2nd ed. 1989.
61. "Character," *Oxford English Dictionary*. 2nd ed. 1989.
62. Beckett, *Godot*, 30.
63. Ibid., 21.
64. Ibid., 2.
65. Ibid.
66. Ibid., 19.
67. "Struggle," *Oxford English Dictionary*. 2nd ed. 1989.
68. "Struggle for existence," *Oxford English Dictionary*. 2nd ed. 1989.
69. Beckett, *Godot* 9.
70. Ibid., 12.
71. Ibid.
72. Viktor E. Frankl, *Man's Search for Meaning: An Introduction to Logotherapy*, Trans. Ilse Lasch (New York: Pocket Books, 1959), 115.
73. James L. Calderwood, "Ways of Waiting in 'Waiting for Godot.'" In *Waiting for Godot* and *Endgame*, ed. Stephen Connor (New York: St. Martin's Press, 1992), 34.
74. Beckett, *Godot* 35.
75. Frankl, 126.
76. Michael Y. Bennett, "Sartre's "The Wall" and Beckett's *Waiting for Godot*: Existential and Non Existential Nothingness." *Notes on Contemporary Literature* (November 2009): 3.
77. Ibid., 2.
78. Beckett, *Godot*, 38.
79. Ibid.
80. Ibid.
81. Ibid.
82. Ibid.

83. Ibid., 39.
84. Ibid.
85. Ibid., 35.
86. Ibid., 44.
87. "Find," *Oxford English Dictionary*, 2nd ed. 1989.
88. "Seek," *Oxford English Dictionary*, 2nd ed. 1989.
89. Beckett,*Godot* 41.
90. Ibid.
91. C. H. Dodd, *The Parables of the Kingdom* (London: Collins, 1935), 18.
92. One of the great interchanges of the play highlights all of the contradictions between passive/active and being/non-being:
 VLADIMIR: What do we do now?
 ESTRAGON: Wait.
 VLADIMIR: Yes, but while waiting.
 ESTRAGON: What about hanging ourselves? (Beckett, *Godot*12)
93. Beckett, *Godot* 57.
94. Ibid., 25.
95. Eric Bently, "Anti-Play," *Samuel Beckett:* Waiting for Godot*: A Casebook*, ed. Ruby Cohn (Houndmills: MacMillan, 1987), 24.
96. Beckett, *Godot* 60.
97. Ibid., 59.
98. Ibid., 60.
99. Ibid.
100. Ibid.
101. "Go," *Oxford English Dictionary*. 2nd ed., 1987.
102. Beckett, *Godot* 7.

Chapter 2

I would like to thank Shai Cohen, a Ph.D. graduate of Linguistics at the University of Massachusetts, Amherst, for his guidance with my linguistic and philosophical readings of language. I would also like to thank Steven H. Gale and Francis Gillen for their valuable feedback on an earlier draft of this chapter.

1. Harold Pinter, The Birthday Party and The Room: Two Plays by Harold Pinter (New York: Grove Press, Inc., 1961), 9.
2. Richard Schechner, "Puzzling Pinter," The Tulane Drama Review 11.2 (Winter 1966): 176
3. Ibid. Bernard Dukore similarly sees that "there is a background, but [the] background is clouded" ("The Theatre of Harold Pinter," The Tulane Drama Review 6.3 (March 1962): 44). John Somers agrees on the importance of subtext as well. Somers argues that Pinter's use of subtext in The Birthday Party was "a fresh and demanding requirement of emerging theatre in the 1950s" ("The Birthday Party: Its Origins, Reception, Themes and Relevance for Today," Cycnos 14.1 (1997): 10). Pinter developed an intertextuality and a

meta-narrative that was unusual to audiences, since audience members could not "use conventional story appreciation and audience reception techniques" (10). Somers suggests that this fact led to the play's poor initial reception.

4. D. Granger, *Financial Times*, 20 May 1958, qtd. in Somers 13.
5. M. W. W., *The Guardian*, 21 May 1958, qtd. in Somers 14.
6. Alan Brien, *The Spectator*, 30 May 1958, qtd. in Somers 14.
7. Harold Hobson, *The Sunday Times*, 25 May 1958, qtd. in Somers 14.
8. Martin Esslin, *The Theatre of the Absurd*, xxi.
9. Ibid.
10. Ibid., 238.
11. Two other scholars in 1962 also align Pinter with the now classic "absurdist" playwright: Samuel Beckett. Bernard Dukore says that only Beckett has plays "similar in texture" to Pinter (Dukore, 43). Ruby Cohn argues that "like Beckett, Pinter looks forward to nothing (not even Godot)" ("The World of Harold Pinter" *The Tulane Drama Review* 6.3 (March 1962): 56). Even to this day, the "absurd" tag still follows *The Birthday Party*. One recent review highlights how directors (and critics) still regard the play's absurdity as central to its meaning. Leah Lowe, writing about the 2004 performance at the American Repertory Theatre in Cambridge, Massachusetts, begins with the absurdity of McCann and Goldberg's interrogation of Stanley: "They begin by asking Stanley what he did yesterday, but their inquires quickly veer into the realm of the absurd" (Performance Review of *The Birthday Party*. *Theatre Journal* 56.3 (2004):510). However, like Naomi Siegel's 2006 review of the play at the McCarter Theater Center in Princeton in *The New York Times*, where she states that the world of the "victim and victimizer may easily be interchangeable"("Theater Review: At a Party with a Dark Side, Menace and Peril Pay a Visit," *The New York Times*, 1 October 2006),Lowe suggests that "Goldberg and McCann, seem as victimized by the general absurdity, the breakdown of language, and the surreal decor as Stanley is by them" (Lowe510).
12. Schechner, 176.
13. Ibid., 177.
14. Ann C. Hall, "Looking for Mr. Goldberg: Spectacle and Speculation in Harold Pinter's *The Birthday Party*," *The Pinter Review* (1999), 49.
15. As Dirk Visser says, McCann and Goldberg have "utmost verbal supremacy," as they are able to "fire off one question after another without Stanley being given a chance to get a word in edgewise" ("Communicating Torture: The Dramatic Language of Harold Pinter." *Neophilologus* 80.2 (1996): 330). The interrogation scene in *The Birthday Party* is exposing us to a lack of linearity, which confuses our sense of what language attempts to do. And our attempt at locating a self through a series of subjective and objective questions, which are not always questions, becomes as frightening and feels as arbitrary as the construction of language itself. The paradox of the empowerment/disempowerment of language can be seen if we reexamine the "informs" and "questions" in *The Birthday Party* that Michael Toolan alerted us to ("'What Makes You Think You Exist?': A Speech Move Schematic and Its Application to Pinter's *The Birthday Party*."

Journal of Pragmatics 32 (2000): 177–201) As Toolan suggested, the informs yield nothing at first. The purely objective (the informs) resulted in no human interaction. But when questions started being asked, when a person responds to another, the questions yield a double-edged sword: compliance and a resulting brutality from ability for interrogator to, then, inform once again. The production of knowledge, from the subjective position, is at once creative, but also allows for destruction for all involved. Because Stanley is not a powerful linguist, he drowns; because power is so interconnected, so does everyone else around him, at least in some way. The interrogation aims for the production of knowledge. However, knowledge is dangerous, as questions yield knowledge and knowledge can be used in so many different ways. It is because Stanley cannot respond, because he is simultaneously disempowered through his false subjectivity created through language and his false language created through subjectivity that Stanley drowns. Martin Esslin, in his introduction to Harold Pinter's "Letter to Peter Wood," says "*The Birthday Party* seemed to many members of its first audiences to start off as a thriller, a mystery play; but, then, it failed to keep its promise: it provided no solution to the mystery" (in Harold Pinter, "Letter to Peter Wood," *The Kenyon Review* 3.3 (Summer 1981): 1)It is because we cannot initially respond to the play, that we are subject to the same violence as Stanley. We are initially "reduced to grunts and gurgles."

Harold Pinter, in his famous letter to the first director of *The Birthday Party*, Peter Wood, emphasizes the fact that Stanley is not articulate: "Stanley fights for his life, he doesn't want to be drowned. Who does? But he is not *articulate*" ("Letter to Peter Wood" 3). Stanley "collapses under the weight of [Goldberg and McCann's] accusation" (3), because,

> Stanley *cannot* perceive his only valid justification—which is he is what he is—therefore he certainly can never be articulate about it. He knows only to attempt to justify himself by dream, by pretence and by bluff, through fright. (5)

Referring to a quote by Pinter in "Writing for the Theatre," Marc Silverstein, in "Keeping the Other in Its Place: Language and Difference in *The Room* and *The Birthday Party*," says that "Language 'keeps the other in its place' by articulating the subject positions from which subjectivity emerges" ("Keeping the Other in Its Place: Language and Difference in *The Room* and *The Birthday Party*." *The Pinter Review* (1992): 2). This subjectivity can only come out through the "symbolic order of culture" (2). Though, Silverstein is writing about McCann and Goldberg, this article can speak to Stanley in that Stanley is kept in his place. Silverstein discusses the paradox of language and power and the resulting subjectivity:

> Because it circulates in an essentially creative rather than destructive manner, because it forms the subject positions within which the structure of the "self" arises, power *empowers* by allowing the "individual" to gain a purchase on subjectivity. At the same time, however, because the ensemble of discourses and desires that produce the subject also structure that subject's

consciousness of its appropriate place within the cultural order, power ulti-
mately *disempowers* its own creations. (7)

The double-edged sword of language is the paradox of the play. In a review
of a 2006 production of the play at McCarter Theater Center in Princeton,
Naomi Siegel of *The New York Times* asks the question, "Is there a suggestion,
in Pinter's post–Holocaust vision of the world, that victim and victimizer may
easily be interchangeable?" This is similar to what Steven H. Gale says about
victim and victimizer, as Gale posits that Goldberg and McCann, "eventually
suffer an end which is no different from that experienced by those they pursue
(*Butter's Going Up: A Critical Analysis of Harold Pinter's Work*(Durham: Duke
University Press), 38). Language empowers and disempowers everyone.

Robert Baker-White suggests that "The audience enters the fictive space
vicariously, but dangerously: as the festivity has been ours, so the violence
becomes ours as well" ("Violence and Festivity in Harold Pinter's *The Birthday
Party, One for the Road,* and *Party Time.*" *The Pinter Review* (1994): 71). The
play is about suffering. We suffer along with Stanley. We are subjected to the
brutality of the interrogation, but we are interrogated ourselves. As Meeta
Ghose suggests, "Pinter's dialogues are so created that the ambiguity is main-
tained and yet they unnerve the audience and open several avenues for interpre-
tation" ("Harold Pinter's *The Birthday Party* as a Comedy of Menace." *Panjab
University Research Bulletin* 18.1 (1987): 64). The play ultimately asks us the
question: "What happened?" As vicarious viewers, we are simultaneously com-
pliant and brutalized. We become the subject of the interrogation. We have to
wade through the violence. In the vein of Camus and Frankl, we, too, have to
overcome suffering. And we have to make sense of it in order to persist.

16. Gale, 41.
17. Francis Gillen, "'All These Bits and Pieces'": Fragmentation and Choice in
Pinter's Plays," *Modern Drama* 17 (1974), 477.
18. Anna Ford, *Pinter, Plays & Politics*, BBC television interview, 1988.
19. Marc Silverstein argues that Pinter's plays are about a struggle for power
(whether victim or victor), where power forecloses the "very possibility of resis-
tance by gathering the occupants of these sites into the 'bosom' of culture." In
this sense, Pinter's characters, "reconstitute and reconfirm the dominant values
of their culture" (1). This dystopian vision of power serves as a terrifying image
of what happens to the cultural order without oppositional politics (9). Ian
Almond argues that Stanley's "gradual struggle breakdown, subjugation, and
assimilation" is comparable to "the progress of the Eckhartian soul as it loses,
in various stages, its individuality, selfhood, reason and sight in order to return,
in silence, to the Absolute One" ("Absorbed into the Other: A Neoplatonic
Reading of *The Birthday Party.*" *Literature & Theology* 14.2 (June 2000): 175).
This relates to Silverstein in that, "Clearly, if Stanley is to be ushered back
into whatever concept of society Goldberg has in mind, the annihilation of
Stanley's resistant selfhood is the first task to be undertaken" (Almond, 181).
As Gale argues, as the play progresses, Stanley unmakes himself as he moves

from essence to existence (Gale, 44–45). Michael Billington also sees Stanley's "resistant selfhood" as a matter of importance in *The Birthday Party*. Not just a play about social conformity, Billington argues that this play is about the need to resist (*The Life and Work of Harold Pinter* (London: Faber and Faber, 1996), 78). Though Stanley has been robbed of the power of sight and speech, Billington suggests that there is, "some grit in the human spirit that resists total submission" (79). Given that Billington argues that Goldberg and McCann, too, are victims, *The Birthday Party* is a complex play, "about a defiant rebel who exposes the insincerity upon which adherence to orthodoxy and tradition actually rests" (80). Billington concludes, in a sense, that this play is political in that it presents the, "imperative need to resist" (82).

20. Bernard Dukore, "The Theatre of Harold Pinter," *The Tulane Drama Review* 6.3 (March 1962), 47.

21. Albert Camus, *The Myth of Sisyphus and Other Essays*, Trans. Justin O'Brien (New York: Vintage Books, 1955), 91.

22. Gale, 39.

23. Pinter, *Birthday Party*, 9.

24. Ibid.

25. Michael Toolan, in "'What Makes You Think You Exist?': A Speech Move Schematic and Its Application to Pinter's *The Birthday Party*," linguistically examines what I feel is the parable-within-the-parable: the interrogation scene. Toolan, operating from the field of linguistics, creates a grammar that he, then, applies to understanding the interrogation scene. He divides all speech into four categories: "questions," "informs," "requests" and "undertakings" (177–201). Since most of Toolan's analysis focuses on just "questions" and "informs," I will focus mostly on these two, as well.

As Toolan argues, between the scene where "GOLDBERG *sighs, and sits at the table right*" to when he stops whistling "The Mountains of Morne," McCann is the main speaker and he produces the most "questions" and "requests," although, as Toolan argues, he is a rather unsuccessful one as his requests are usually not complied with and his questions are not answered very well (188). Thereafter, Goldberg takes control and from when Stanley says, "You'd better be careful" to the place in the play where McCann snatches his glasses, there is a marked change in the speech patterns: "[D]espite the atmosphere of physical coercion, the scene is almost devoid of the Proposal-based used of language to do things and get things done, and instead is overwhelmingly Proposition-based, the general use of language to describe, inform, analyse, and express" (190). In the first half of this "scene," Stanley answers Goldberg's questions with questions; in the latter half, Stanley answers the questions with informs, "as if he has 'adjusted' to supplying a more submissive kind of reply" (190). The final part of the interrogation scene, which Toolan characterizes as ending with Stanley's scream, is made up of a series of brutal informs. Even Goldberg's question, "What makes you think you exist?," for Toolan, "amounts to an Inform which declares 'You think you exist—but you don't!'" (193). Goldberg's attack of Stanley's "core of selfhood, identity, and presence" and

Stanley's failure to respond (except as a being "reduced to grunts and gurgles, and ambiguous physical outbursts"), is "indicative of the profound interconnections between personhood and acts of informing, questioning, requesting, and undertaking" (193).

I introduce Toolan's language and arguments about the play because it helps us to investigate the subtext of the play. Richard Schechner sees Pinter's subtext carrying "a heavy baggage of implication, confusion, and nuance" ("Puzzling Pinter" 176). Part of the reason for this is the confusion between questions and informs. I believe that the very meaning of the play is about the confusion over questions and informs.

26. Pinter, *Birthday Party* 13.
27. Ibid., 14.
28. Especially since Stanley, a few lines down, asks Petey, "What's it like out today?" (Ibid. 14), John's explanation of the phrase "Good day" in David Mamet's *Oleanna* serves as a wonderful parallel/explanation: "Because ["good day"] is the essence of all human communication. I say something conventional, you respond, and the information we exchange is not about the "weather," but that we both agree to converse. In effect, we agree that we are both human" (David Mamet, *Oleanna* [New York: Vintage Books, 1993], 53).
29. Pinter, *Birthday Party* 9.
30. There is a debate among linguists and philosophers of language about this topic and the way the reference of proper names and demonstratives are determined. Descriptivists, such as Gottlob Frege and Bertrand Russell, stating it in a very basic manner, argue that proper names should be replaced with descriptions. And Non-Descriptivists, such as Saul Kripke, again, stating it simply, say that one cannot determine a referent by a description, but by external factors (how the name is used, etc.).
31. Pinter, *Birthday Party* 48.
32. Ibid.
33. Ibid., 51–52.
34. Ibid., 54.
35. Ibid., 54.
36. Ibid.
37. Ibid.
38. Ibid., 65.
39. Ibid., 36.
40. Ibid., 14.
41. Ibid.
42. Ibid.
43. Ibid., 15
44. Ibid., 52.
45. Ibid., 86.
46. Ibid., 9.
47. Ibid., 87.
48. Ibid.

Chapter 3

1. Martin Esslin, *The Theatre of the Absurd* (New York: Anchor Books, 1961), 162.
2. Ibid., 160, 162.
3. Ibid., 163–164.
4. W. F. Sohlich, "Genet's *The Blacks* and *The Screens*: Dialectic of Refusal and Revolutionary Consciousness," *Comparative Drama* 10 (1976), 218.
5. Wallace Fowlie, "New Plays of Ionesco and Genet," *The Tulane Drama Review* 5.1 (September 1960), 46.
6. Ibid.
7. Kimberly W. Bentson aptly describes the confrontation of worldviews in both Genet's play and Amiri Baraka's short satire written in response, "Great Goodness of Life: A Coon Show":

> *The Blacks* involves the condemnation of white society in a series of suffocating illusions while envisaging a triumphant Negro rebellion as reality. *Great Goodness of Life*, on the other hand, is an accusatory exposition of a segment of the black community. Yet there remains in Genet's play a level of absurdity which is entirely unacceptable in Baraka's vision of a completely liberated black nation...Genet's vision of liberation, which proceeds from his own unique experience within society, is seen by Baraka as perhaps the most deceptive of all illusions. Thus, in response to Genet, Baraka stages the trial of the black traitor (Court Royal) which is the offstage action of *The Blacks*. Genet subtitled his play "a clown show" to show the stage action is a farce or practical joke, something not to be taken seriously; he thus renders it bearable to his hypothetical white audience. The subtitle of *Great Goodness of Life* is "coon show," yet another reversal of Genet. For Baraka's play, which is meant for a black audience, is no joke. Court Royal is unsympathetically portrayed as a murderer of the black spirit, and the message is deadly serious. (*Baraka: The Renegade and the Mask* [New Haven: Yale University Press, 1976], 216–17)

For the only article solely on Baraka's play, refer to my forthcoming article in *Callaloo*: "Dominance and the Triumph of the White Trickster Over the Black Picaro in Amiri Baraka's *Great Goodness of Life: A Coon Show*" (forthcoming). This article argues the following: "Baraka presents how domination yields the triumph of a presumably white trickster over an African American picaro. The entire play, then, becomes ironic: the trickster should not come from the ruling class; chaos should not be ordered by a judge; and the roles should be reversed, the satire seems to want to present the triumph of a black trickster over a white picaro in the face of domination. Thus, Baraka's satire becomes an African American satire turned upon its head. The black picaro is not even given a chance 'to use whatever trickery or knavery is necessary to obtain [the] end' of becoming part of the social order. He is forced out of it, into submission, and ultimately into blackface."

8. Debby Thompson, "'What Exactly is Black?': Interrogating the Reality of Race in Jean Genet's *The Blacks*," *Studies in 20th Century Literature* 26.2 (2002), 396.
9. Ibid., 397–8.
10. Bénédicte Boisseron and Frieda Ekotto, "Genet's *The Blacks*: 'And Why Does One Laugh at a Negro?'" *Paragraph: A Journal of Modern Critical Theory* 27.2 (2004), 98.
11. Ibid., 100.
12. Edward W. Said, *Orientalism* (New York: Vintage Books, 1994), 2.
13. Ibid., 3.
14. Homi K. Bhabha, *The Location of Culture* (London: Routledge, 1994), 97.
15. Ibid., 99.
16. Ibid., 100.
17. UnaChaudhuri, "The Politics of Theater: Play, Deceit, and Threat in Genet's *The Blacks*," *Modern Drama* 28.3 (1985), 364.
18. Sohlich, 218–219.
19. Charles Forsdick, "Camus and Sartre: The Great Quarrel," *The Cambridge Companion to Camus*, Ed. Edward J. Hughes (Cambridge: Cambridge University Press, 2007), 124.
20. Ibid., 121–123.
21. David Bradby, "Genet, the Theatre and the Algerian War.(Jean Genet'splay*Les Paravents*)." *Theatre Research International*, 19.3 (Autumn 1994),230.
22. Philip Hallie, "Camus and the Literature of Revolt," *College English* 16.1 (Oct. 1956), 25.
23. Jacques Ehrmann, "Camus and the Existential Adventure," *Yale French Studies* 25 (1960), 96.
24. Bradby, "Genet, the Theatre and the Algerian War" 228.
25. Chaudhuri, 364.
26. Philip Knee, "An Ethics of Measure: Camus and Rousseau," *Existentialist Thinkers and Ethics*, Ed. Christine Daigle (Montreal: McGill-Queen's University Press, 2006), 110.
27. Sohlich, 219.
28. Richard C. Webb, "Ritual, Theatre, and Jean Genet's *The Blacks*," *Theatre Journal* 31 (1979), 447–9.
29. Ibid., 452.
30. Ibid.
31. Ibid.
32. Loren Kruger, "Ritual into Myth: Ceremony and Communication in *The Blacks*," *Critical Arts* 1.3 (1980), 62.
33. Ibid., 60.
34. Webb, 458.
35. Gene A. Plunka, "Victor Turner and Jean Genet—Rites of Passage in *Les Nègres*," *The Theatre Annual* 45 (1991), 65–6.
36. Ibid., 67.
37. Victor Turner, *The Forest of Symbols: Aspects of Ndembu Ritual* (Ithaca: Cornell University Press, 1967), 105.

38. Plunka, "Victor Turner and Jean Genet" 67.
39. Ibid., 76.
40. Jean Genet, *The Blacks: A Clown Show* (New York: Grove Press, Inc., 1960), 4. The spotlighting of the character undergoing the trial can be highlighted from Amiri Baraka's response to this play, "Great Goodness of Life: A Coon Show," where a black postal worker is put on trial by a racist judge and "walks right up to the center of the lights" (*Kuntu Drama: Plays of the African Continuum*, ed. Paul Carter Harrison [New York: Grove Press, Inc., 1974], 157).
41. Genet, *The Blacks* 4.
42. Ibid., 10.
43. Genet, 9.
44. Ibid., 12.
45. Webb, 457.
46. Ibid.
47. Kruger, 60.
48. Genet, *The Blacks* 8.
49. Ibid.
50. Ibid., 15.
51. Ibid., 33.
52. Plunka, "Victor Turner and Jean Genet" 77.
53. Johan Huizinga, *Homo Ludens: A Study of the Play Element in Culture* (Boston: Beacon Press, 1950), 1.
54. Boisseron and Ekotto, 100.
55. Ibid., 111.
56. Genet, The Blacks 4.
57. Derek F. Connon, "Confused? You Will Be: Genet's *Les Nègres* and the Art of Upsetting the Audience," *French Studies: A Quarterly Review* 50.4 (October 1996), 426.
58. Chaudhuri, 373.
59. Carl Lavery, "Racism and Alienation Effects in *Les Nègres*," *Essays in Memory of Michael Parkinson and Janine Daknyns*, Ed. Christopher Smith (Norwich: School of Mod. Lang. & European Studies, University of East Anglia, 1996), 315.
60. Chaudhuri, 366.
61. Michael Y. Bennett, "Clowning Around in James Purdy's *The Paradise Circus*," *Notes on Contemporary Literature* 38.3 (May 2008), 7.
62. Mikhail Bhaktin, *Rabelais and His World*, Trans. by Helene Iswolsky (Bloomington: Indiana University Press, 1984), 21.
63. Tobin Siebers, "Introduction: What Does Postmodernism Want? Utopia," *Heterotopia: Postmodern Utopia and the Body Politic*, Ed. Tom Siebers (Ann Arbor: The University of Michigan Press, 1994), 25.
64. David Bradby, "Blacking Up—Three Productions by Peter Stein," *A Radical Stage: Theatre in Germany in the 1970s and 1980s*, Ed. W. G. Sebald (Oxford: Berg, 1988), 23.
65. Ibid., 24.
66. Ibid., 26.
67. Ibid.

68. Jon McKenzie, *Perform or Else: Discipline to Performance* (London: Routledge, 2001), 5.
69. Ibid.
70. Herbert Blau, "The Faith-Based Initiative of the Theater of the Absurd," *Journal of Dramatic Theory and Criticism* 16.1 (Fall 2001), 4.
71. William W. Demastes, *Theatre of Chaos: Beyond Absurdism, Into Orderly Disorder* (Cambridge: Cambridge University Press, 1998), xii.

Chapter 4

1. Martin Esslin, *The Theatre of the Absurd* (New York: Anchor Books, 1961), 126–127.
2. Wallace Fowlie, "New Plays of Ionesco and Genet," *The Tulane Drama Review* 5.1 (September 1960), 43.
3. Ibid.
4. Eugene Ionesco, *Notes and Counter Notes*, Trans. Donald Watson (New York: Grove Press, 1964), 21–22.
5. Emmanuel Jacquart, "Ionesco's Political Itinerary," *The Dream and the Play: Ionesco's Theatrical Quest*. Ed. Moshe Lazar (Malibu: Undena, 1982), 64.
6. Ionesco, *Notes and Counter Notes* 24.
7. Jacquart, 64.
8. Ionesco, Notes and Counter Notes 89.
9. Ibid., 90.
10. Jacquart, 67.
11. Ibid.
12. Ibid., 70.
13. Ibid., 71.
14. Ibid.
15. Ibid.
16. David B. Parsell, "A Reading of Ionesco's *Rhinoceros*," *Furman Studies* 21.4 (1974), 13.
17. Richard Schechner, "An Interview with Ionesco," Trans. Leonard C. Pronko, *The Tulane Drama Review* 7.3 (Spring 1963), 164.
18. Richard Schechner, "The Inner and Outer Reality," *The Tulane Drama Review* 7.3 (Spring 1963), 190.
19. Parsell, 15.
20. Eugene Ionesco, *Rhinoceros and Other Plays* (New York: Grove Press, Inc., 1960), 51.
21. Ibid., 13.
22. James Mills, "The Dualism of Décor and Direction in Ionesco's *Rhinocéros*," *Proceedings of the Utah Academy of Sciences, Arts and Letters* 75 (1998), 56. The most current readings of the play express the metaphoric centrality of *non-traditional* characters, giving credence to the need for interpretation. These scholars do not go as far as calling the play a parable, but the weight they give to extended metaphor turn these readings in the parabolic direction. Mills cites,

for one, the theory set forth by Antonin Artaud as an influence for Ionesco: "Like Antonin Artaud, the avant-garde critic whom he emulated, Ionesco sought to substitute a new symbolic language, or language in space and movement, for the spoken one" (55). Arguing that exaggerated plastic imagery is not only created through the materialization of speech and stereotypical characters, but through direction, production and staging, Mills suggests that the decor and stage directions are role characters that also function as "major thematic metaphors" (55–56).

Telory W. Davies writes of a 2002 production of the play at the Berkeley Repertory Theatre and also speaks of the set like a character. Davies notes that the production used "highly physical ways" to demonstrate the socially absurd condition and ideology that Ionesco portrayed in his play: the actors moved like rhinoceroses, the set took on the shape of a rhinoceros horn, and the set rotated 90-degrees resulting in the front door coming up from the ground (645). Furthermore, Davies suggests that Damashek, the director, let "the stage and its properties… speak for [the] characters whose words are hopelessly inadequate" (645).

In relation to the interconnectedness of words and space, we must examine, as Mills and Davies do, the set as character and the relational language that creates our perceptual reality of it. The play opens up with a "square in a small provincial town" (Ionesco, *Rhinoceros* 3). For Mills, referring to the unspecified land and the unidentified town, he says, "The scenery of the opening act serves as a metaphor for humanity's alienation in a world ruled by the omnipresent beast" (Mills, "Dualism of Decor" 56).

23. Ionesco, *Rhinoceros* 48.
24. Ionesco, *Rhinoceros* 5.
25. Immanuel Kant, in *Groundwork of the Metaphysics of Morals*, formulates his concept of the *categorical imperative* through the concepts of the *maxim* and *universal law*. A maxim is, as defined by the *Oxford English Dictionary*, "A proposition, *esp.* one which is pithily worded, expressing a general truth drawn from science or experience" and, "A rule or principle of conduct." A maxim is a general rule that is supposed to guide a doer through *all* situations, whatever he or she may encounter. For example, "If I make a promise, I will keep it." One will keep his or her promise no matter what the situation. Universal law, in relation to Kant, is understood as how things always *must* or *ought to* be. Kant's categorical imperative is stated in many different ways in his *Groundwork of the Metaphysics of Morals*; here is one of them: "*I ought never to act except in such a way that I could also will that my maxim should become a universal law [sic]*" (Kant, 15). In other words, in order to be an ethical act, one's personal maxim *must* apply for *everyone* in *every* situation.

There are two philosophy articles separated by 45 years that discuss the syllogism with respect to ethics. In 2006, in "Maxims in Kant's Practical Philosophy," Richard McCarty suggests that since Kant did little to define *maxim*, he assumed that his students knew what he meant. McCarty referenced Kant's lecture notes that equated the maxim with the major premise of

the practical syllogism, which is how Christian Wolff explained it ("Maxims in Kant's Practical Philosophy." *Journal of the History of Philosophy* 44.1 (2006): 67–68):

> The way Wolff understood human action, we cannot act without seeing our action as good. When we act, what happens is the soul is a kind of argument known as a practical syllogism. We represent some object or condition as good through volition or desire, and then we judge that acting a certain way can bring about that object or condition. From a pair of representations like these we then conclude with a third representation, that so acting is good. For example: 1. *Healthy things are good; 2. Exercising is healthy; 3. Therefore, exercising is good.* Here the major premise, "Healthy things are good," is known as the maxim. Since it is a representation of something as good, the maxim would be either a desire or a volition, depending on the quality or distinctness of that representation. The conclusion of the practical syllogism would likewise be either a desire or a volition, since it too is a representation of goodness. But Wolff usually referred to this derived statement as a "motive." The maxim provides the rational basis for the motive, the compelling reason for action. Action then follows from this type of reasoning provided a bodily movement is coordinated with the motive through the pre-established harmony of soul and body. (McCarty 68–69)

Unlike for Wolff, where the consequence was the principle that determined moral correctness, Kant saw the maxim—the major premise—as what mattered (McCarty 69). Given that Kant's students understood the maxim to like the major premise of a syllogism, for the purpose of this article, I will, too, equate the maxim with the major premise of a syllogism.

In "The Ethical Syllogism,"1961, Alfred E. Haefner explains that an "ethical syllogism" is a "purely individual" arrangement of propositions that helps one arrive at a judgment of obligation ("The Ethical Syllogism." *Ethics* 71.4 (July 1961): 289). Haefner explains the structure of the ethical syllogism in the following way:

> In the major premise of an ethical syllogism I express *my perception of the social norm* obtaining in such-and-such a situation. In the first minor premise I report my *observation* of the situation in which I actual find myself involved; in the second minor premise I state my *intention* of accepting the social norm form myself. The conclusion is a *judgment of obligation*: "Then I ought to do so-and-so" or "I ought to behave in such-and-such a manner." This leads to decision and action, or, eventually, to justification of an act already done." (289)

Haefner suggests that this ethical syllogism helps one determine their own ethical response to a variety of situations. However, Haefner explains that since our own individual situations vary greatly and our perceptions of the social norm vary as well, then this type of ethical syllogism does not reference the categorical imperative.

The syllogism, then, can serve as a guiding principle of ethics. Whether constructed as a self-serving guide, as in the case of Haefner, or as a universal guide, as is the case of Wolff and Kant, the syllogism is intimately tied to the maxim. In *Rhinoceros*, there is a tension between the Haefner and Kantian syllogisms that has to do with the maxim/major premise being a universal law.

26. Reuben Y. Ellison and Stowell C. Goding, *Rhinoceros*, by Eugene Ionesco, Reuben Y. Ellison and Stowell C. Goding, eds. (New York: Holt, Rinehart and Winston, 1961), v.
27. Ionesco, *Rhinoceros* 28–29.
28. Davies, 645–646.
29. Ionesco, *Rhinoceros*7.
30. Ibid.
31. Ibid.
32. Ibid., 17.
33. Ibid.
34. Ibid., 15.
35. Ibid., 99.
36. Ibid., 98.
37. Ibid., 99.
38. Ibid., 102.
39. Ibid.
40. Ibid., 107.
41. Davies, 645.
42. Ibid., 646.

Conclusion

An earlier version of this chapter was presented at the 2010 Comparative Drama Conference: Michael Y. Bennett, "The Female Absurd," Comparative Drama Conference, Loyola Marymount University. 26 March 2010.

1. Celeste Derksen, "A Feminist Absurd: Margaret Hollingsworth's *The House That Jack Built*," *Modern Drama* 45.2 (Summer 2002), 209.
2. Ibid., 212.
3. Jean-Paul Sartre, "Introduction," *The Maids and Deathwatch: Two Plays*, Jean Genet (New York: Grove Press, Inc., 1961), 31.
4. Ibid., 28.
5. Ibid., 29.
6. Ibid., 9–10.
7. Ibid., 31.
8. Bert O. States, *Great Reckonings in Little Rooms: On the Phenomenology of the Theater* (Berkeley: University of California Press, 1985), 34.
9. Henley, 27.
10. William W. Demastes, *Beyond Naturalism: A New Realism in American Theatre* (New York: Greenwood Press, 1988), 139.

11. Scot Haller, "Her First Play, Her First Pulitzer Prize," *Saturday Review* November 1981, 42.
12. Demastes, 138–140.
13. Ibid., 143.
14. Henley, 48.

Addendum #1

1. "Parable." *Oxford English Dictionary.* 2nd ed., 1987.
2. Excellent summaries of the state of parable research can be found in A. M. Hunter, *Interpreting the Parables* (London: SCM Press, Ltd., 1960); Geraint Vaughan Jones, *The Art and Truth of the Parables: A Study in Their Literary Form and Modern Interpretation* (London: S.P.C.K., 1964); James Champion, "The Parable as an Ancient and Modern Form," *Journal of Literature & Theology* 3.1 (March 1989), 16–39.
3. Heinz Politzer, "Franz Kafka and Albert Camus: Parables for Our Time," *Chicago Review* 14.1 (Spring 1960), 48.
4. John Dominic Crossan, *Raid on the Articulate: Comic Eschatology in Jesus and Borges* (New York: Harper & Row, Publishers, 1976), 98.
5. Günther Bornkamm describes how else Jewish parables differ from the parables of Jesus. He explains how Jewish parables are illustrative and the parables of Jesus are the teaching themselves: "The rabbis also relate parables in abundance, to clarify a point in their teaching and explain the sense of a written passage, but always as an aid to the teaching and an instrument in the exegesis of an authoritatively prescribed text. But that is just what they are not in the mouth of Jesus, although they often come very close to those of the Jewish teachers in their content and thought, Jesus makes free use of traditional and familiar topics. Here the parables are the preaching itself and are not merely serving the purpose of a lesson which is quite independent of them" (*Jesus of Nazareth* [New York: Harper & Row, 1960],69). Asher Feldman goes even further, looking at the root of the word *midrash*: "The origin and basis of Midrashic Metaphors, Similes and Parables are to a large extent exegetical. This might well have been expected. For Midrash, as its root *darash* implies, means exposition. And one of the main objects of the Rabbis in the vast field of Talmudic and Midrashic literature was to expound the law and to impress its true significance upon their immediate disciples and larger audiences" (*The Parables and Similes of the Rabbis: Agricultural & Pastoral,* 2nd ed. [Cambridge: Cambridge University Press, 1927], 2).
6. William G. Kirkwood, "Storytelling and Self-Confrontation: Parables as Communication Strategies," *Quarterly Journal of Speech* 69 (1983), 58–74.
7. Paul Ricoeur, "Biblical Hermeneutics." *Semeia* 4 (1975): 126.
8. Hunter, 12.
9. Amazingly, because of its central role in parable studies, his work has still not been translated into English.
10. Champion, 19.

11. C. H. Dodd, *The Parables of the Kingdom* (London: Fontana Books, 1965), 18.
12. John Dominic Crossan, *In Parables: The Challenge of the Historical Jesus* (New York: Harper & Row, Publishers, 1973), 15.
13. Dan Otto Via, Jr., *The Parables: Their Literary and Existential Dimension.* (Philadelphia: Fortress Press, 1980), 7.
14. Jones, 17.
15. "Parables,"*Catholic Encyclopedia.* 6 July 2005. <http://newadvent.com>.
16. Sallie McFague, *Speaking in Parables: A Study in Metaphor and Theology.* (Philadelphia: Fortress Press, 1975), 13. McFague's definition points to the problem found in the definition of parables by two scholars of Jewish parables. Aryeh Wineman and Steve Zeitlin mistranslate *mashal* as parable. As noted earlier in the paper, the word "parable" comes from the Hebrew word *mashal* (by way of the Septuagint translation, *parabole*). *Mashal*, however, does not translate as parable. Some *meshalim* are parables; however, many are short wise sayings or allegories, or analogies. *Mashal* refers to a Rabbinic story or wise saying. Wineman and Zeitlin are casting too broad a net here with their definition of parable. Their definitions clearly point to allegory, while the vast majority of scholars in the field of parable studies demarcate parable's clear break from allegory. Wineman defines parable most basically as "an imaginative story whose meaning refers to something quite beyond itself; it alludes to an analogy or application not contained within the story proper" (*The Hasidic Parable* (Philadelphia: The Jewish Publication Society, 2001), xiii). This definition directly contradicts noted parable scholar McFague's definition: "A parable is not an allegory where the meaning is extrinsic to the story...Rather, as an extended metaphor, the meaning is found only within the story itself although it is not exhausted by that story." Zeitlin's definition of the parable running parallel to real life also seems to contradict McFague ("A Penchant for Parable," *Because God Loves Stories: An Anthology of Jewish Storytelling*, Ed. Steve Zeitlin [New York: Touchstone, 1997], 277).

The major problem here is the lack of scholarship on Jewish parables. Wineman and Zeitlin represent two of only a handful of scholars doing Jewish parable research. Scholars of Jewish parables, with the exception of David Stern and Brad H. Young (to a point), have not referred to the scores of books and articles on Christian parables. Needless to say, scholars of Judaism would not refer to scholars of Christianity on the same matter, but the "Christian" in "Christian parables" only modifies "parables." "Christian parables" are most basically parables, just as "Jewish parables" are, on their most basic level, parables. Again with the exception of Stern, scholars of Jewish parables must not, as Stern notes, "misidentify" parables with allegory or ma'aseh—"paradeigma, an example, or exemplum: an anecdote told to exemplify or illustrate a lesson, moral or otherwise" (*Parables in Midrash: Narrative and Exegesis in Rabbinic Literature* [Cambridge: Harvard University Press, 1991], 13). On a side note, even the great Jacob Neusner—author of over 1000 books—is off-track with his definition of parables. Neusner defines them as similes (*Rabbinic Narrative: A Documentary Perspective. Vol. 4, The Precedent and the Parable in Diachronic*

View [Leiden: Brill, 2003], 109.) The author of this paper hopes it will not only succeed in redefining the parable, but encourage scholars of Jewish parables to learn from the headway made by scholars of Christian parables (without conflating the Jewish part of their parables with the Christian part of their parables). Jews have a wonderful tradition of parables; it is a shame when they are read and conflated with allegory, simile, or mere analogy.

17. Dodd, 23. He was talking specifically about parables here, but he defined parables as metaphors.

18. Northrop Frye, *Anatomy of Criticism: Four Essays* (Princeton: Princeton University Press, 1990), 123.

19. Funk, 139.

20. Sallie McFague TeSalle, *Speaking in Parables: A Study in Metaphor and Theology* (Philadelphia: Fortress Press, 1975), 4.

21. Mary Ann Tolbert, *Perspectives on the Parables: An Approach to Multiple Interpretations* (Philadelphia: Fortress Press, 1979), 44–48.

22. Ibid., 46.

23. Ruth Etchells, *A Reading of the Parables of Jesus* (London: Darton, Longman and Todd, Ltd., 1998), 6–8.

24. John Dominic Crossan, "Parable and Example in the Teaching of Jesus," *New Testament Studies* 18.3 (1972), 285–307.

25. Dan O. Via, Jr., "Parable and Example Story: A Literary-Structuralist Approach," *Linguistica Biblica* 25–26 (1973),27.

26. William G. Kirkwood, "Parables as Metaphors and Examples," *Quarterly Journal of Speech* 71 (1985), 422–440.

27. Ibid., 424.

28. Stern, 9–10. As stated earlier, Jacob Neuser defines Jewish parables as similes. This is further proof for my theory that *parabolē* encompasses many of the same definitions as *mashal*. The question has long been asked how to treat the parables that begin with the line, "The Kingdom of God is like…" From the Hebraic perspective, this is in line with the format of the *mashal-nimshal*: "The Hebrew word for parable, Mashal, yields a passive, (2) Nimshal, thus (1) the parable and (2) the base-pattern or situation or transaction or event or proposition that is replicated in the simile constructed by the parable (Neusner, 112). Going further, clearly, with even limited knowledge of the parables of Jesus, one can see the structural similarities of the *mashal*, as Neusner defines it, with the parables of Jesus: "The parabolic narrative is totally abstract, asking for an act of imagination, (1) not mentioning specific authorities, (2) not placing the action in concrete time and a determinate, locative setting, and (3) not invoking an authoritative text…" (Neusner, 110).

29. It has been debated for quite some time how many parables of Jesus there are. The author of this article fully intends to return to this question, however at a later date.

30. Craig L. Blomberg, *Interpreting the Parables* (Downers Grove: InterVarsity Press, 1990).

31. B. B. Scott, *Hear Then the Parable* (Minneapolis: Fortress, 1989).

32. Joachim Jeremias, *The Parables of Jesus*, Revised Ed. (New York: Charles Scribner's Sons, 1962, 19.
33. Ibid., 25.
34. Ibid., 22.
35. Norman Perrin, *Rediscovering the Teaching of Jesus* (New York: Harper & Row, Publishers, 1967), 39.
36. Ibid., 84, 86.
37. John Drury, in *The Parables in the Gospels* (New York: Crossroad, 1985), takes a "historical-structural" approach (4). Drury argues that the task of scholars like Perrin is impossible since we can never get back to original place of Jesus's ministry. Instead, we can understand the historical setting. "The meaning of most of the parables," Drury says, "is tied into a past and particular historical crisis: the emergence of the Christian religion out of the Jewish, and the task of self-definition which it imposed"(6).
38. Dan O. Via, Jr., *The Parables: Their Literary and Existential Dimension* (Philadelphia: Fortress Press, 1967), 77.
39. Amos N. Wilder, *Early Christian Rhetoric: The Language of the Gospel* (Cambridge: Harvard University Press, 1971), 84.
40. Ibid., 76.
41. Ricoeur, 115.
42. Wilder, 77.
43. Kirkwood, "Storytelling," 58.
44. Ibid., 68.
45. William R. Herzog II, *Parables as Subversive Speech: Jesus as Pedagogue of the Oppressed* (Louisville: Westminster/John Knox Press, 1994), 7.
46. Ibid., 29.
47. Richard Q. Ford, *The Parables of Jesus: Recovering the Art of Listening* (Minneapolis: Fortress Press, 1997), 9.
48. Politzer, 48.
49. Crossan, *Raid* 98.
50. Ibid., 96–98.
51. Crossan, *Raid*, 93, 95.
52. Wilder, 77.
53. Crossan, *Raid*, 97.

Addendum #2

1. There is one other article worth mentioning here: Modupe O. Olaogun, "Parables in the Theatre: A Brief Study of Femi Osofisan's Plays,"*Okike*27-28 (1988), 43–55. The first paragraph tries to define parables and the next four paragraphs are about authors who use the parabolic form, from Orwell to Brecht. Besides having only one paragraph defining parables, the definition is too easy to dismiss. Olaogun says that the parabolic will "subsume the allegorical and the fabular" (43). This is simply just not the case. Allegories and fables are distinct genres. The fundamental difference between parable and fable is

twofold. First, parable must be expressed in the ordinary, if it is to fit the classical definition, as opposed to a fable, which (almost) always deals with animals or the fantastic. Second, the parable discusses what one person did and not what people do. In a fable, on the other hand, "the particular story is invented to represent a general pattern of behavior, with the widest application" (H. J. Blackham, *The Fable as Literature* [London: The Athlone Press, 1985], xiv).

2. G. W. Brandt, "Realism and Parables: from Brecht to Arden," *Contemporary Theatre* (New York: St. Martin's Press, 1962), 35.

3. A. M. Hunter, *Interpreting the Parables* (London: SCM Press, Ltd., 1960), 9.

4. Amos N. Wilder, *Early Christian Rhetoric: The Language of the Gospel* (Cambridge: Harvard University Press, 1971), 73.

5. Paul Ricoeur, "Biblical Hermeneutics" *Semeia* 4 (1975), 115.

6. Ibid.

7. Brandt, 55.

8. Jenny S. Spencer, *Dramatic Strategies in the Plays of Edward Bond* (Cambridge: Cambridge University Press, 1992), 109.

9. Wilder, 77.

10. John Dominic Crossan, *Raid on the Articulate: Comic Eschatology in Jesus and Borges* (New York: Harper & Row, Publishers, 1976), 95.

11. William G. Kirkwood, "Storytelling and Self Confrontation: Parables as Communication Strategies," *Quarterly Journal of Speech* 69 (1983), 58–74.

12. Spencer, 110.

13. Mary Ann Tolbert, *Perspectives on the Parables: An Approach to Multiple Interpretations* (Philadelphia: Fortress Press, 1979), 44–8.

14. Spencer, 125.

15. Ricoeur, 88, 126–27.

16. Kirkwood, "Storytelling and Self Confrontation" 65.

17. Jack Zipes argues that myths have morphed into fairy tales and they are really one in the same, and that the purpose of both is to reinscribe the beliefs of the society (or bourgeoisie) at the time when they were written: *Fairy Tale as Myth: Myth as Fairy Tale* (Lexington: The University Press of Kentucky, 1994).

18. Crossan, *Raid* 98–9.

19. Spencer, 109.

20. Sallie McFagueTeSalle, *Speaking in Parables: A Study in Metaphor and Theology* (Philadelphia: Fortress Press, 1975), 73.

21. Ricoeur, 66.

22. Ric Knowles, *Reading the Material Theatre* (Cambridge: Cambridge University Press, 2004), 3.

23. Ibid., 18.

24. Ibid.

25. Norman Perrin, *Rediscovering the Teaching of Jesus* (New York: Harper & Row, Publishers, 1967).

26. Dan Otto Via, Jr., *The Parables: Their Literary and Existential Dimension* (Philadelphia: Fortress Press, 1980), 97, 100.

27. Sallie McFague, *Metaphorical Theology: Models of God in Religious Language* (Philadelphia Press, 1987), 20.

28. William A. Beardslee, *Literary Criticism of the New Testament*(Philadelphia: Fortress Press, 1971),18.

29. Stanton B. Garner, Jr., *Bodied Spaces: Phenomenology and Performance in Contemporary Drama* (Ithaca: Cornell University Press, 1994), 40.

30. Ibid., 39.

31. Herbert Blau, *The Audience* (Baltimore: Johns Hopkins University Press, 1990), 11.

32. Bert O. States, *Great Reckonings in Little Rooms: On the Phenomenology of the Theater* (Berkeley: University of California Press, 1985), 127.

33. Bert O. States, "Performance as Metaphor" *Theatre Journal* 48.1 (1996), 16.

34. Alan Read, *Theatre and Everyday Life: An Ethics of Performance* (London: Routledge, 1993), 1.

35. Read, 10.

36. States,"Performance as Metaphor" 25.

Bibliography

Albee, Edward. *Who's Afraid of Virginia Woolf?* New York: Signet, 1983.

Almond, Ian. "Absorbed into the Other: A Neoplatonic Reading of *The Birthday Party.*" *Literature & Theology* 14.2 (June 2000): 174–88.

Anouilh, Jean. "Godot or the Music-Hall Sketch of Pascal's *Pensées* as Played by the Fratenllini Clowns." *Arts* #400, January 27, 1953.*Casebook on Waiting for Godot*, edited by Ruby Cohn. New York: Grove Press, Inc., 1967, 12–13.

Aristotle. *Poetics.* Mineola: Dover Publications, Inc., 1997.

Atkinson, Brooks. "Theatre: Beckett's 'Waiting for Godot." *The New York Times*, April 20, 1956.

Audiberti, Jacques. "At the Babylone a Fortunate Move on the Theater Checkerboard." *Arts* #394, January 16, 1953, *Casebook on Waiting for Godot*, edited by Ruby Cohn,13–14.New York: Grove Press, Inc., 1967.

Baker-White, Robert. "Violence and Festivity in Harold Pinter's *The Birthday Party, One for the Road*, and *Party Time.*" *The Pinter Review* (1994): 61–75.

Baraka, Amiri. "Great Goodness of Life: A Coon Show." In *Kuntu Drama: Plays of the African Continuum*, edited by Paul Carter Harrison, 156–68. New York: Grove Press, Inc., 1974.

Beardslee, William A. *Literary Criticism of the New Testament.* Philadelphia: Fortress Press, 1971.

Beckett, Samuel. *Happy Days.* New York: Grove Press, Inc., 1994.

———. *Waiting for Godot.* New York: Grove Press, Inc., 1954.

Bennett, Michael Y. "Clowning Around in James Purdy's The Paradise Circus." *Notes on Contemporary Literature* 38.3 (May 2008): 7–10.

———. "The Female Absurd." *Comparative Drama Conference.* Loyola Marymount University. 26 March 2010.

———. Review, *Waiting for Godot. Theatre Journal* 62.1 (March 2010): 110–111.

———. Review-Essay, "Away from the Absurd?: The Critical Response to Beckett at 100." *KritikonLitterarum* 36.3/4 (2009): 230–238.

———. "The Revolt Against Existentialism: Camus and the Parable of Estragon's Struggle with the Boot in *Waiting for Godot.*" In *Samuel Beckett's* Waiting for Godot, edited by Ranjan Ghosh. Amsterdam: Rodopi, 2012. *forthcoming.*

———. "Sartre's "The Wall" and Beckett's *Waiting for Godot*: Existential and Non-Existential Nothingness." *Notes on Contemporary Literature* (November 2009): 2–3.

Bently, Eric. "Anti-Play," *Samuel Beckett:* Waiting for Godot*: A Casebook*, edited by Ruby Cohn, 24–24. Houndmills: Macmillan, 1987.

Bentson, Kimberly W. *Baraka: The Renegade and the Mask.* New Haven: Yale University Press, 1976.

Bhabha, Homi K. *The Location of Culture.* London: Routledge, 1994.

Bhaktin, Mikhail. *Rabelais and His World,* translated by Helene Iswolsky. Bloomington: Indiana University Press, 1984.

Billington, Michael. *The Life and Work of Harold Pinter.* London: Faber and Faber, 1996.

Blackham, H. J. *The Fable as Literature.* London: The Athlone Press, 1985.

Blanchard, Marc. "Before Ethics: Camus's *Pudeur.*" *MLN* 112.4 (1997): 666—82.

Blau, Herbert.*The Audience.* Baltimore: Johns Hopkins University Press, 1990.

———. "The Faith-Based Initiative of the Theater of the Absurd," *Journal of Dramatic Theory and Criticism* 16.1 (Fall 2001): 3–13.

Blomberg, Craig L. *Interpreting the Parables.* Downers Grove: InterVarsity Press, 1990.

Boisseron, Bénédicte, and Frieda Ekotto. "Genet's *The Blacks*: 'And Why Does One Laugh at a Negro?' " *Paragraph: A Journal of Modern Critical Theory* 27.2 (2004): 98–112.

Bornkamm, Günther. *Jesus of Nazareth.* New York: Harper & Row, 1960.

Bovard, Karen. Performance Review of *Peter and Jerry: Act I: Homelife, Act II: The Zoo Story. Theatre Journal* 56.4 (December 2004): 691–93.

Bradby, David. "Beckett's Shapes." *Samuel Beckett:* Waiting for Godot*: A Casebook*, edited by Ruby Cohn, 114–16. Houndmills: MacMillan, 1987.

———. "Blacking Up—Three Productions by Peter Stein." In *A Radical Stage: Theatre in Germany in the 1970s and 1980s,* edited by W. G. Sebald, 18–32. Oxford: Berg, 1988.

———. "Genet, the Theatre and the Algerian War. (Jean Genet's Play *Les Paravents*)." *Theatre Research International* 19.3 (Autumn 1994): 226–37.

Brandt, G. W. "Realism and Parables: From Brecht to Arden." In *Contemporary Theatre*, 33–56. New York: St. Martin's Press, 1962.

Brantley, Ben. "Language, the Muse That Provokes Stoppard and Albee." *The New York Times.* 18 February, 2008.

Brater, Enoch. "Rethinking Realism and a Few Other Isms." In *Around the Absurd: Essays on Modern and Postmodern* Drama, edited by Enoch Brater and Ruby Cohn, 293–302. Ann Arbor: The University of Michigan Press, 1990.

———. "Talk About Landscapes: What There is to Recognize." *Modern Drama* 49.4 (Winter 2006): 501–513.

Brewer, Maria Minich. "A Semiosis of Waiting." *Samuel Beckett:* Waiting for Godot*: A Casebook*, edited by Ruby Cohn, 150–54. Houndmills: MacMillan, 1987.

Bryden, Mary. *Samuel Beckett and the Idea of God.* New York: Macmillan, 1998.

Bugliani, Ann. "The Biblical Subtext in Beckett's *Waiting for Godot.*" *Journal of Dramatic Theory and Criticism* 16.1 (2001): 15–38.

Calderwood, James L. "Ways of Waiting in 'Waiting for Godot.'" In *Waiting for Godot* and *Endgame,* edited by Steven Connor. New York: St. Martin's Press, 1992.

Camus, Albert. *Le mythe de Sisyphe: EssaisurL'Absurde.* Gallimard, 1942.

———. *The Myth of Sisyphus: And Other Essays.* Trans. Justin O'Brian. New York: Vintage Books, 1955.

———. *The Rebel: An Essay on Man in Revolt.* New York: Vintage Books, 1956.

Carey, Benedict. "How Nonsense Sharpens the Intellect." *The New York Times* 6 October 2009.

Carroll, David. "Rethinking the Absurd: *Le Mythe de Sisyphe.*" *The Cambridge Companion to Camus,* edited by Edward J. Hughes, 53–66. Cambridge: Cambridge University Press, 2007.

Champion, James. "The Parable as an Ancient and Modern Form." *Journal of Literature & Theology* 3.1 (March 1989): 16–39.

"Character." *Oxford English Dictionary.* 2nd ed. 1989.

Chaudhuri, Una. "The Politics of Theater: Play, Deceit, and Threat in Genet's *The Blacks.*" *Modern Drama* 28.3 (1985): 362–376.

Cohn, Ruby, "The World of Harold Pinter." *The Tulane Drama Review* 6.3 (March 1962): 55–68.

Cohn, Ruby, ed. *Casebook on* Waiting for Godot. New York: Grove Press, Inc., 1967.

———. *Samuel Beckett:* Waiting for Godot*: A Casebook.* Houndmills: MacMillan, 1987.

———. "Waiting." In *Samuel Beckett's Waiting for Godot,* edited by Harold Bloom, 41–52. New York: Chelsea House Publishers, 1987.

———. "Introduction: Around the Absurd." In *Around the Absurd: Essays on Modern and Postmodern Drama,* edited by Enoch Brater and Ruby Cohn, 1–9. Ann Arbor: The University of Michigan Press, 1990.

Connon, Derek F. "Confused? You Will Be: Genet's *Les Nègres* and the Art of Upsetting the Audience." *French Studies: A Quarterly Review* 50.4 (October 1996): 425–438.

Cornwell, Neil. *The Absurd in Literature.* Manchester: Manchester University Press, 2006.

Cotter, Holland. "A Broken City. A Tree. Evening." *The New York Times.* 2 December 2007.

Cousineau, Thomas. *Waiting for Godot: Form in Movement.* Boston: Twayne Publishers, 1990.

Crossan, John Dominic. *In Parables: The Challenge of the Historical Jesus.* New York: Harper & Row, Publishers, 1973.

———. "Parable and Example in the Teaching of Jesus" *New Testament Studies* 18.3 (1972): 285–307.

———. *Raid on the Articulate: Comic Eschatology in Jesus and Borges.* New York: Harper & Row, Publishers, 1976.

Daigle, Christine, ed. *Existentialist Thinkers and Ethics*. Montreal & Kingston: McGill-Queen's University Press, 2006.

Davies, Telory W. Performance Review of *Rhinoceros*. *Theatre Journal* 54.4 (December 2002): 645–46.

Demastes, William W. *Beyond Naturalism: A New Realism in American Theatre*. New York: Greenwood Press, 1988.

———. *Theatre of Chaos: Beyond Absurdism, Into Orderly Disorder*. Cambridge: Cambridge University Press, 1998.

Derksen, Celeste. "A Feminist Absurd: Margaret Hollingsworth's *The House that Jack Built*." *Modern Drama* 45.2 (Summer 2002): 209–230.

Derrida, Jacques, *Dissemination*, translated by Barbara Johnson. Chicago: The University of Chicago Press, 1983.

———. *Speech and Phenomena*, translated David Allison. Evanston: Northwestern University Press, 1973.

"Disposition." *Oxford English Dictionary*. 2nd ed. 1989.

Dodd, C. H. *The Parables of the Kingdom*. London: Collins, 1935.

Drury, John. *The Parables in the Gospels*. New York: Crossroad, 1985.

Dukore, Bernard. "The Theatre of Harold Pinter." *The Tulane Drama Review* 6.3 (March 1962): 43–54.

Ehrmann, Jacques. "Camus and the Existential Adventure." *Yale French Studies* 25 (1960): 93–97.

Ellison, Reuben Y., and Stowell C. Goding. "Avant-Propos." In *Rhinoceros*, by Eugene Ionesco, edited by Reuben Y. Ellison and Stowell C. Goding, v–vii. New York: Holt, Rinehart and Winston, 1961.

Esslin, Martin. "The Theatre of the Absurd." *The Tulane Drama Review* 4.4 (May 1960): 3–15.

———. *The Theatre of the Absurd*. Garden City: Anchor Books, 1961.

———. Editor. *Absurd Drama*. Middlesex: Penguin, 1965.

———. "What Beckett Teaches Me: His Minimalist Approach to Ethics," *Samuel Beckett Today* 2 (1993): 13–20.

———. "Beckett and the Quest for Meaning," *Samuel Beckett Today* 11 (2001): 27–30.

Etchells, Ruth. *A Reading of the Parables of Jesus*. London: Darton, Longman and Todd, Ltd., 1998.

Farber, Vreneli. Performance Review of *Waiting for Godot*, *Theatre Journal* 53.4 (December 2001): 653–55.

Feldman, Asher. *The Parables and Similies of the Rabbis: Agricultural & Pastoral*, 2nd ed. Cambridge: Cambridge University Press, 1927.

"Find," *Oxford English Dictionary*, 2nd ed. 1989.

Ford, Anna. *Pinter, Plays & Politics*. BBC Television Interview. 1988.

Ford, Richard Q. *The Parables of Jesus: Recovering the Art of Listening*. Minneapolis: Fortress Press, 1997.

Forsdick, Charles. "Camus and Sartre: The Great Quarrel." In *The Cambridge Companion to Camus*, edited by Edward J. Hughes, 118–30. Cambridge: Cambridge University Press, 2007.

Fotiade, Ramona. *Conceptions of the Absurd: From Surrealism to the Existential Thought of Chestov and Fondane*. Oxford: Legenda, 2001.

Foucault, Michel. *The Order of Things: An Archaeology of the Human Sciences*. New York: Vintage Books, 1970.

Fowlie, Wallace. "New Plays of Ionesco and Genet. *The Tulane Drama Review* 5.1 (September 1960): 43–48.

Frankl, Viktor E. *Man's Search for Meaning: An Introduction to Logotherapy*, translated by Ilse Lasch. New York: Pocket Books, 1959.

Frye, Northrop. *Anatomy of Criticism: Four Essays*. Princeton: Princeton University Press, 1990.

Funk, Robert W. *Language, Hermeneutic, and Word of God: The Problem of Language in the New Testament and Contemporary Theology*. New York: Harper & Row, Publishers, 1966.

Gaensbauer, Deborah B. *The French Theater of the Absurd*. Boston: Twayne Publishers, 1991.

Gale, Steven H. *Butter's Going Up: A Critical Analysis of Harold Pinter's Work*. Durham: Duke University Press, 1977.

Garner, Jr., Stanton B. *Bodied Spaces: Phenomenology and Performance in Contemporary Drama*. Ithaca: Cornell University Press, 1994.

Genet, Jean. *The Blacks: A Clown Show*. New York: Grove Press, Inc., 1960.

———. The Maids *and* Deathwatch: *Two Plays*. New York: Grove Press, Inc., 1961.

Ghose, Meeta. "Harold Pinter's *The Birthday Party* as a Comedy of Menace." *Panjab University Research Bulletin* 18.1 (1987): 59–67.

Gillen, Francis. "'All These Bits and Pieces': Fragmentation and Choice in Pinter's Plays." *Modern Drama* 17 (1974): 477–87.

"Go." *Oxford English Dictionary*. 2nd ed. 1989.

Gordon, Jane. "Theater Review: An Albee Revival (and a Premiere)," *The New York Times* 6 June, 2004.

Gordon, Jeffrey. "The Triumph of Sisyphus." *Philosophy and Literature* 32.1 (2008): 183–190.

Gupta, Suman. "Samuel Beckett, *Waiting for Godot*." In *The Popular and the Canonical: Debating Twentieth-Century Literature 1940–2000*, edited by David Johnson, 210–61. London: Routledge, 2005.

Haefner, Alfred E. "The Ethical Syllogism." *Ethics* 71.4 (July 1961): 289–95.

Hall, Ann C. "Looking for Mr. Goldberg: Spectacle and Speculation in Harold Pinter's *The Birthday Party*." *The Pinter Review* (1999): 48–56.

Hall, H. Gaston. "Aspects of the Absurd." *Yale French Studies* 25 (1960): 26–32.

Haller, Scot. "Her First Play, Her First Pulitzer Prize." *Saturday Review*, November 1981.

Hallie, Philip. "Camus and the Literature of Revolt." *College English* 16.1 (Oct. 1954): 25–32, 83.

Herzog II, William R. *Parables as Subversive Speech: Jesus as Pedagogue of the Oppressed*. Louisville: Westminster/John Knox Press, 1994.

Hewes, Henry. "Mankind in the Merdecluse." *Saturday Review*, May 5, 1956. In *Casebook on Waiting for Godot*, edited by Ruby Cohn, 67–69. New York: Grove Press, Inc., 1967.

Homan, Sidney. "Playing Prisons." In *Samuel Beckett:* Waiting for Godot*: A Casebook*, edited by Ruby Cohn, 181–93. Houndmills: MacMillan, 1987.

Horkheimer, Max, and Theodor W. Adorno. *Dialectic of* Enlightenment, translated by John Cumming. New York: Continuum, 1972.

Hribar, Darja. "Rewriting the Dramatic Convention of the Theatre of the Absurd in Slovene Translation." In *On the Relationship Between Translation Theory and Translation Practice,* edited by JeanPeeters, 141–49. Frankfurt: Peter Lang, 2005.

Hughes, Edward J., ed. *The Cambridge Companion to Camus*. Cambridge: Cambridge University Press, 2007.

Huizinga, Johan. *Homo Ludens: A Study of the Play Element in Culture.* Boston: Beacon Press, 1950.

Hunter, A. M. *Interpreting the Parables.* London: SCM Press, Ltd., 1960.

Ionesco, Eugene. "Dans les armes de la ville." *Cahiers de la Companie Madeleine Renaud-Jean-Louis Barrault* 20 (October 1957): 2–5.

———. *The Bald Soprano.* In *Four Plays*, translated by Donald M. Allen, 7–42. New York: Grove, 1958.

———. *Rhinoceros and Other Plays.* New York: Grove Press, Inc., 1960.

———. *Notes and Counter Notes,* translated by Donald Watson. New York: Grove Press, 1964.

Isherwood, Charles. "Theater Review: *Waiting for Godot*: Those Two Tramps Again, Stuck in Place after 50 Years." *The New York Times*, 26 October, 2006.

Jacquart, Emmanuel. "Ionesco's Political Itinerary." In *The Dream and the Play: Ionesco's Theatrical Quest*, edited by Moshe Lazar, 63–80. Malibu: Undena, 1982.

Jeremias, Joachim. *The Parables of Jesus.* Rev. Ed. New York: Charles Scribner's Sons, 1962.

Johansson, Birgitta. "Beckett and the Apophatic in Selected Shorter Texts." *Samuel Beckett Today/Aujourd'hui* 9 (2000): 55–66.

Jones, Geraint Vaughn. *The Art and Truth of the Parables.* London: S. P. C. K., 1964.

Judt, Tony. *Postwar: A History of Europe Since 1945.* New York: Penguin Books, 2005.

Kant, Immanuel. *Groundwork of the Metaphysics of Morals.* Ed. and Trans. Mary Gregor. Cambridge: Cambridge University Press, 1999.

Kern, Edith. "Drama Stripped for Inaction: Beckett's Godot." *Yale French Studies* 14 (1954): 41–47.

Kirkwood, William G. "Parables as Metaphors and Examples." *Quarterly Journal of Speech* 71 (1985): 422–440.

———. "Storytelling and Self Confrontation: Parables as Communication Strategies." *Quarterly Journal of Speech* 69 (1983): 58–74.

Kirshenblatt-Gimblett, Barbara. "A Parable in Context: A Social Interactional Analysis of Storytelling Performance." In *Folklore: Performance and*

Communication, edited by Dan Ben-Amos and Kenneth S. Goldstein, 105–30. The Hague: Mouton, 1975.

Klein, Alvin. "Theater: Crazy But True, Ionesco at the Shakespeare Festival," *The New York Times*, 20 August, 2000.

Knee, Philip. "An Ethics of Measure: Camus and Rousseau." In *Existentialist Thinkers and Ethics*, edited by Christine Daigle, 107–19. Montreal: McGill-Queen's University Press, 2006.

Knowles, Ric. *Reading the Material Theater*. Cambridge: Cambridge University Press, 2004.

Knowles, Ronald. "The Road to Basingstok: *The Birthday Party* and the IRA." *The Pinter Review* (1992): 73–76.

Kritzman, Lawrence D. "Camus' Curious Humanism or the Intellectual in Exlie," *MLN* 112.4 (Sept. 1997): 550–75.

Kruger, Loren. "Ritual into Myth: Ceremony and Communication in *The Blacks*." *Critical Arts* 1.3 (1980): 59–69.

Lavery, Carl. "Racism and Alienation Effects in *Les Nègres*." In *Essays in Memory of Michael Parkinson and Janine Daknyns*, edited by Christopher Smith, 313–17. Norwich: School of Mod. Lang. & European Studies, University of East Anglia, 1996.

LeJuez, Brigette. *Beckett Before Beckett*. Trans. Ros Schwartz. London: Souvenir Press, 2008.

Levy, Alan. "Theatre Arts, August, 1956." In *Casebook on Waiting for Godot*, edited by Ruby Cohn, 74–78. New York: Grove Press, Inc., 1967.

Levy, Shimon. "On and Offstage: Spiritual Performatives in Beckett's Drama." *Samuel Beckett Today/Aujourd'hui* 9 (2000): 17–29.

Lowe, Leah. Performance Review of *The Birthday Party*. *Theatre Journal* 56.3 (2004): 508–10.

Mailer, Norman. "A Public Notice on Waiting for Godot." *The Village Voice*, May 7, 1966, In *Casebook on Waiting for Godot*, edited by Ruby Cohn, 69–74. New York: Grove Press, Inc., 1967.

Mamet, David. *Oleanna*. New York: Vintage Books, 1993.

McCarty, Richard. "Maxims in Kant's Practical Philosophy." *Journal of the History of Philosophy* 44.1 (2006): 65–83.

McFague, Sallie. *Metaphorical Theology: Models of God in Religious Language*. Philadelphia: Fortress Press, 1982.

———. *Speaking in Parables: A Study in Metaphor and Theology*. Philadelphia: Fortress Press, 1975.

McKenzie, Jon. *Perform or Else: From Discipline to Performance*. New York: Routledge, 2001.

Mills, James. "The Dualism of Décor and Direction in Ionesco's *Rhinoceros*." *Proceedings of the Utah Academy of Sciences, Arts and Letters* 75 (1998): 55–62.

Neusner, Jacob. *Rabbinic Narrative: A Documentary Perspective. Vol. 4, The Precedent and the Parable in Diachronic View*. Leiden: Brill, 2003.

Ngezem, Eugene. "Disabling the Disabled: Samuel Beckett and the Plight of the Handicapped." *Notes on Contemporary Literature* 34.5 (2004): 13–16.

Ngezem, Eugene. "Modern Marriage in Collapse: A Study of Selected Plays of Samuel Beckett and Harold Pinter," *Language Forum* 31.1 (2005): 99–111.

Niditch, Susan. *Folklore and the Hebrew Bible.* Minneapolis: Fortress Press, 1993.

Olaogun, Modupe O. "Parables in the Theatre: A Brief Study of Femi Osofisan's Plays." *Okike* 27–28 (1988): 43–55.

Oxford English Dictionary. 2nd ed., 1987.

"Parables," *The Catholic Encyclopedia*, 1 June 2005, <http://www.newadvent.org/cathen/11460a.htm>.

Parsell, David B. "A Reading of Ionesco's *Rhinoceros*." *Furman Studies* 21.4 (1974): 13–15.

Perrin, Norman. *Rediscovering the Teaching of Jesus.* New York: Harper & Row, Publishers, 1967.

Pinter, Harold. The Birthday Party *and* The Room: *Two Plays by Harold Pinter.* New York: Grove Press, Inc., 1961.

———. "Letter to Peter Wood," *The Kenyon Review* 3.3 (Summer 1981): 1–5.

Plunka, Gene A., "Victor Turner and Jean Genet—Rites of Passage in *Les Nègres*." *The Theatre Annual* 45 (1991): 65–88.

Politzer, Heinz. "Franz Kafka and Albert Camus: Parables for Our Time." *Chicago Review* 14.1 (Spring 1960): 47–67.

Read, Alan. *Theatre and Everyday Life: An Ethics of Performance.* London: Routledge, 1993.

Read, Sir Herbert. "Foreword." In *The Rebel: An Essay on Man in Revolt*, by Albert Camus, 3–11. New York: Vintage Books, 1956.

Rehm, Rush, Carl Weber and Wendell Cole. "Memorial Resolution: Martin Esslin." *Stanford Report."* May 5, 2004.

Richards, I. A. *The Philosophy of Rhetoric.* New York: Oxford University Press, 1965.

Ricoeur, Paul. "Biblical Hermeneutics." *Semeia* 4 (1975): 29–148.

Robbe-Grillet, Alain. "Samuel Beckett or Presence on the Stage." *Critique*, February, 1953. In *Casebook on Waiting for Godot*, edited by Ruby Cohn, 15–21. New York: Grove Press, Inc., 1967.

Robinson, James E. "Sisyphus Happy: Beckett Beyond the Absurd." *Samuel Beckett Today/aujourd'hui* 6 (1997): 343–52.

Royle, Peter. *The Satre–Camus Controversy: A Literary and Philosophical Critique.* Ottawa: University of Ottawa Press, 1982.

Sagi, Avi. *Albert Camus and the Philosophy of the Absurd.* Manchester: Manchester University Press, 2002.

Said, Edward W. *Orientalism.* New York: Vintage Books, 1994.

Sanyal, Debarati. "Broken Engagements." *Yale French Studies* 98 (2000): 29–49.

Sartre, Jean-Paul. "Introduction." In The Maids *and* Deathwatch: *Two Plays*, by Jean Genet, 7–32. New York: Grove Press, Inc., 1961.

———. "No Exit." In "No Exit" *and Three Other Plays.* New York: Vintage International, 1989. 1–46.

Schechner, Richard. "An Interview with Ionesco." Translated by Leonard C. Pronko. *The Tulane Drama Review* 7.3 (Spring 1963): 161–68.

———. "The Inner and Outer Reality." *The Tulane Drama Review* 7.3 (Spring 1963): 187–217.

———. "Puzzling Pinter." *The Tulane Drama Review* 11.2 (Winter 1966): 176–184.

Schmidt, Kerstin. *The Theater of Transformation: Postmodernism in American Drama*. Amsterdam: Rodopi, 2005.

Scott, Bernard Brandon. *Hear Then the Parable: A Commentary on the Parables of Jesus*. Minneapolis: Fortress Press, 1990.

"Seek." *Oxford English Dictionary*, 2nd ed. 1989.

Serralta, Frédéric, "Sobre el teatrodelabsurdo (de Juan del Encina a Juan Mateu)," *Revista de Literatura* 67.133 (2005): 181–90.

Siebers, Tobin. "Introduction: What Does Postmodernism Want? Utopia." In *Heterotopia: Postmodern Utopia and the Body Politic*, edited by Tobin Siebers, 1–39. Ann Arbor: The University of Michigan Press, 1994.

Siegel, Naomi. "Theater Review: At a Party with a Dark Side, Menace and Peril Pay a Visit," *The New York Times*, 1 October 2006.

Silverstein, Marc. "Keeping the Other in Its Place: Language and Difference in *The Room* and *The Birthday Party*." *The Pinter Review* (1992): 1–9.

Simpson, Paul. "Odd Talk: Studying Discourses of Ambiguity." In *Exploring the Language of Drama: From Text to Context*, edited by Jonathan Culpeper, Mick Short, and Peter Verdonk, 34–53. London: Routledge, 1998.

Sohlich, W. F. "Genet's *The Blacks* and *The Screens*: Dialectic of Refusal and Revolutionary Consciousness." *Comparative Drama* 10 (1976): 216–34.

Somers, John. "*The Birthday Party*: Its Origins, Reception, Themes and Relevance for Today." *Cycnos* 14.1 (1997): 7–18.

Spencer, Jenny S. *Dramatic Strategies in the Plays of Edward Bond*. Cambridge: Cambridge University Press, 1992.

States, Bert O. *The Shape of Paradox: An Essay on* Waiting for Godot. Berkeley: University of California Press, 1978.

———. *Great Reckonings in Little Rooms: On the Phenomenology of the Theater*. Berkeley: University of California Press, 1985.

———. "Performance as Metaphor." *Theatre Journal* 48.1 (1996): 1–26.

Stern, David. *Parables in Midrash: Narrative and Exegesis in Rabbinic Literature*. Cambridge: Harvard University Press, 1991.

"Struggle." *Oxford English Dictionary*. 2nd ed. 1989.

"Struggle for existence." *Oxford English Dictionary*. 2nd ed. 1989.

"Temperament." *Oxford English Dictionary*. 2nd ed. 1989.

TeSalle, Sallie McFague. *Speaking in Parables: A Study in Metaphor and Theology*. Philadelphia: Fortress Press, 1975.

Thompson, Debby. "'What Exactly Is Black?': Interrogating the Reality of Race in Jean Genet's *The Blacks*." *Studies in 20th Century Literature* 26.2 (2002): 395–425.

Tolbert, Mary Ann. *Perspectives on the Parables: An Approach to Multiple Interpretations.* Philadelphia: Fortress Press, 1979.

Toolan, Michael. " 'What Makes You Think You Exist?': A Speech Move Schematic and Its Application to Pinter's *The Birthday Party.*" *Journal of Pragmatics* 32 (2000): 177–201.

Turner, Victor. *The Forest of Symbols: Aspects of Ndembu Ritual.* Ithaca: Cornell University Press, 1967.

Via, Jr., Dan O. *The Parables: Their Literary and Existential Dimension.* Philadelphia: Fortress Press, 1967.

———. "Parable and Example Story: A Literary-Structuralist Approach." *Linguistica Biblica* 25–26 (1973): 21–30.

Visser, Dirk. "Communicating Torture: The Dramatic Language of Harold Pinter." *Neophilologus* 80.2 (1996): 327–40.

Walling, Jane. " 'Dim Whence Unknown': Beckett and the Inner Logos." *Samuel Beckett Today/Aujourd'hui* 9 (2000): 105–18.

Webb, Richard C. "Ritual, Theatre, and Jean Genet's *The Blacks.*" *Theatre Journal* 31 (1979): 443–66.

Wellwarth, George. *The Theater of Protest and Paradox: Developments in the Avant-Garde Drama.* Revised Ed. New York: New York University Press, 1971.

Wenham, David. *The Parables of Jesus.* Downers Grove: InterVarsity Press, 1989.

Westgate, J. Chris. Performance Review of *Waiting for Godot.Theatre Journal* 56.2 (May 2004): 301–303.

Wilder, Amos N. *Early Christian Rhetoric: The Language of the Gospel.* Cambridge: Harvard University Press, 1971.

Williams, Raymond. "A Modern Tragedy." In *Samuel Beckett:* Waiting for Godot*: A Casebook*, edited by Ruby Cohn, 109–11. Houndmills: MacMillan, 1987.

Wineman, Aryeh. *The Hasidic Parable.* Philadelphia: The Jewish Publication Society, 2001.

———. "On the Hasidic Parable." *Judaism* 45.3 (Summer 1996): 33–39.

Young, Brad H. *The Parables: Jewish Tradition and Christian Interpretation.* Peabody: Hendrickson Publishers, LLC, 1998.

Zatlin, Phyllis. "Greek Tragedy or Theatre of the Absurd?: Montes Huidobro's *Oscuro total.*" *Latin American Theatre Review* 37.2 (2004): 115–126.

Zeitlin, Steve. "A Penchant for Parable," In *Because God Loves Stories: An Anthology of Jewish Storytelling*, edited by Steve Zeitlin, 277–88. New York: Touchstone, 1997.

Zipes, Jack. *Fairy Tale as Myth: Myth as Fairy Tale.* Lexington: The University Press of Kentucky, 1994.

Zucker, Richard. "The Happiness of Sisyphus." *Kinesis* (1987): 41–65.

Index